A GUIDE TO HISTORIC
Tampa

A GUIDE TO HISTORIC
Tampa
FLORIDA

STEVE RAJTAR

Charleston London

History
PRESS

Published by The History Press
Charleston, SC 29403
www.historypress.net

Cover inage: University of Tampa. *Courtesy of the Florida Photographic Collection.*

First published 2007

Manufactured in the United Kingdom

ISBN 978.1.59629.253.6

Library of Congress Cataloging-in-Publication Data

Rajtar, Steve, 1951-
 A guide to historic Tampa / Steve Rajtar.
 p. cm.
 Includes bibliographical references and index.
 ISBN-13: 978-1-59629-253-6 (alk. paper)
 1. Tampa (Fla.)--History. 2. Tampa Region (Fla.)--History. 3. Tampa (Fla.)-
-Guidebooks. 4. Tampa Region (Fla.)--Guidebooks. 5. Neighborhood--
Florida--Tampa--History. 6. Historic sites--Florida--Tampa. 7. Historic
buildings--Florida--Tampa. 8. Architecture--Florida--Tampa. 9. Tampa
(Fla.)--Buildings, structures, etc. I. Title.
 F319.T2R35 2007
 975.9'65--dc22
 2007017774

CONTENTS

INTRODUCTION

Many cities have a single event, industry, geographic feature or other raison d'être. Not so with Tampa, which was formed as several distinct neighborhoods with varied societies, which grew together to form the modern city. Tampa was not unlike a griddle onto which one pours several different flavors of pancake batter, and as they cook each expands to merge with the others, forming a large interconnected whole, with each section retaining much of its original flavor. Such is Tampa.

Downtown Tampa began as the sixteen-square-mile Fort Brooke military reservation, and the homes and businesses that grew up around it. Ybor City and West Tampa were established as cigar-producing towns in 1885 and 1894.

Hyde Park was created in 1886, and by 1893 it was proclaimed to be the most aristocratic section of Tampa. Soon after came the elegant Bayshore. Nearby upscale Palma Ceia and Beach Park followed in the 1920s.

Port Tampa developed as an industrial and commercial center in the 1890s. Outbreaks of yellow fever in 1886–87 encouraged development in the higher ground of Tampa Heights. Development of Ballast Point and Sulphur Springs was facilitated by their connection to the streetcar line during the 1890s.

Palmetto Beach, near Ybor City, began with three cigar factories in about 1897 and homes for their workers. Its DeSoto Park became a popular destination for "tin can tourists" in the 1920s. That same decade, Davis Islands was created from a pair of small islands and a great deal of sand dredged from Tampa Bay.

These and other neighborhoods developed, often in near isolation from the rest of the area, and over time all have grown together to form a patchwork of architecture, languages, businesses and traditions that make Tampa an interesting place in which to wander. The first portion of this book traces the events that, since the sixteenth century, have resulted in today's Tampa.

The second portion describes the historic structures that remain standing (and a few that do not) in the major Tampa neighborhoods. You can stroll down the streets and see who built them, who lived there, what they are used for now and why we remember them.

Tampa is a city of variety, from preserved quaint century-old buildings to completed structures which were still being built last week. You can find almost anything in Tampa, and the pages that follow tell how it became what it is today.

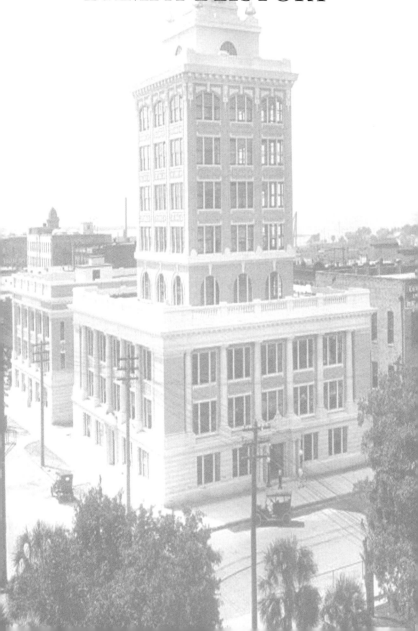

Part I

HIGHLIGHTS OF TAMPA HISTORY

THE 1500S

PONCE DE LEON

Ponce de Leon and his men sailed from Puerto Rico on March 3, 1513, and sighted land on April 2. They sailed southward from their initial contact point near Cape Canaveral and entered the Gulf of Mexico on June 3. They spent three weeks on Florida's west coast and perhaps entered Tampa Bay, then headed back to Puerto Rico after they were attacked by natives.

In 1521 Ponce returned to Florida aboard two ships, with two hundred men, fifty horses and directions to spread Christianity and establish a colony. Some historians believe he visited the Pinellas Peninsula, while others say his exploration was limited to the area around Charlotte Harbor. In an attack by the natives, Ponce suffered a leg wound which became infected and caused his death after he landed in Havana in July of 1521.

PANFILO DE NARVAEZ

Seeking legendary gold and slaves, Panfilo de Narvaez landed on the Pinellas Peninsula on April 16, 1528, then his men cut their way through to a large bay which he named La Bahia de la Cruz (the Bay of the Cross). Finding only a minimal amount of gold, they marched northward along the Gulf of Mexico to the territory of the Apalachee natives. From them he took grain, which kept his band going into Texas and Mexico. Only four of the original four hundred men who started the expedition finished it. While in Florida, they abandoned any hope of establishing a permanent settlement because of resistance by the Apalachees.

One of the survivors, Cabeza de Vaca, appeared in Mexico after eight years of wandering. After he returned to Spain, he published an account of the expedition in 1537. It included stories of cities of gold and jewels, based on tales he had heard from the natives. One man who was fascinated with such accounts was Hernando de Soto.

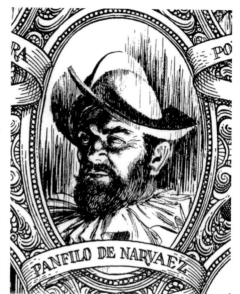

Panfilo de Narvaez

This sixteenth-century drawing depicts Panfilo de Narvaez, who departed from Spain with six hundred men aboard five ships. Because of a hurricane and desertion, only two-thirds reached Florida. Of the rest, half died on the march to the Florida panhandle, and many more took sick. After eight years, only four survived the journey. *Courtesy of the Florida Photographic Collection.*

HERNANDO DE SOTO

In 1539, Hernando de Soto and a contingent of 622 men arrived at Tampa Bay at the request of Spain's King Charles V to seek wealth and explore the possibility of colonization. De Soto was promised a half share of the gold and jewels he would find. However, since he didn't find the type of wealth he was looking for in the west Florida area, he attacked the natives.

Hernando de Soto

This is a drawing of the landing of de Soto at Tampa Bay, published in 1859 in Lambert A. Wilmer's *Life, Travels and Adventures of Ferdinand de Soto, Discoverer of the Mississippi.* As had de Narvaez, de Soto headed north and died along the route. However, more of de Soto's men survived to return to reach Mexico. *Courtesy of the Florida Photographic Collection.*

Eventually, he and his men headed north in search of wealth and food. In May of 1541, de Soto died from a fever and was placed in a hollow oak trunk which his men sank in the Mississippi River. His remaining 310 men reached Tampico, Mexico, on September 10, 1542.

MARTYR SITE

In 1549 Father Luis Cancer de Barbastro led an expedition to establish a mission among the Timucuans and Calusas. He had been warned to avoid Tampa Bay, but the expedition sailed there anyway. In an area along present Bayshore Boulevard, Cancer was bludgeoned to death by natives on June 26, 1549, one day after celebrating the first Catholic Mass recorded in North America.

TANPA

The name "Tanpa" was first reported in 1562 by Hernando de Escalante Fontaneda to be the name of one of twenty-two native villages near Tampa Bay. Fontaneda at age thirteen had been washed ashore near Sarasota in 1545 and was rescued by the Calusas, with whom he lived for seventeen years. It is believed that "Tanpa" meant "close to it" (as close to Tampa Bay), "split wood for quick fires," "sticks of fire" or "the place to gather sticks," and its spelling was modified when the Spaniards began writing on their own maps.

DON PEDRO MENENDEZ

In 1566 Don Pedro Menendez de Aviles sailed to Florida seeking a passage from Tampa Bay to the Atlantic Ocean, and to fare better than the previous conquistadors. He and five hundred soldiers reached Charlotte Harbor on February 14 and traded peacefully with the Calusas, who encouraged Menendez to attack the enemy Timucuans at Tocobaga.

Menendez explored the Hillsborough River, which disappointed him when it became obvious that it did not lead to the Atlantic Ocean. He met with the leaders at Tocobaga, but many Spanish and Calusas were massacred there by the end of 1567.

Spain gave up further attempts to conquer and colonize the area inhabited by fierce natives. However, the diseases they left behind eventually decimated the native populations. When expeditions returned in the 1700s, the native societies were reduced to little more than shell mounds and artifacts.

THE 1700S

JUAN BAPTISTA FRANCO

In 1756 and 1757, Tampa Bay was explored by Juan Baptista Franco who searched for timber to be used for ships' masts. He called the area Tampa, based on the accounts of friendly natives.

HILLSBOROUGH RIVER

In May of 1757, the river was first explored by Europeans after nearly two centuries when Don Francisco Maria Celi entered it and named it Rio de San Julian y Arriaga. He continued upstream to a small waterfall.

The river and county were in 1772 named by Dutch cartographer Bernard Romans for Wills Hill, Viscount Hillsborough of England. As secretary of state for the colonies under King George III, Hillsborough was in charge of collecting information about English overseas possessions. He was interested in Florida following his acquisition of a grant of land there, and dispatched Romans to investigate it.

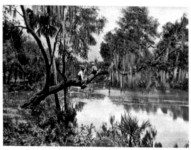

Hillsborough River

In 1900 this is how the river appeared as it flowed through early Tampa. It was also known as the Locktsapopka River for the Creek words *lokcha* and *papka*, meaning the "place where acorns are eaten." *Courtesy of the Florida Photographic Collection.*

SPANISHTOWN CREEK

Spanish Cuban fishermen and straw hat makers arrived in the late 1770s in the area near today's Bayshore Boulevard. They lived in palmetto-thatched huts along Spanishtown Creek, a small stream

which once emptied into Tampa Bay between today's Magnolia and Cedar Avenues. Theirs was the first white settlement on Tampa Bay.

JOSE GASPAR

In 1783 a Royal Spanish Navy lieutenant, Jose Gaspar, took over the war sloop *Florida Blanca*. Over the next twelve years, he captured or destroyed at least thirty-six other ships.

In 1821 Gaspar decided that it was time to retire and convinced his crew to split up their fortune. However, they came upon a merchant ship and decided to have just one more adventure before giving up pirating. Unfortunately for them, the ship they attacked turned out to be a disguised United States Navy warship.

Following a bloody battle, just as the victorious naval officer was boarding his ship, Gaspar jumped into the sea to avoid capture, and he drowned. Later, his memory was kept alive by his cabin boy, Juan Gomez, who survived the battle and recounted the stories of the pirates.

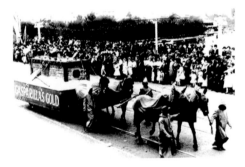

Gasparilla Parade

Since 1904, Tampa has hosted a festival to commemorate the activities of pirate Jose Gaspar. A highlight of the celebration is the Gasparilla Parade, shown here in 1915 crossing the Lafayette Street Bridge. *Courtesy of the Florida Photographic Collection.*

Gaspar's actual home base was located to the south at Charlotte Harbor. Nevertheless, he was chosen as the symbol for a Tampa festival by Louise Frances Dodge. She was hired as the *Tampa Tribune* society editor in 1903 by Wallace F. Stovall, who assigned her the task of developing a winter event which would attract tourists. With the help of George W. Hardee, a visitor from Louisiana, a festival similar to the Mardi Gras of New Orleans was established beginning in 1904.

Moored along Bayfront Boulevard is a replica of an eighteenth-century pirate ship, named after Gaspar and constructed in 1954. It is used in Tampa's festive annual Gasparilla celebration, which includes an attack and sacking of the city conducted by local businessmen disguised as pirates who arrive by ship. A highlight of the festival is a parade to honor King Gasparilla and his Queen, elected by an exclusive club known as Ye Mystic Krewe of Gasparilla.

The 1810s

James Gadsden

A reconnaissance expedition in 1818 confirmed Tampa as the appropriate place to set up an army post. Colonel James Gadsden, who had served as an aide-de-camp of General Andrew Jackson, set out the boundaries of what was to become Fort Brooke.

Gadsden was memorialized by the naming of Gadsden Point, the southern end of the Interbay Peninsula. He was also known for the Gadsden Purchase, an 1853 acquisition he negotiated to enlarge the United States with land that is now the southern portion of Arizona and New Mexico.

The 1820s

Treaty of Moultrie Creek

Effective September 18, 1823, a landmark treaty guaranteed natives the right to reside on reservations in South Florida, free from hassle by white settlers. The Seminoles were removed from the Alachua region to a reservation, which reached approximately thirty miles north of Tampa Bay. That lasted for a while, until the area unexpectedly became desirable for settlement.

The first permanent white settlers in the area were Levi and Nancy Collar, who homesteaded an area about six miles east of today's downtown in 1824. Collar built a boat which he used to bring fresh fruit from Havana and sell it to the Fort Brooke soldiers. In 1838 their home was burned by Seminoles, but the Collars escaped to Fort Brooke.

Fort Brooke

Fort Brooke was established as Cantonment Brooke by Colonel George M. Brooke on January 20, 1824, on a sixteen-square-mile site which Andrew Jackson had suggested in 1818. It served as an outpost to protect settlers from the Seminoles in the 1820s, and as the headquarters of the army during the Seminole Wars of 1835–42 and 1853–58. During the Civil War, Union gunboats were repulsed by cannon mounted there.

The first child born at the fort was Colonel Brooke's son, John M. Brooke. During the Civil War, he directed the conversion of the USS *Merrimac* into the CSS *Virginia*, the first ironclad warship.

The army established a cemetery at Fort Brooke during the Second Seminole War for the graves of soldiers, civilian employees and Indians. While a parking garage was being built on the site in 1980, graves were discovered and removal was necessitated. Oaklawn Cemetery became the new resting place for 102 soldiers and white civilians. The remains of the forty-two Indians buried at Fort Brooke were reinterred at the Seminole Shrine on Orient Road.

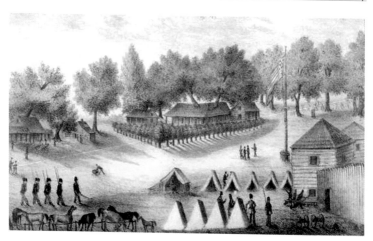

Fort Brooke Barracks

A major role of the fort was as a holding place for Indians who were captured or who surrendered, and then were placed on ships for transport to the Indian Territory. This is an 1837 lithograph of the soldiers' barracks and tents, published by T.F. Gray and James of Charleston, South Carolina. *Courtesy of the Florida Photographic Collection.*

Fort Brooke Garrison

Fort Brooke closed in 1883, and most of its land was opened to homesteading. Some of the garrison's buildings remained, such as this one, which was photographed after 1900. The Fort Brooke land was annexed by Tampa in 1907. *Courtesy of the Florida Photographic Collection.*

THE 1830S

POST OFFICE

The first Tampa post office opened on July 25, 1831. From then until September 13, 1834, the town was officially known as Tampa Bay. Tampa's first postmaster was J. Alfonso DeLaunay, who served from 1852 until 1860. He was also Tampa's mayor in 1856–57.

Other post offices were established as Port Tampa (1890), Port Tampa City (1892), West Tampa (1894) and Ybor City (1904).

HILLSBOROUGH COUNTY

On January 25, 1834, Hillsborough County was created as Florida's nineteenth county, largely as a result of the lobbying of Augustus Steele. He was then appointed as the first Hillsborough County judge. In addition to the area it occupies today, Hillsborough County also included today's counties of Charlotte, DeSoto, Hardee, Highlands, Manatee, Pinellas, Polk and Sarasota. At the time, the total white population of the area was 836.

FORT KING TRAIL

Through Tampa, following the present 8th Avenue through Ybor City to the east, was the military road established in 1825 connecting Forts Brooke and King (Ocala). Along the trail in Sumter County on December 23, 1835, Major Francis L. Dade and over one hundred of his men were massacred in the first battle of the Second Seminole War.

JOHN DARLING

John Darling came to Fort Brooke as an ordnance sergeant, and following the Second Seminole War remained in the area to enter the grocery business. At the outbreak of the Civil War, Darling was the richest man in South Florida.

Indian Chief Billy Bowlegs received a peace medal from President Martin Van Buren, and presented it to his friend, Thomas P. Kennedy. Darling and Kennedy formed a partnership and operated the Kennedy Trading Post, the largest store in early Tampa. It was located at the east end of today's Brorein Street Bridge at Ashley Drive.

John Darling Lodge

Early merchant John Darling was memorialized by the Free and Accepted Masons, who named their lodge after him. The lodge building as it appeared in 1922 is shown in this Burgert Brothers photograph. *Courtesy of the Florida Photographic Collection.*

ODET PHILIPPE

Count Odet Philippe, originally from Lyon, France, moved to Charleston, likely from Haiti, during the 1810s to manufacture cigars. He had financial problems and moved to Florida, where he was involved in shipwreck salvage near Key West.

In the late 1830s, he settled in Tampa and purchased three lots near Fort Brooke. Philippe ran three billiard parlors, a bowling alley and an oyster bar located near the intersection of Ashley Drive and Whiting Street. He also was involved in the businesses of building homes and dealing in slaves.

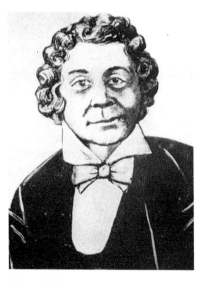

Odet Philippe

This is a nineteenth-century drawing of Odet Philippe, who was active in cigar making, home building, the slave trade and shipwreck salvage before operating an oyster bar, billiard parlors and a bowling alley. He moved to Safety Harbor during the 1840s, and became the area's first non-native permanent settler. *Courtesy of the Florida Photographic Collection.*

KILGORE HOTEL

Tampa's first hotel opened in 1837 as the Tampa Hotel. The twelve-room structure located just north of Fort Brooke on the riverfront was owned by Captain Rufus D. Kilgore, so it was locally known as the Kilgore Hotel.

THE 1840S

INDIAN MOUND

During the 1840s, between the Second and Third Seminole Wars, the U.S. Army maintained a presence in Tampa to protect the settlers. At the northeast corner of today's Channelside Drive and Florida Avenue was a lookout post, located in a gumbo-limbo tree.

The tree grew atop a fifty-foot-tall Timuquan mound, which dated back about two thousand years, and had evidence of elaborately decorated temples and homes of shamans and chiefs. After the army left the area in 1882, the material constituting the mound was hauled off to fill in the Jackson Street ditch from Marion Street to the Hillsborough River.

FIRST UNITED METHODIST CHURCH

On July 26, 1846, a Methodist church was organized with circuit rider J.C. Ley conducting the first services in a small frame structure made

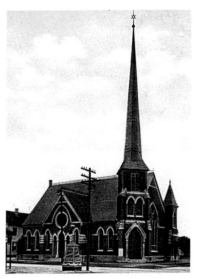

First United Methodist Church

This image of the First Methodist Church appears on a postcard mailed in 1909, when the sanctuary was located at the corner of Kennedy Boulevard and Morgan Street. In 1968, the congregation moved to a new church building at 1001 North Florida Avenue. *Courtesy of the Florida Photographic Collection.*

from salvaged lumber on the bay shore. Called the Church by the Sea, it was washed away in a hurricane on September 23, 1848.

Reportedly, Stonewall Jackson donated five dollars toward the cost of constructing the next church building, one room completed in 1853 at the northeast corner of Kennedy Boulevard and Morgan Street under the supervision of Captain Leroy G. Lesley, himself a Methodist minister, and his oldest son, John T. Lesley. That "Little White Church" seated only sixty, and then in 1885 was enlarged. It was destroyed by a fire.

JOHN JACKSON

John Jackson, originally from Ballybag, Ireland, moved to Tampa in 1847, the year it became the county seat. He made his first survey of the city during that year, and he performed a second one on a section a little to the east in 1850. His surveyed another section in 1853, and that year combined all three into a single survey to be the "general map of the city of Tampa." That map is still used to describe much of the downtown area. Many of the names of the downtown streets were selected by Jackson, including those named for several of the U.S. presidents.

In February of 1862, Jackson served as acting mayor, then as mayor for nineteen days. With Union troops approaching, Mayor Hamlin V. Snell sold his properties and fled the city, so Jackson took over to finish his term. Jackson won the next election, but less than three weeks later the city government ceased to function. The Jacksons were largely responsible for the bringing of a Catholic priest to serve in Tampa.

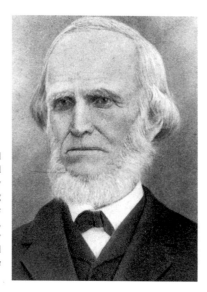

John Jackson

Jackson in the early 1850s performed the first three surveys of Tampa and combined them into a generally accepted map of downtown. During the following decade, he became Tampa's ninth mayor. However, because of the takeover of the city by Union soldiers, his term of office lasted only a few days. *Courtesy of the Florida Photographic Collection.*

JAMES McKAY

In 1848, two years after he arrived in Tampa, Captain James McKay from Thurso, Scotland, constructed a home for himself and his wife, Matilda, at the southwest corner of Franklin and Jackson Streets. He established the area's first sawmill, founded a mercantile store and operated shipping lines, which opened Tampa to the outside world. McKay built the 1848 courthouse at a cost of $1,368 on the Courthouse Square at the corner of Madison and Franklin Streets, and in 1858 opened a cattle trade with Cuba. The following year, he was elected mayor.

INCORPORATION

The town of Tampa was founded on February 12, 1849, when it had only 185 residents other than soldiers stationed at Fort Brooke. The early business center of town was along Washington Street.

The first charter was dissolved in 1852 and another was issued in September of 1853. It reincorporated as a city on December 15, 1855, and Joseph B. Lancaster served as its first mayor for nine months until he died in office.

Tampa's corporate charter was revised and improved by the state legislature in April of 1887, and the first mayor under the new municipal government was George B. Sparkman. In 1890 a $10,000 building to house the city government and the police department was built on the south side of Kennedy Boulevard between Franklin Street and Florida Avenue. The police remained there until 1915.

THE 1850s

OAKLAWN CEMETERY

This is Tampa's first public burying ground, set aside in 1850 by the city council for "white and slave, rich and poor." The first person buried there was Mrs. B.J. Hagler, in June of 1850.

Within an iron fence is a marble sculpture created in Italy, marking the plot of Domenico Ghira, who moved to Tampa in 1849, and his wife, Domenica Masters Ghira. Domenico was the first native-born Italian to settle permanently in the city, and he had large real estate holdings within the downtown area. Centrally located is the sexton house, also known as the Pavilion or Gazebo, built in 1910 at a cost of $410.

The area just to the northeast of the cemetery was known as The Scrub and was a community of former slaves shortly after the Civil War. Today, a large part of it is known as the Central Park Village Housing Project, and it includes several old homes and churches serving black residents.

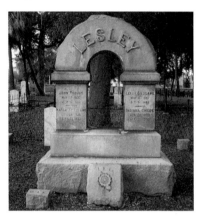

Oaklawn Cemetery

One of the more unusual monuments in Oaklawn Cemetery is this one for John T. Lesley (1835–1919), who with his father built the 1853 Methodist church and organized the Sunny South Guards to protect Tampa from the Union army at the outbreak of the Civil War. *Photo by the author.*

SACRED HEART CHURCH

Land at 507–09 North Florida Avenue was donated by the county commission in 1853 for the construction of a church. During 1857–

59, the St. Louis Catholic Church was built and named for King Louis IX of France. Reverend C.A. Mailley served as the resident pastor for its twenty families.

Ground was broken for the present church building, renamed as Sacred Heart, in 1899. The cornerstone was laid in 1900 and the building was dedicated on January 15, 1905. It has a combination of Roman, Gothic and Byzantine styles generally known as Romanesque, and was patterned after a church in Galveston, Texas, that was designed by Nicholas Clayton.

The floor plan is that of a Roman cross with a large dome at the crossing. Its main altar of Italian marble was donated by two Lutherans, the Smith Brothers (the ones famous for their cough drops). In 1903, their mother died while vacationing at the Tampa Bay Hotel and the Catholics provided services for her.

Sacred Heart College, founded as a private boys' school in September of 1899 and operated by the Society of Jesus, occupied the same city block. In 1929, it was renamed Tampa College and in 1939 became Jesuit High School. On February 12, 1956, its new 120-acre school campus was dedicated at 4701 North Himes Avenue. It remains an all-male school.

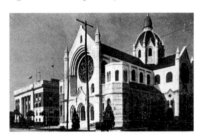

Sacred Heart Church

This church has seventy stained-glass windows designed specifically for it and crafted by the Meyer Company of Munich, Germany. The large Resurrection window triptych on the left side of the transept was donated by Sarah A. Moore as a memorial to her husband, W.M. Moore. This image appears on a 1909 postcard. *Courtesy of the Florida Photographic Collection.*

TAMPA HERALD

Tampa's first newspaper, the *Tampa Herald*, was first published on January 10, 1854, by M. Whit Smith and Reverend Cooley Sumner Reynolds. In November of that year, they sold it to James Jones, who renamed it the *Florida Peninsular* in 1855. It continued until 1871, except for a lapse during the Civil War. That was necessitated because publisher William Spencer joined the Confederate army and died during the war from typhoid fever. His brothers resumed publication on April 28, 1866.

FIRST PRESBYTERIAN CHURCH

Reverend Edmond Lee, who owned a small general store and apothecary shop, organized a Presbyterian church in 1854. He rowed to Tampa from Manatee to preach.

Since 1900, the sanctuary of the First Presbyterian Church, founded in 1884 and officially incorporated in 1900, has been located at the northwest corner of Zack and Marion Streets. The present sanctuary was built there in 1922 with two front entrances flanking the main door, and a pointed seventy-foot corner tower. The adjoining manse on the Zack Street side was built in 1924 by the Woman's Auxiliary and the John Chapel Tims Educational Building on Marion Street was constructed in 1949. The Memorial Building at the corner of Marion and Polk Streets was also built in 1949.

FIRST BAPTIST CHURCH

The First Baptist Church was organized in 1859 by twenty-four charter members. Its early membership included whites and both free and slave blacks. Prominent contributors included many cattlemen, including Jacob Summerlin, William B. Hooker and William B. Henderson. The congregation originally worshipped in a wooden building at the corner of Tampa and Twiggs Streets. In 1865 a group broke off to form the black Beulah Baptist Institutional Church with Reverend Elder Hadley as its first pastor. They erected a frame church, which in 1881 was moved to Harrison Street. In 1925 the present larger building was dedicated and is still used for services.

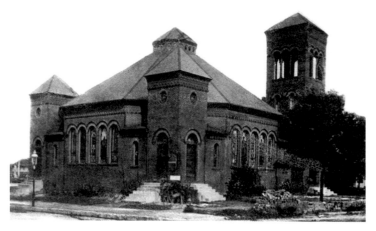

First Baptist Church

This is a 1907 image of the First Baptist sanctuary, which was built at the southwest corner of Lafayette Street (Kennedy Boulevard) and Plant Avenue in 1896. It cost $15,000, which included a five-hundred-seat auditorium, which could expand to a capacity of eight hundred. It was replaced by another large church on the same site in 1925. *Courtesy of the Florida Photographic Collection.*

THE 1860s

CATTLE INDUSTRY

In 1860 Hillsborough had more cattle than any other of Florida's thirty-seven counties. One early entrepreneur who engaged in the transport of cattle was James McKay, who noticed that much of Cuba's cattle population had been killed in several revolutions waged against Spain. Beginning in 1858, McKay had begun regular sailings to Cuba with cattle, starting with thirty steers that had been raised by Jacob Summerlin.

The cattle trade with Cuba shifted focus from earlier overland cattle drives northward to Baldwin and transport from there by rail to Charleston and Savannah. Cattlemen in Brevard County began herding animals across the state via the Old Capron Trail. Doubloons received by McKay and placed in the stream of commerce resulted in prosperity for Tampa. Port facilities were modified to better accommodate cattle as cargo.

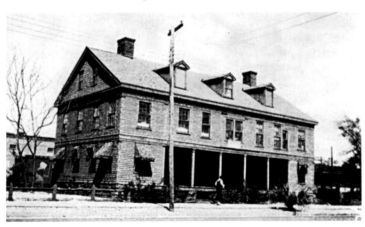

Orange Grove Hotel

The Orange Grove Hotel of William B. Hooker at the northwest corner of Madison and East Streets started out as his personal residence. It was operated as a hotel, beginning in 1869, by his son-in-law, Henry L. Crane. The building was used as the railroad depot before it was torn down in 1945. *Courtesy of the Florida Photographic Collection.*

Others, including Ferris and Son, also engaged in the shipping of cattle from Tampa. W.G. Ferris had arrived at Fort Brooke in 1842 to open a store for the military reservation, then expanded to shipping in 1860. "Granny" Cowart operated the first dairy in Tampa, utilizing forty to fifty head that had been driven in from the range.

At the outbreak of the Civil War, many local residents opposed Secession. The local economy was based largely on international trade, along with shipping to domestic ports as far north as New York City, and desired to stay out of a major domestic conflict. The Union blockade of Tampa Bay shifted much of the cattle trade from Tampa to Charlotte Harbor. McKay's sailings to Cuba were allowed in exchange for his providing supplies to the Union army. That, and shipments of cattle to Union-occupied Key West, resulted in Confederate authorities accusing McKay of treason. Support by cattlemen, lawyers and judges who were sympathetic to the Union cause resulted in McKay's being allowed to continue his shipments.

When by 1863 the South needed the cattle to feed its troops, McKay officially shifted his economic-driven allegiance from the Union, but never completely supported the Confederacy. He and others in the Tampa area were still more interested in trading beef for gold doubloons instead of Confederate dollars, so they never fully committed to feeding the army. Those Florida cattle which did make it to Confederate soldiers were generally of the poorest available quality. Cattlemen were allowed to serve in the Cow Cavalry (also known as the Commissary Battalion) instead of the regular army, which kept them close to home and able to protect their homes, families and herds. Under the leadership of C.J. Munnerlyn, they rounded up cattle and delivered them to Confederate soldiers.

Sunny South

On January 29, 1861, the *Sunny South* newspaper was established by former Mayor J. Alfonso DeLaunay and his brother. Publication ceased shortly after the outbreak of the Civil War and the printing presses and equipment were moved to the interior of the state so they would not fall into the hands of Union troops.

Civil War

In September of 1861, Captain John T. Lesley organized the Sunny South Guards, stationed at Fort Brooke. Five other companies of soldiers were formed in Tampa and most saw action in Virginia or on western battlefields.

On June 30, 1862, Union gunboats *Sagamore* and *Ethan Allen* shelled the city after Tampa refused to surrender. The five Confederate guns

could not reach the boats and little damage was done to the town of about one thousand residents.

Donald B. McKay and his father, Captain James McKay, ran their ships through the Union naval blockade to take beef to Cuba and other foodstuffs to Alabama. To England, they carried cotton, molasses and tobacco. Union troops on October 16–17, 1863, marched on land following the USS *Tahoma* and USS *Adela* bombarding the city from the area near present-day Davis Islands. They burned the McKays' cotton ships, the *Scottish Chief* and *Kate Dale*. The McKays were captured and briefly imprisoned in 1864.

A minor skirmish occurred on October 18, 1863, near Ballast Point. Six Confederate soldiers died and seven were captured. No one knows how many were wounded. Three Union soldiers were killed, twelve were wounded and five were captured.

In 1864 Finnegan's Brigade was ordered to the Shenandoah Valley from Fort Brooke, leaving at best a small, depleted force to guard the fort and the city. Furthermore, several of those who remained were temporarily away in early May on a cattle drive. On May 6–7, a contingent of Union black infantry and white cavalry led by Brigadier General Daniel P. Woodbury came ashore at Hooker's Point and captured the town. Although they seized Confederate government property, they respected the private property ownership rights of Tampa's citizens. When the city's soldiers returned from the war, they had homes and businesses to come home to, and did not find the devastation common in other occupied and damaged cities. Federal troops finally left Tampa in 1869.

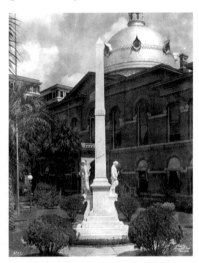

CIVILIAN CASUALTY

Despite being bombarded with Union shells three times during the Civil War, Tampa had only one civilian casualty. An unexploded eight-inch shell landed in Oaklawn Cemetery, and it was retrieved by blacksmith Addison Mansell. He emptied the powder from the shell and poked a red-hot wire into it. The flareup that produced burned his face and nearly caused him to lose the sight in one eye.

Confederate Monument

During the Civil War, many from Hillsborough County served in the Confederate army. This monument to honor them was dedicated by the United Daughters of the Confederacy at another location on January 2, 1911, then was moved to the courthouse grounds. *Courtesy of the Florida Photographic Collection.*

THE 1870S

RECONSTRUCTION

Tampa's population declined significantly by the end of the Civil War. Some left to avoid the conflict. Others left so they would not be governed by Union occupation troops. The major industry that brought back the Tampa economy was cattle. It was not dependent upon Northern interests and produced gold doubloons, which were called "cattlemen's currency" and were considered to be more stable than dollars.

Between 1868 and 1878, Florida was North America's largest exporter of beef, allowing Tampa to recover from the war faster than many other Southern cities. Prosperity, however, drew many new settlers to the area. Undeveloped land was claimed by farmers, black and white, creating a rivalry with open range cattlemen. Tampa's

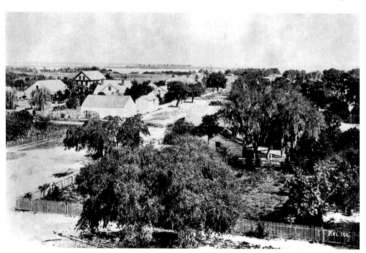

Downtown Tampa

Early Tampa's downtown had more trees than buildings, and any construction was rarely taller than three stories. This Burgert Brothers photograph from 1882 is of the corner on which the Tampa City Hall now sits. *Courtesy of the Florida Photographic Collection.*

businessmen welcomed the farmers as potential customers. Local newspapers generally supported the shift from ranching to farming. In the 1870s, cattle shipping to Cuba moved its focus from Tampa to Punta Rassa, and local political control included fewer cattlemen and more urban businessmen.

YELLOW FEVER

Tampa was no stranger to deadly yellow fever. Residents had already experienced outbreaks in 1836 (49 cases, 19 dead), 1841 (2 cases), 1849 (3 cases, 3 dead), 1853 (about 200 cases) and 1858 (about 270 cases, about 30 dead). In 1867 the fever again appeared, and some residents blamed it on people disembarking from Captain James McKay's *Southern Steamer*. The resulting outbreak killed 12.

In 1871 another local outbreak coincided with the docking of the HM *Cool*. Local doctors warned that the disease was likely brought to Tampa by seagoing passengers. There were forty reported cases and ten died.

However, they were not the only individuals who may have spread the disease. In 1887 a local fruit importer named Charlie Turk died in September from yellow fever. Within two weeks, the disease spread throughout Tampa's neighborhoods and 79 died from it. Records show 750 reported cases of the disease, which closed the cigar factories and brought much of the city's economy to a halt until early 1888.

Later in 1888, another outbreak resulted in about 300 cases of which about ten died. Port Tampa also had outbreaks in 1892 and 1894. In each, there were four reported cases and one death.

JOHN WALL

In 1873 Dr. John P. Wall of Tampa concluded that yellow fever was transmitted by mosquitoes. However, his findings were not generally accepted until the same conclusion was reached by Dr. Carlos Finlay of Cuba in 1881 and Dr. Walter Reed of the United States in 1900.

On March 2, 1876, Wall founded the *Sunland Tribune*, a Democratic newspaper that in 1883 became known as the *Tampa Tribune*, with no relation to the present newspaper of the same name. Wall also served as the first president of the Board of Trade and, from 1878 to 1880, the mayor of Tampa.

FIRST BRIDGE

In 1874 Josiah C. Hanna built the first bridge over the Hillsborough River, near Nebraska Avenue. Hanna homesteaded land along the

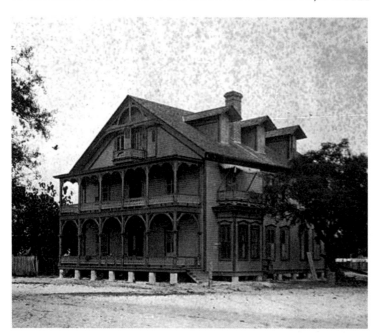

Crafts' Hotel

Despite there being little tourist trade until decades later, Tampa of the 1870s still needed hotels, many of which catered to wealthy Northerners who wished to escape their home states' winters. James C. Field took this picture in the 1870s of the large Crafts' Hotel, which burned down in April of 1886. *Courtesy of the Florida Photographic Collection.*

river where it makes a sharp bend, at the eastern end of the Hamilton Health subdivision. The current at that point in the river formed a circular pattern, known as Hanna's Whirl. His bridge was destroyed by a flood in 1880.

THE 1880S

CITRUS INDUSTRY

Citrus was introduced into Florida by the Spanish during the 1500s. In 1880 the state's first citrus nursery, the Buckeye Nursery, opened in Tampa. The Florida Citrus Commission was founded in 1909 and had its initial headquarters in Tampa. Although freezes have essentially eliminated the citrus industry from northern Hillsborough, the county remains a major grower as the tenth leading citrus producer in Florida. The county itself grows more than any state other than Florida and California.

ACADEMY OF THE HOLY NAMES

On July 18, 1881, Sisters Marie Augustin and Marie Maurice of the Holy Names of Jesus and Mary arrived in Tampa from Key West to

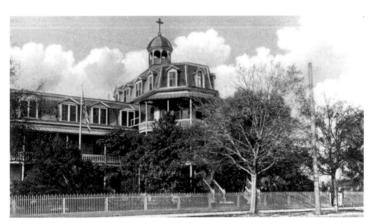

Academy of the Holy Names

From 1891 until 1926, the home of the Academy of the Holy Names was this long brick building with a landscaped front yard. It took up most of the north side of Twiggs Street, stretching from Morgan to Pierce Streets. From 1926 until 1928, the school was located in temporary quarters on Central Avenue, then moved to Bayshore Boulevard. *Courtesy of the Florida Photographic Collection.*

start a Catholic school. Classes of the Academy of the Holy Names began in an abandoned blacksmith and gun shop at the corner of Franklin and Zack Streets in September of that year. They moved to a two-story building on the corner of Franklin and Harrison Streets in 1889. Bishop John Moore of St. Augustine in 1891 purchased property for the construction of a permanent home on Twiggs Street.

In 1928 the school moved to a sixteen-acre tract at 3319 Bayshore Drive on the former estate of Angel La Madrid Cuesta. Between 1952 and 1962, new wings were added to its main building, together with a chapel, auditorium and a separate boys school for grades one through eight.

Cigars

Tampa was considered to be a good location for the manufacture of cigars. Its range of temperature and humidity was similar to that of Key West and Havana, and it was also served by railroads and steamship lines. Its cost of living was less than other cities of comparable size.

In the early 1880s, there was only one cigar factory in downtown Tampa. Gonzalez, Castillo and Co. sat at the southeast corner of Franklin and Jackson Streets just south of a large drainage ditch that ran the length of Jackson Street to the Hillsborough River. The company was owned by three Cubans—Ynosente Gonzalez, Manuel Castillo and Domingo Valdez.

St. Peter Claver School

In 1883 Father William Tyrell, the pastor of Tampa's St. Louis Catholic Church, purchased the Methodist church building on Morgan Street to be used for a school for black children. Two sisters of the Holy Names began classes for sixteen children there on February 2, 1894, but ten days later it was destroyed by an arsonist. It was rebuilt on land purchased by Father Tyrell at the corner of Governor and Scott Streets.

The first church building was erected in 1915. In 1916 Governor Trammell issued a warrant for the arrest of three white sisters who taught black students at another school in violation of a law prohibiting it. To avoid a similar situation at St. Peter's, the school closed. It reopened later when the law was declared inapplicable to private schools. The old wooden building was replaced by a new brick one in 1929, and an annex was built in 1952.

The church, named for a saint who opposed slavery and who ministered to black slaves, is located at 1203 North Nebraska Avenue. It was dedicated in 1969.

Tampa Heights

In the early 1880s, Tampa Heights developed as Tampa's first suburb. Located a mile north of downtown, its higher elevation was thought to make it a healthier place to live. Many moved there from downtown in 1887, when Tampa experienced a yellow fever epidemic. Early prominent residents of the neighborhood included Wallace F. Stovall, Joseph P. Robles and William B. Henderson. Henderson had come to Tampa with his father in 1846, opened a store and served in the Seventh Florida Regiment during the Civil War. He later served as the president of the Tampa Building and Loan Association, the West Tampa Land and Improvement Company and other business and community organizations. He also was a substantial contributor to fund the establishment of one of Tampa's early schools for black students.

Thomas P. Kennedy Jr. is credited with coming up with the name "Tampa Heights," and it is also known as the Highlands and the Heights. A four-block Tampa Heights subdivision was created in 1889 by William B. Henderson.

South of 7th Avenue were constructed homes for professionals and businessmen, and simpler frame homes for the working class were built between Columbus Drive to Palm Avenue. Rather than a single developer, homes were generally constructed by individual builders. Most homes had large front porches, used by residents for relaxing and socializing with neighbors. The area was served by the Tampa Street Railway Company and reached West Tampa via the Fortune Street Bridge, constructed in 1892.

Phosphate

In 1883 the discovery of phosphate in the nearby Bone Valley area provided a new industry for Tampa. Phosphate was also discovered in the Hillsborough River and in the undeveloped portion of southern Hillsborough County. Tampa remains as one of the world's largest exporters of phosphate.

Railroads

The Tampa, Peace Creek and St. Johns River Railroad was created in 1879, and renamed as the Jacksonville, Tampa and Key West Railway in 1881. In 1893 the line went bankrupt and most of it was reincorporated in 1899 as the Jacksonville and St. Johns River Railway and sold to the Plant System.

Tampa's first Plant System railroad depot in 1883 was located in Captain John Miller's house on Waters Street, between Twiggs and

Zack Streets. The tracks for the line reached Tampa in 1884, and were extended to Port Tampa in 1885.

In 1889 a second line reached the city, the Florida Central and Peninsula Railroad. In 1907 the Tampa Northern Line connected Tampa to Brooksville. The Tampa and Western Railroad Company was incorporated in 1893. The Tampa and Gulf Coast Railroad was founded in 1907 by Charles H. Brown, who served as Tampa's mayor in 1921–24.

FIRST NATIONAL BANK

The Bank of Tampa was established on November 10, 1883, with James P. Taliaferro as its president and Thomas C. Taliaferro as its cashier. Its first home was rented space at the northwest corner of Franklin and Washington Streets, with windows covered with chicken wire. In 1886 it received a national charter and was renamed the First National Bank of Tampa, and its even later name was the First National Bank of Florida.

In 1889 the bank had a new four-story marble building erected at the corner of Franklin and Madison Streets. It was later the home of the *Tampa Daily Times*, which enlarged it. It became part of the office building of the Merchants Association of Tampa, which was later demolished.

BRANCH OPERA HOUSE

A three-story opera house was built on the west side of Franklin Street, between Kennedy Boulevard and Madison Street. It was owned by Henry L. Branch, the son of Dr. Franklin Branch. It opened on March 7, 1884, with a performance of the comedy *Fats*

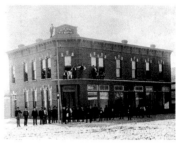

Bank of Tampa

These men have assembled in front of the Bank of Tampa at the southwest corner of Franklin and Washington Streets, likely not long after this new building opened on February 13, 1886. It was downtown Tampa's first brick building, and shows an angled corner entrance typical of banks constructed through the 1920s. *Courtesy of the Florida Photographic Collection.*

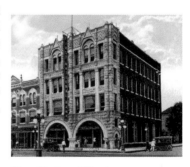

First National Bank

This photograph from about 1911 shows the four-story First National Bank of Florida, which was erected in 1889 at the corner of Franklin and Madison Streets. The granite façade was removed and used on a furniture company building northward on Franklin Street when this one was replaced by a thirteen-story tower in 1925. *Courtesy of the Florida Photographic Collection.*

Hotel H.B. Plant

At the intersection of Ashley Drive and Madison Street, a large rambling hotel was built in 1884 on the former site of Bryan and Keefe's grocery warehouse and was named after Henry B. Plant. It was owned by Jerry T. Anderson and was heated by a wood stove located in the upstairs hall. The second floor was a popular meeting place for business and social activities. *Courtesy of the Florida Photographic Collection.*

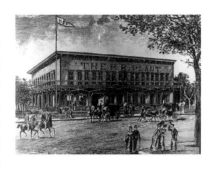

Branch Opera House

Shown in this photograph of Franklin Street from the 1870s is the Branch Opera House, flanked by a pair of stores. The large hall on the second floor served as the town's meeting place for most important affairs. Below was the hardware store of George H. Packwood and William A. Morrison. *Courtesy of the Florida Photographic Collection.*

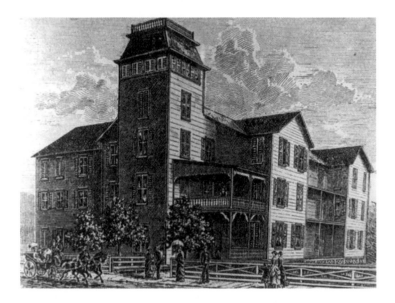

Palmetto Hotel

This is a photograph of a drawing made in 1884 of the Palmetto Hotel, which was built that year. It was located at the northeast corner of Florida Avenue and Polk Street, a portion of the site now occupied by the federal courthouse. *Courtesy of the Florida Photographic Collection.*

by Lambert and Richardson's Dramatic Troupe.

PALMETTO HOTEL

In 1884 Judge N.G. Buff of Terre Haute, Indiana, built a wooden three-story hotel on North Florida Avenue. With forty rooms and a five-story tower, for years it was the leading commercial hotel in Tampa. It was torn down in about 1960, and in its place now stands the federal courthouse.

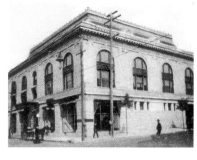

Board of Trade

This is an early photograph of the offices of the Tampa Board of Trade, founded in 1885 to support the city's businesses and relationships with other cities. It was renamed the Tampa Chamber of Commerce in 1928 and is credited with major roles in establishing two universities within the city. *Courtesy of the Florida Photographic Collection.*

TAMPA BOARD OF TRADE

In 1885 the Tampa Board of Trade was established with President Dr. John P. Wall, Vice President John T. Lesley and Secretary Thomas A. Carruth. They supported the Plant System, an innovative transportation system, which included bridges, waterworks and railroads that connected Tampa with other cities.

In 1928, the Board became the Tampa Chamber of Commerce. One of its earliest projects was the formation of the University of Tampa to occupy the bankrupt Tampa Bay Hotel. In 1939 the chamber was instrumental in the establishment of MacDill Air Force Base. In the mid-1950s, the chamber was successful in the creation of another school, the University of South Florida.

Vicente Ybor

This is a drawn portrait of the man most responsible for bringing the cigar industry to Ybor City. He built his home, named "La Quinta," on 12th Street at the northwest corner with 17th Street, completing it on December 22, 1886. He was renowned for the lavish parties he threw there. The house was torn down during the 1940s. *Courtesy of the Florida Photographic Collection.*

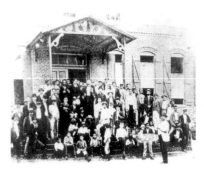

Ybor Cigar Factory

Shown in this early 1890s photo is the western entrance to the Ybor factory with Jose Marti standing on the iron steps from which he had just addressed a crowd in support of Cuban independence. Because of the historic speech, the portico shown in the photo was removed and taken to Havana, and replaced with the one that exists today. *Courtesy of the Florida Photographic Collection.*

VICENTE YBOR

The cigar industry in the area now known as Ybor City was founded by Vicente M. Ybor, who in 1885 built the first cigar factory on 7th Avenue. In October of that year, through V. Martinez Ybor and Company, he purchased forty acres from John T. Lesley. The cost was $9,000, of which $4,000 was provided by citizens of Tampa. The original Ybor land was bounded by 11th and 15th Streets and 6th and 7th Avenues. Ybor bought fifty additional acres, stretching to the shores of Hillsborough Bay. The chamber of commerce adopted certain measures, which allowed the introduction of cigar factories.

In mid-1886, a new brick factory was completed at the southwest corner of 9th Avenue and 14th Street, and Ybor moved his operation into it. The old building was donated to the workers involved in the establishment of what became Ybor City, and it was converted into a theater with an artistic stage designed by Federico Ayala.

Ybor had moved from Key West to avoid his employees' demands for better working conditions and higher wages. The site was recommended by Gavino Gutierrez, a Spanish civil engineer who had investigated the area in 1884 as a possible site for a guava processing plant. Gutierrez later established an estate which he called Spanish Park, later the site of the Spanish Park Restaurant at 3517 7th Avenue.

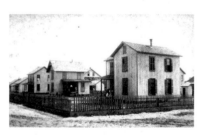

Cigar Workers' Homes

Vicente Ybor founded the Ybor City Land and Improvement Company on October 15, 1885. Through it, by the end of 1886, 176 homes such as those shown here were erected for Ybor's cigar makers. The area which became known as Ybor City became a part of Tampa, as its Fourth Ward, on June 2, 1887. *Courtesy of the Florida Photographic Collection.*

The need for experienced cigar makers was aided by a devastating fire in Key West on April 1, 1886, which nearly destroyed the city of 18,000. Cigar factories, including the "El Principe de Gales" factory of Vicente Ybor, burned to the

ground and workers moved to Cuba and Tampa. Some who went to Havana eventually wound up in Tampa.

For a time, the Ybor cigar factory was the largest cigar-producing factory in the world, and employed 20 percent of all cigar makers in Ybor City. It also provided a meeting place for Cuban patriots. Architect and contractor C.E. Purcell designed and built the factory and fifty of the homes for workers. The factory was added to the National Register in 1972.

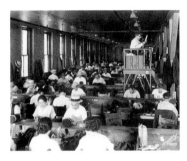

Inside a Cigar Factory

In most large cigar factories, workers sat at tables in large workrooms and contributed about twenty-five cents a week to a lector, shown in this photo of the Cuesta-Rey factory in an elevated seat. Lectors read to the workers as they rolled cigars, providing an exposure to the news of the world and great works of literature. *Courtesy of the Florida Photographic Collection.*

Sanchez and Haya

Ignacio Haya followed Vicente Ybor to Tampa from Key West and set up a cigar factory on 7th Avenue. In 1919 the building became the home of M. Bustillo and Company, with five hundred workers producing Espadilla brand cigars. The building was later owned by the Berriman Brothers Cigar Company. *Courtesy of the Florida Photographic Collection.*

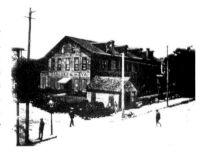

CIGAR WORKERS

The early cigar workers in Ybor City, downtown Tampa and West Tampa were paid by the number of cigars they produced, not the number of hours it took them. As they worked, they listened to lectors whose reading material often included newspapers, especially partisan ones which advocated the removal of Spanish rule in Cuba. It also included poetry and the works of Spanish authors, so the workers were often well informed on current events and familiar with literature.

Most became members of mutual aid societies established by various ethnic groups, which helped immigrants adapt to new surroundings. Activities at clubhouses included dominoes, cards, dances and other recreation. The clubs also had connections with doctors, hospitals and pharmacies, so their members could obtain medical care and medicine.

SANCHEZ AND HAYA

When Ignacio Haya heard about Ybor's move from Key West to the Tampa area, he followed him and purchased twenty acres to build his own factory. Although Ybor's was completed first, his Cuban workers went on strike just before production was to begin because Ybor had hired a Spaniard to work with them. Haya hired only Cubans, so his company's first factory located at 1502 7th Avenue produced Tampa's first clear Havana cigar on April 13, 1886. Within a year, Sanchez and Haya was producing half a million each month.

FIRST CONGREGATIONAL CHURCH

This congregation organized on October 28, 1885, at the home of Caroline A. Pettingill, and was led by Franklin M. Sprague. A white frame church at 1104 North Florida Avenue was its first permanent home. In 1906 a new sanctuary was dedicated at 2201 North Florida Avenue in honor of Obadiah H. Platt, an early Tampa pioneer. At the time, it was surrounded by an orange grove.

The church was active in the community and organized the Cuban Congregational Church and the Union Congregational Church, both in West Tampa. During the 1930s, church membership reached 1,500. However, after a decline in membership, the church relocated in 1956. The Florida Avenue building was later sold to the Polish-American Democratic Club.

The First Congregational Church of Tampa was later renamed as the First United Church of Tampa. In 2002 it merged with the United

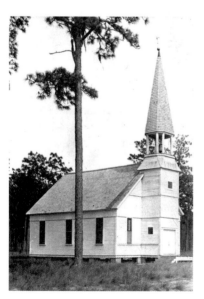

First Congregational Church

This is a photograph of the white frame church erected on North Florida Avenue for the congregation of the First Congregational Church, established in 1885. Another church was built in 1906 a little farther north on Florida Avenue. The church later merged with another into today's First United Church of Tampa. *Courtesy of the Florida Photographic Collection.*

Community Church of North Tampa to form a new First United Church of Tampa.

NEWSPAPERS

The year 1886 saw the establishment of two new Tampa newspapers. *Southern Progress* began providing news for black residents. The *Tampa Journal* was started by H.J. Cooper, who had previously published the *Tampa Guardian*.

MAAS BROTHERS

In 1898 brothers Abe and Isaac Maas built the Abe Maas Dry Goods Palace into the city's only complete department store with clothing, furniture and household items. That year, they moved into the former three-story Krause Building on the southeast

Abe Maas

This is Abe Maas, photographed in about 1930. He moved from Georgia to Tampa in 1886, rented a store at the southeast corner of Franklin and Twiggs Streets and turned it into the Abe Maas Dry Goods Palace. Together with his brother, Isaac, the business evolved into the huge Maas Brothers Department Store. *Courtesy of the Florida Photographic Collection.*

corner of Franklin and Zack Streets. When that location was outgrown, they built a store which rose eight stories. In 1929 the Maas Brothers store affiliated with the Hahn Department Stores, which later became the Allied Stores Corporation. The store was owned by the national company while being operated by the Maas family.

The store used male salesmen until World War II, when women replaced those who were needed on the battlefields. Maas Brothers was one of Tampa's first air-conditioned stores and had the city's first escalator. Maas Brothers closed in February of 1991, and the building was razed in 2006 to make room for a five-hundred-unit residential condominium project.

ALMERIA HOTEL

The first three-story brick building in Tampa was completed at the northeast corner of Franklin and Washington Streets in 1886. Its owner, Dr. Howell T. Lykes, named it after his wife, Almeria. The hotel building housed the offices of Lykes Brothers, Inc., from 1947 until 1968.

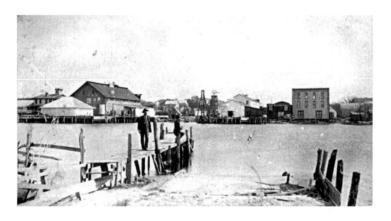

Tampa Ferry

Until 1888, the Hillsborough River was crossed by the Tampa Ferry, located at a landing at the western end of Jackson Street. From there westward, a flat barge operated by Jesse Hayden was pulled across the river along a steel cable. The slow crossing made development of the western lands possible but inconvenient. *Courtesy of the Florida Photographic Collection.*

HYDE PARK

In 1886 Obadiah H. Platt of Hyde Park, Illinois, acquired twenty acres across the Hillsborough River from downtown Tampa to create the city's first subdivision. He named it for his hometown, and with the Tampa Bay Hotel, attention was focused on developing the area west of the river. Hyde Park in the 1910s and 1920s became the neighborhood of choice for many of Tampa's business leaders and other prominent people.

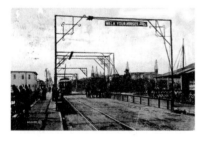

Lafayette Street Bridge

Henry B. Plant convinced the city to build a bridge to make his Tampa Bay Hotel more accessible. At a cost of $15,000, the Lafayette Street Bridge was constructed and put the ferry out of business in 1888. That first wooden swing bridge was replaced in 1913 by this one made from steel and concrete. *Courtesy of the Florida Photographic Collection.*

TAMPA DAILY NEWS

Tampa's first daily newspaper, the *Tampa Daily News*, was founded in 1887 by O.H. Jackson. It ceased publication in 1896.

TIBBETTS' CORNER

In the early 1880s, on the southwest corner of Kennedy Boulevard and Franklin Street was the City Barber Shop managed by Charles M. Turk.

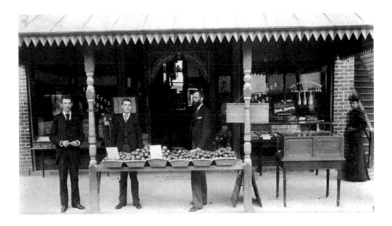

Tibbetts' Corner

This 1890s photograph shows men standing by apples for sale at the Tibbetts Brothers confectionery. The Tibbetts business later expanded to two other buildings on Franklin Street , Tibbetts' Other Corner (at the intersection with Harrison Street) and Tibbetts' Middle Store. *Courtesy of the Florida Photographic Collection.*

The immediate vicinity was crowded with saloons and gambling dens. In August of 1887, it was completely destroyed by fire.

Afterward, a new building was erected for the confectionery store of the Tibbett Brothers, so the corner became known as Tibbetts' Corner. Later, the building became the home of a real estate office.

JOSE POYO

Jose Dolores Poyo was one of the many immigrants from Cuba arriving in 1886–87 in shiploads of more than two hundred, twice a week. Poyo brought with him *El Yara*, a newspaper begun in 1869 in Key West and named for the place where a Cuban revolution began in 1868. *El Yara* was Tampa's first Spanish-language publication. It did not last long, as Poyo took it with him when he moved back to Key West a few months later.

To replace *El Yara*, *Revista de Florida* (*Florida Magazine*) was founded and published by Ramon Rivero Rivero, who before moving to Tampa in 1886 had served as a lector in Ybor's Key West factory. Rivero later also published *El Critico do Ybor City* (*The Ybor City Critic*) and, in 1893, *Cuba*.

TAMPA ELECTRIC COMPANY

A company formed by 1887 to provide electricity for the city became known as the Tampa Electric Light and Power Company. That same year, the company installed Tampa's first traffic lights. It constructed

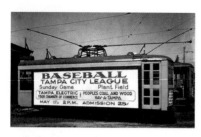

Electric Streetcar

The Tampa Electric Company ran the electric trolley line, with cars that ran on steel rails and obtained their power through antenna-like poles which connected with electric wires overhead. They provided an opportunity for advertisements, such as this poster announcing baseball games in 1931. *Courtesy of the Florida Photographic Collection.*

a power plant at the corner of Tampa and Cass Streets in 1888. In 1890 it became the Florida Electric Company. In 1899 it incorporated as the Tampa Electric Company. Peter O. Knight became its president in 1924.

In addition to providing electricity, it also ran electric trolleys to provide transportation throughout Tampa. In 1912, its 67 trolley cars ran on forty-seven miles of track. Just before the trolley went out of business in 1946, it was running 168 cars.

PORT TAMPA

The area known as Black Point (or Gadsden Point) is closer to Tampa Bay and the Gulf of Mexico than is downtown Tampa, which is situated at the mouth of the Hillsborough River. Henry B. Plant recognized the value of such a location and focused his shipping efforts on Black Point rather than the downtown area. The River and Harbor Act of 1880 provided for a nineteen-foot channel to Port Tampa, but only an eight-foot channel to the Hillsborough River.

Plant built a nine-mile spur line from Tampa to Black Point, which became known as Port Tampa. He added a freight and passenger

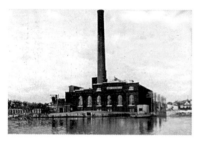

Tampa Electric Company

Shown here is an image that appears on postcards of the early 1920s, depicting the power plant of the Tampa Electric Company. From 1914 until 1956, the company had its main offices at the corner of Tampa and Cass Streets. *Courtesy of the Florida Photographic Collection.*

railroad station, railroad yards, a railroad car repair shop, workers' homes, a pier and a power plant constructed of brick. Settlement of the area began with Egmont Key ship pilots and merchants from Havana. Development in earnest began when C.W. Prescott, James W. Fitzgerald and H.G. Warner formed the Port Tampa Building and Loan Association, which lent money for home lots which cost from $100 to $1,000.

The spur line opened on February 5, 1888. By June of

that year, the Plant Steamship Company was providing service to Havana on the ships *Olivette* and *Mascotte*. Local boats connected Port Tampa with St. Petersburg, Egmont Key and Green Springs. Adjacent to the wharf on pilings was Plant's three-story hotel known as The Inn, which accommodated eighty-five guests. An annex, the fourteen-guest St. Elmo Inn, sought Northern visitors and was a social center for Tampa residents.

Facilities were enlarged after phosphate became the port's largest export. Two large wooden phosphate elevators were built in 1892, followed by a steam-operated wooden elevator in 1903. Then came a larger wooden elevator in 1906 and one constructed of steel in 1925. The warehouses were dismantled in 1951 and the elevators were torn down in January of 1971.

Port Tampa was the site of the world's largest electrical sign, which was first lighted in 1953. It spelled out "Atlantic Coast Line Port Tampa Terminals" with letters 19 feet tall and up to 13 feet wide. The whole sign was 76 feet tall and 387.5 feet wide, using 4,000 feet of red neon tubing.

Port Tampa was annexed by Tampa on May 11, 1961.

PICNIC ISLAND

On July 4, 1888, an area south of Port Tampa was opened as the Picnic Island beach amusement resort by Colonel S.G. Harvey. It started out as an island, but the addition of sand later made it a part of the mainland. One could ride the *Yellow Gal* commuter train from the Polk Street station in downtown Tampa for forty cents one-way, forty-five cents round-trip. It was busy, as it made nine trips daily.

TAMPA BAY HOTEL

Henry B. Plant, who opened a rail line into Tampa in 1884 after purchasing the Florida Transit and Peninsula Railroad, bought sixty acres west of the Hillsborough River from Jesse Hayden with a plan to build a hotel to attract railroad passengers. Hayden had previously acquired the land in a trade for a white horse and a wagon. The Tampa Board of

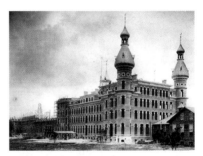

Tampa Bay Hotel Construction

This 1890 photograph shows the Tampa Bay Hotel under construction. All glass in the 511 windows was imported from France. It took 452 freight cars of bricks, many manufactured in Cincinnati. For fire and hurricane protection, walls and ceilings were reinforced by rails formerly used by the South Florida Railroad. *Courtesy of the Florida Photographic Collection.*

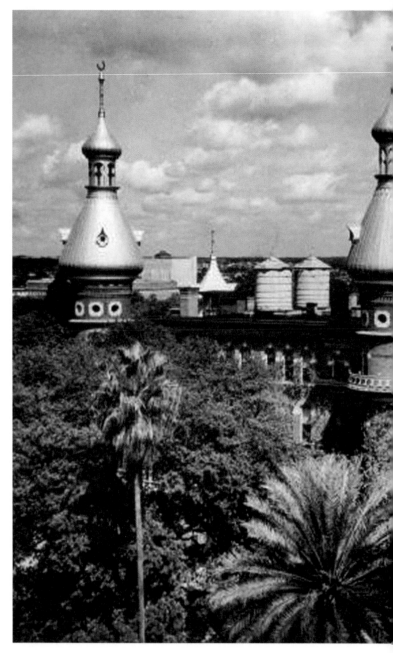

University of Tampa

On August 2, 1933, what had been Tampa Junior College became the University of Tampa, which moved into the former hotel building. Now named Plant Hall, it has been the main building of the university ever since. It was added to the National Register of Historic Places on December 5, 1972. *Courtesy of the Florida Photographic Collection.*

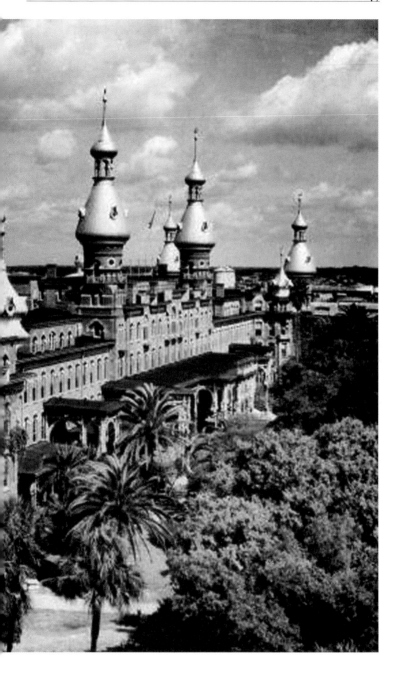

Trade wanted Plant to build the hotel on the east side of the river, but New York architect J.A. Wood felt that the land on the western side had a better contour and setting.

This early luxury hotel was built in 1888–91 by Plant for the patrons of his railroad line at a cost of $3 million. It shows a Moorish Revival style, and is modeled after the Alhambra palace in Granada, Spain. There are twelve towers with bulbous domes and cupolas, ornate porches and covered cornices. The hotel included onsite kennels for its guests' hunting dogs.

During the Spanish-American War, the hotel served as the headquarters of the troops leaving for Cuba. At that time, Clara Barton stayed in the hotel. Author Stephen Crane wrote *The Price of the Harness* while he was a guest.

In 1905, six years following Plant's death, during a period when the Plant Investment Company failed to pay the taxes on the land, the city bought 150 acres including the hotel for $125,000.36. It was then leased to David Lauber for $10,000 a year and operated as a hotel until 1932. In 1933 the small Henry B. Plant Museum (known as the Tampa Municipal Museum until 1974) was established in the hotel, and it continues to feature displays on the history of Tampa and the hotel, the Spanish-American War, Henry Plant and the Victorian lifestyle of the hotel's guests.

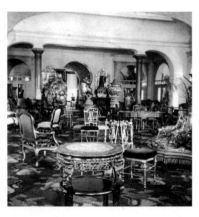

Tampa Bay Hotel Parlor

When the Tampa Bay Hotel was operating, a focal point was the ornate rotunda lobby, shown in this 1903 photograph by George W. Griffith. When the University of Tampa moved in, the spacious lobby was reduced in size to provide more room for classrooms. *Courtesy of the Florida Photographic Collection.*

CITY WATER

In 1889 a pair of artesian wells were drilled at 6th Avenue and Jefferson Street. They were used by the Tampa Waterworks Company to supply the entire city with water for fighting fires, home and industrial uses. In 1923 they were purchased by the city, which soon completed a water plant along the Hillsborough River to begin obtaining most of its water from that source.

THE 1890s

LAS NOVEDADES

This restaurant, whose name means "the novelties," was founded in 1890, and was visited by future president Theodore Roosevelt at the turn of the century. Manuel Menendez operated it as a coffee shop, popular with cigar makers from the Sanchez and Haya factory across the street. The original building burned down in November of 1891, and was rebuilt the following year. It was later named El Goya.

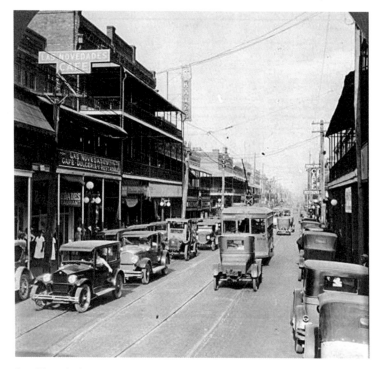

Las Novedades

This is a photograph taken on August 16, 1926, looking westward along Ybor City's 7th Avenue. The tall building on the left is the popular Las Novedades restaurant, operating in a building constructed in 1892. *Courtesy of the Florida Photographic Collection.*

OUR LADY OF PERPETUAL HELP CATHOLIC CHURCH

The first Catholic Mass in Ybor City was held on March 16, 1890, in Mr. Tissler's home on 6th Avenue. A church building was completed in 1891 by Fathers John B. Quinlan and Thomas de Carriere, and was initially named Our Lady of Mercy. That sanctuary was demolished in 1991 after serving its congregation for one hundred years. The new sanctuary for the church renamed Our Lady of Perpetual Help dates to 1937.

EARLY FAIRS

Fairs in Tampa were started by Henry B. Plant in 1890 to entertain his Tampa Bay Hotel guests and promote interest in South Florida. Horse races were held on a track built by him northwest of the hotel. The fairs ended in 1899 after Plant died, resumed for 1905 and 1906, and the next was held in 1910.

ST. JAMES EPISCOPAL CHURCH

This congregation formed in 1891 and held its early services and meetings in its members' homes, St. Andrew's Episcopal Church, the Harlem School on Harrison Street and the Odd Fellows Hall. In August of 1892, Reverend Matthew McDuffie became its first resident priest, and in 1901 the church began to be served by its first white priest. In 1919 it moved into a new sanctuary on India Street, and sixty years later began construction on a building that stood at 1819 North Boulevard.

THE *TAMPA DAILY TIMES*

In 1893 Colonel Silas A. Jones, supported by William B. Henderson, Vicente Ybor and several other financial backers, purchased the *Tampa Journal* and the *Tampa Tribune*. The merger of the two resulted in the *Tampa Daily Times*, which was initially published by H.J. Cooper at the former plant of the *Tampa Journal* at the southeast corner of Franklin and Washington Streets. It was taken over by Donald B. McKay in 1898. He leased the newspaper to Ralph Nicholson and David E. Smiley, who purchased the assets of the company in 1935. Its last issue was printed on August 14, 1982.

EXCHANGE NATIONAL BANK.

On the northeast corner of Franklin and Twiggs Streets was the home of Captain Domenico Ghira, the first native-born Italian to

Our Lady of Perpetual Help

Shown here is the sanctuary of Our Lady of Perpetual Help Catholic Church, constructed in Ybor City in 1891. Although a new sanctuary was built in 1937, this one continued in use until it reached a century of age and was demolished in 1991. *Courtesy of the Florida Photographic Collection.*

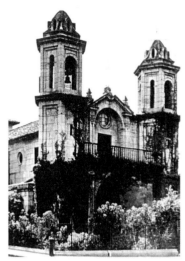

Tampa Fairgrounds

Fairs in Tampa which were begun by Henry B. Plant took place at the Florida Fairgrounds near the Tampa Bay Hotel. The fifty-acre site along the north side of B Street, between North Boulevard and Brevard Avenue, was traded to the University of Tampa in 1973 for other lands. The former fairgrounds are partially surrounded by a high stuccoed wall. *Courtesy of the Florida Photographic Collection.*

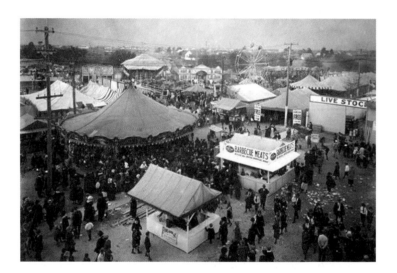

Salvation Army

The Tampa Corps of the Salvation Army were established in 1893 at the southeast corner of Kennedy Boulevard and Franklin Street. Its founders were Captain Wilbur Hall and Lieutenant Fred Weller. Thirty years after its founding, its workers posed for this group portrait in front of their headquarters. *Courtesy of the Florida Photographic Collection.*

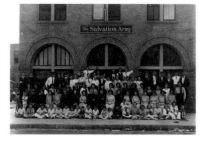

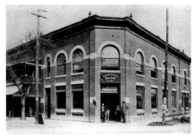

Exchange National Bank

This bank first opened on April 16, 1894, in the building shown in this 1895 photograph, previously the home of Gulf National Bank. During the 1890s, prominent attorney Peter O. Knight had his law office on the second floor. *Courtesy of the Florida Photographic Collection.*

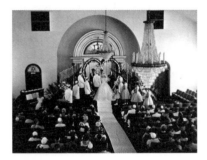

Rodeph Sholom Synagogue

This is a photograph of the interior of the Rodeph Sholom Synagogue at 309 East Palm Avenue. Depicted are Martin Horwitz and Sandra Markowitz during their 1961 wedding. *Courtesy of the Florida Photographic Collection.*

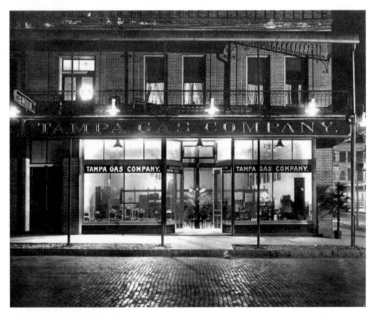

Tampa Gas Company

The gas company organized in 1895 and natural gas was used in street lamps beginning in 1898, but it took years for it to become popular for home use. During 1914, the company moved its office into this new brick building at the southeast corner of Madison and Tampa Streets, with the Madison Hotel upstairs. *Courtesy of the Florida Photographic Collection.*

permanently reside in Tampa, having arrived in 1849. He became an American citizen in 1853 and was a prominent merchant. Later on the corner was the Roberts Building, in which was located the city's first telephone company headquarters.

By 1925 the Exchange National Bank moved into a large two-story building with tall columns. Later, a tall skyscraper annex was added.

SCHAARAI ZEDEK TEMPLE

The Schaarai Zedek Congregation was formed on December 10, 1894, in downtown Tampa. In the late 1890s, it moved to 1209 North Florida Avenue and was led by Abe Maas, M.H. Cohen and R. Bucksbaum.

The Liberal Jewish congregation moved into a new temple at 1901 North Central Avenue in 1918. In late 1924, it moved to the northeast corner of Delaware and DeLeon Streets (to a building later used by the Christian Fellowship), and its Central Avenue building was converted to the Hebrew Free School. The congregation later relocated to 3303 West Swann Avenue.

In 1903 members of the congregation had disagreements over religious policies, and some formed a new Orthodox congregation known as the Rodeph Sholom Synagogue. They moved to a two-story masonry building at 309 East Palm Avenue. The new congregation was headed by Rabbi Adolph Burger. It later moved to 2713 Bayshore Boulevard.

TAMPA TRIBUNE

In 1895 a new newspaper appeared in Tampa and the ownership of another was reorganized. The *Tampa Herald* began publication and continued until 1902. The *Tampa Tribune*, begun by Wallace F. Stovall in 1893, began to be published as a daily on January 1, 1895, by The Tampa Tribune Publishing Company, formed by a group of citizens to help the newspaper out of financial problems. Stovall served as its president and treasurer.

By 1910 Stovall purchased the interests of the other investors—W.E. Bledsoe, C.E. Harrison, Peter O. Knight, J.S. McFall, Emilio Pons, Seidenberg and Co., Sanchez and Haya, C.C. Whitaker and C.A.M. Ybor—so that Stovall was once again its sole owner. The newspaper was sold in 1925 to a syndicate organized by Lulette Gunby for $1.2 million. Two years later, it was sold to S.E. Thomason and John S. Bryan, previously the general manager of the *Chicago Tribune* and the publisher and editor of the *Richmond News-Ledger*.

On January 21, 1941, the newspaper was granted a license to operate radio station WFLA-AM. In 1943 Virgil "Red" Newton took

West Tampa Homes

This 1903 photograph depicts a row of West Tampa cigar makers' homes, often referred to as "shotgun houses." It was said that one could fire shotgun through the front doorway and through the hall that ran the length of the house, hitting no walls before the pellets hit the back of the house. *Courtesy of the Florida Photographic Collection.*

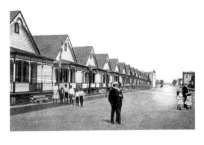

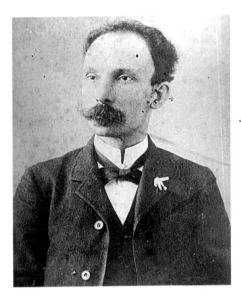

Jose Marti

Marti made twenty-one visits to Tampa and made emotional speeches in favor of Cuban independence. Those on November 26 and 27, 1891, were entitled "With All and For All" and "The New Growth," which resulted in donations to the cause and the enlistment of volunteers to sail to Cuba to fight for freedom. *Courtesy of the Florida Photographic Collection.*

Tampa Fire Department

This Burgert Brothers photograph taken October 3, 1919, shows a group of Tampa firemen aboard one of their LaFrance fire trucks. Just five years previous to the picture, they were using horse-drawn wagons to transport themselves and their equipment to fires. *Courtesy of the Florida Photographic Collection.*

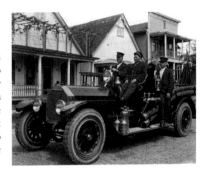

over as the newspaper's managing editor and remained in that position until 1964. In 1966 a Pulitzer Prize was awarded to *Tampa Tribune* reporter John Frasca, who authored a series of articles concerning an unjustly jailed man from Polk County. Control of The Tribune Co. was acquired by Richmond Newspapers, Inc., which became a subsidiary of Media General, Inc.

In 1976, John S. Bryan III became the publisher of both the *Tampa Times* and the *Tampa Tribune*. James A. Clendinen, who had served as the editorial page editor and retired in 1985, was inducted into the Florida Newspaper Hall of Fame in 1991.

WEST TAMPA

West Tampa was established by Hugh C. Macfarlane, a former prosecutor. It attracted cigar companies from downtown and some from Ybor City. It was surveyed and platted in 1892.

West Tampa incorporated as a separate municipality on May 18, 1895, rather than existing merely as a Tampa neighborhood. In June of 1899, the West Tampa City Hall and fire station was built at the corner of Albany Avenue and Main Street. The West Tampa skyline was dominated by Cespedes Hall, a five-story building with four towers constructed in 1894, located at the same intersection. It was named for Carlos Manuel de Cespedes, a leader of the Ten Years War in Cuba, and included an opera house and two additional meeting halls.

By 1912 West Tampa had a population of over ten thousand, making it the fifth largest city in Florida. It was annexed by Tampa on January 1, 1925.

JOSE MARTI

Jose Marti, a Cuban teacher who advocated the ouster of the Spanish from his island, was exiled from Cuba in 1871 and 1879. He lived in New York City from 1881 to 1895 and wrote many articles supporting freedom for Cuba.

Marti and his Ybor City volunteers, armed with whatever weapons they could acquire or make, sailed from Tampa to Cuba in 1895 with the intent of taking back their island. In a skirmish on May 19 of that year at Dos Rios in the Cuban province of Oriente, Marti and several of his men were killed. Their deaths merely inflamed the spirits of others who were willing to carry on the fight against the Spanish.

FIRE DEPARTMENT

Tampa's first volunteer fire department was organized in 1884 with seven bucket brigades. Its first professional paid fire department was authorized by ordinance passed on May 10, 1895. A.J. Harris moved from Savannah, Georgia, to become the city's first chief of the twenty-two-member department. Its headquarters were located on Florida Avenue between Lafayette and Jackson Streets, and there were initially five fire stations.

Spanish-American War Camp

This 1898 photo depicts some of the cavalry troops who camped and trained in Tampa, awaiting deployment to Cuba. Tampa was selected over Miami, New Orleans and Pensacola because of its port and rail facilities and its nearness to Cuba. *Courtesy of the Florida Photographic Collection.*

SPANISH-AMERICAN WAR

Some claim that the cause of the Spanish-American War was the large number of revolutionary activities taking place in Ybor City and Key West during the late 1880s and 1890s. Cubans had begun small rebellions in the 1860s, such as the Ten Years War which began in 1868, and many emigrated to Ybor City by the late 1880s as exiles for such anti-government activities. Leaders of cigar factories often read to the workers, as they sat at their benches, from revolutionary newspapers. By 1896, cigar workers established thirty patriotic clubs in Ybor City and eleven in West Tampa, providing a structure for the Cuban Revolutionary Party. Cigar makers helped to fund the revolution.

On February 28, 1878, the survivors of the sinking of the battleship *Maine* arrived in Port Tampa aboard the steamship *Olivette*, and they were received as heroes. In April, President McKinley demanded that Spain abandon Cuba, a move that was supported by the residents of Tampa. Spain refused.

War was declared and American troops and dignitaries passed through Tampa and Port Tampa on their way to Cuba. Celebrities such as Theodore Roosevelt, William Jennings Bryan and Clara Barton spent time in the city before shipping out to Cuba, and they received support from the area's Cuban immigrants.

Upon the urging of Henry Plant, Tampa became the official port of embarkation for troops, and Plant's steamships and railroads were used to bring soldiers and supplies from other parts of the country

Clara Barton

This group is enjoying a picnic in Tampa while waiting for troops to be shipped to Cuba at the beginning of the Spanish-American War. One of the central figures is Clara Barton who in 1881 established the American Red Cross. *Courtesy of the Florida Photographic Collection.*

to Florida to await the last leg of their journey to Cuba. His Tampa Bay Hotel was the headquarters for the officers as they awaited orders sending them to Cuba. It was also a comfortable place for war correspondents to stay and interact with the officers.

The enlisted men camped near the hotel, and eventually rode on Plant's trains from the downtown area to Port Tampa, where they waited to board the ships bound for war. In Port Tampa, Captain and Reverend J.T. Johnson formed the Advent Christian Church on April 10, 1898, and constructed a wooden frame church so soldiers waiting to sail would have a place to worship. The invasion force of 16,000 left Port Tampa for Cuba on June 14, 1898. They were followed by 4,000 more a few days later and a squadron of American cavalry and 550 Cubans on June 20. The war officially ended on August 12, 1898.

St. Ignatius Catholic Church

The first Catholic Mass in Port Tampa was celebrated by Father Daniel O'Sullivan from Tampa on June 19, 1898, in the home of Manuela Garcia at the corner of Fitzgerald and Prescott Streets. Bishop John Moore of the Diocese of St. Augustine dedicated a new church at 7002 South Fitzgerald Street on May 14, 1899.

John B. Gorrie Elementary School

A portion of this red brick school was built in 1889, although Board of Public Instruction records indicate that a Hyde Park Grammar School was in existence by 1884. Eight of the present classrooms date to 1889 and eight others were added in 1903. The cafeteria and eight more classrooms were added in 1912, and the final original section was completed in 1926.

It was originally known as the Hyde Park School and the Hyde Park Trade School and was renamed in 1915. The school was renovated in the late 1970s, and has a bus shelter that used to be a streetcar shed.

Gorrie Elementary School

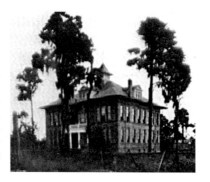

The original portion of this school, still in operation today, was built in 1889 with eight classrooms. It was renamed in 1915 to honor Dr. John B. Gorrie, the Apalachicola doctor who invented the ice-making machine and whose work led to the development of modern refrigeration and air conditioning. *Courtesy of the Florida Photographic Collection.*

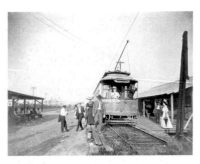

Jules Verne Park

When this photo was taken in 1910, the southern terminus of the trolley line was here at Jules Verne Park, created and named by Emelia Chapin. She also paid for a Japanese style pavilion built in 1894 extending over the water's edge. The park was renamed Ballast Point Park in 1920. *Courtesy of the Florida Photographic Collection.*

CIRCULO CUBANO

This club was organized on October 10, 1899, as the October 10 Cuban National Club and was renamed the Circulo Cubano de Tampa in 1902. It used a building erected in 1892 and then built another in 1907 at 14th Street and 10th Avenue. The two-story building costing $18,000 burned down on April 30, 1916, as a result of a fire on stage after a theatrical performance.

The present building designed by Bonfoey and Elliott was constructed in 1917–18 for $60,000 with a Beaux-Arts Classical style. Inside is a nine-hundred-seat theater, ballroom, boxing arena, pharmacy, library, gymnasium and cantina. Circulo Cubano promoted athletics more than did the other clubs. It was placed on the National Register in 1972.

JULES VERNE PARK

The city's first electric trolley cars were operated by a company organized by Chester W. Chapin, a financier from New York. Chapin in 1892 supported financially the formation of the Tampa Suburban Company, which in 1894 became Consumers Electric Light and Street Railway Company, selling electricity and transportation.

The initial electric trolley line began in 1892 and linked downtown, Ballast Point, Ybor City and West Tampa. Later, while it was controlled by his wife, Emelia W. Chapin, three acres were purchased at the Ballast Point end of the trolley line to be transformed into a park. She named it for Jules Verne, who in his novel *From the Earth to the Moon* had his fictional spacecraft launch site at Bell Shoals along the Alafia River, not far from Tampa.

Ballast Point, so named because schooners loaded or dumped their ballast material here, was used as an early pleasure resort. Houses constructed nearby ranged from two-story Queen Annes to modest bungalows.

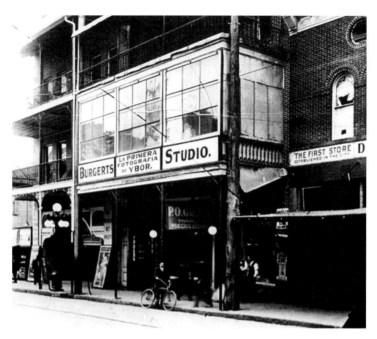

Burgert Brothers Studio

The most famous professional photographers in Tampa were the Burgert Brothers, members of a family which produced many of the historical images which remain of Ybor City, the downtown area, and other subjects. This is a 1919 photo of their Ybor City studio, located in a 1907 building of the Sanchez and Haya Real Estate Company. *Courtesy of the Florida Photographic Collection.*

BURGERT BROTHERS

By 1899, the photography studio of Samuel and William Burgert was in business on East 7th Avenue in Ybor City. They advertised themselves as "Photographers and Artists in Oil, Crayon and Pastel." Other family members in the business included Jean and Walter Burgert. In addition to photographs, they sold cameras and supplies at the Tampa Photo and Art Supply Company at 207–11 East Kennedy Boulevard.

By 1919 the company was known as the Burgert Brothers. Alfred and Jean Burgert had a studio at 814½ North Franklin Street, then 506½ North Franklin Street, then 409 East Kennedy Boulevard. During the 1920s, they moved to 608 East Madison Street, and then to 3101 North Florida Avenue. In 1939 they moved into another building close to the Bay View Hotel. The business continued under the Burgert Brothers name until it closed in 1963.

THE 1900S

SULPHUR SPRINGS

In 1891 the Van Dyke Bridge was constructed to facilitate access to Sulphur Springs. Although the bridge was removed long ago, there still exists a memorial marker at the intersection of River Cove Drive and Alaska Street, just east of Nebraska Avenue on the north side of the Hillsborough River.

In 1900 J.H. Krause sold to Dr. J.H. Mills the springs and adjacent land on the north side of the Hillsborough River and south of Bird Street, which had been used for decades by those seeking the springs' healing powers. Mills added a dance pavilion, swimming pool and Ferris wheel, and the area was connected to downtown by a trolley line. Later additions included a toboggan slide, gazebo, alligator farm and arcade.

The area was described as "Tampa's Coney Island." In the 1920s, Josiah Richardson turned the area into an affordable resort for city residents and Northern visitors. The Tampa city limits were extended in 1923 to include Sulphur Springs.

The Sulphur Springs Hotel and Arcade (also known as

Sulphur Springs Tower

Sulphur Springs has been a popular place to swim and relax since the early days of Tampa. It had many historical buildings including a theater, shopping complex and entertainment attractions, but its enduring symbol is this water tower erected in 1927 and still visible from Interstate 275. *Courtesy of the Florida Photographic Collection.*

the Nebraska Hotel) was built in 1926 with a double-tiered arcade along the front that sheltered the sidewalk. It was considered by many to be a complete town under a single roof, and a predecessor to the modern shopping mall. In the arcade beginning in 1948 was radio station WHBO, the first Florida full-time country music station. The complex was torn down in 1967 to provide room for a parking lot for a greyhound racetrack.

In 1927, engineer Grover Poole constructed the 210-foot tall water for Richardson. An elevator took visitors to an observation balcony at the top. Richardson mortgaged the resort to build the tower, but in the early 1930s Richardson went broke. During its use as a water tower, the upper one-fourth of the tower held 125,000 gallons, pumped from artesian springs nearby. The remainder of the structure consists of seven rooms, one on each floor. Richardson intended the seven rooms to be turned into clubrooms, but economic difficulties precluded that. During the 1970s, the land was used as the Tower Drive-In Theater, and in 2002 the area was purchased by the city and turned into the public River Tower Park.

RUPERTO PEDROSO

The Freethinkers of Marti and Maceo organized on October 26, 1900, and held their early meetings at 1300 East 8th Avenue, the boarding house of one of their members, Ruperto Pedroso. The organization built its own two-story brick building in 1908 at the corner of 6th Avenue and 11th Street.

After surviving an assassination attempt, Jose Marti stayed in the boardinghouse with Ruperto and his wife, Paulina, who had moved to Tampa in 1878. The Pedrosos returned to Cuba in 1910 and were honored as heroes of the revolution. The old wooden boardinghouse was intended to be used as part of a memorial, but it burned down during the 1950s. The site is now a park, which was financed in part by $25,000 donated by former Cuban president Fulgencio Batista.

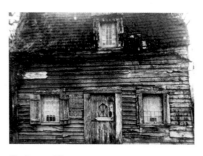

Pedroso Home

Ruperto and Paulina Pedroso were Tampa cigar workers from the 1880s until 1910, when they returned to Cuba. While in Tampa, they also helped to organize La Sociedad Libres and worked for Cuba's independence from Spain. This is a nineteenth-century photograph of their boardinghouse, used for revolutionary activities. *Courtesy of the Florida Photographic Collection.*

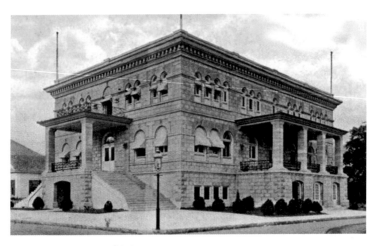

German American Club

From 1909 until World War I, this was the home of Tampa's German American Club. Thereafter, the building was occupied by the Labor Temple Association (1919-24), the Young Men's Hebrew Association (1924–44), Los Caballeros de la Luz, and is now owned by the city. *Courtesy of the Florida Photographic Collection.*

GERMAN AMERICAN CLUB

This organization was founded in 1901 with George Stecher as its president. A cornerstone was laid for a clubhouse at 2105 North Nebraska Avenue on February 23, 1908, and opened for its members on January 1, 1909. Because of anti-German sentiment, the club closed down during World War I.

GENERAL STRIKE OF 1901

Labor concerns have always complicated the manufacture of cigars in Florida, and constituted a major reason for the move of manufacturers from Key West to Tampa. A dispute between the Cigar Makers International Union (CMIU) and the local predominantly Cuban La Resistencia resulted in a major problem for Tampa in early 1901.

The local organization demanded the closing of the Jacksonville Cuesta-Rey factory because it paid wages less than were available in Tampa. When Cuesta-Rey and Company declined, most of its workers in West Tampa walked out, leaving only members of CMIU. La Resistencia then demanded higher wages and the firing of CMIU members. The Cigar Manufacturers Association of Tampa became involved and refused to give in to the local union's demands. What resulted was a general strike that crippled the industry.

Sixteen who were considered to be leaders of the strike were kidnapped in August and placed on a ship to Honduras. The cigar factories reopened with workers who did not favor the strike, and

by November 25, 1901, production was essentially back to normal. Many Italian immigrants replaced the striking Cubans, resulting in a diminished strength for La Resistencia.

ST. ANDREW'S EPISCOPAL CHURCH

This congregation held its first organizational meeting on July 24, 1871. A wooden sanctuary was built in 1883 with a design by Reverend John Henry Weddell of New York.

The present church's cornerstone was laid in 1904 while William C. Gray was the bishop and William W. DeHard served as its rector. The Spanish Renaissance–style building was designed by Miller and Kennard, and incorporated stained glass and the communion rail which came from the original wooden church. The present sanctuary was completed in 1907 at 505 North Marion Street.

TAMPA HEIGHTS METHODIST CHURCH

This congregation organized in 1900, growing out of a small Sunday school held in a kindergarten on Morgan Street the year before. Pioneer settler Colin M. Blake was a major financial contributor for

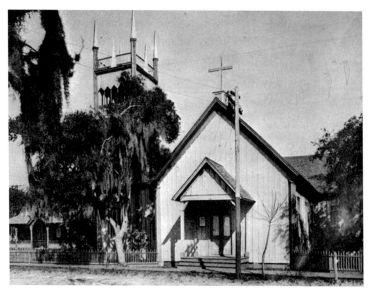

St. Andrew's Episcopal Church

This church building for St. Andrew's Episcopal was designed by Reverend J.H. Weddell of New York. It was built of wood in 1883 at 505 North Marion Street. This photograph of the sanctuary and parsonage was taken in 1898. *Courtesy of the Florida Photographic Collection.*

the construction of its first building. Its first pastor was Reverend Henry Hice.

The first church building was erected on the southwest corner of Central and Ross Avenues on land donated by U.S. Representative Stephen M. Sparkman. While Reverend Smith Hardin was its pastor in 1910–14, additional lots were acquired and construction of a brick church was begun at 503 East Ross Avenue. It was completed while Reverend I.C. Jenkins was the pastor in 1914–17. The three-story educational building was erected in 1927. By that time, the congregation had grown to 1,600 members.

A fire damaged the building in 1947 and it was rebuilt with three brick stories and a five-columned portico the following year. As its congregation shrank, the church shared its facilities with the Christian Refugee Center, the Ybor City Child Development Center and other organizations. On May 25, 1969, the building was sold to the Tyler Temple United Methodist Church, which was organized in 1917 as Keeney United Methodist Church in Hyde Park.

PALM AVENUE BAPTIST CHURCH

This church was founded in 1900 by a group of First Baptist Church members who lived in Seminole Heights. Its first minister was Reverend Charles Nash. The three-story brick church building at 1909 North Florida Avenue was erected in four stages from 1901 to 1912, with the oldest portion (1901–05) on the northeast near Palm Avenue. Nearby is its sixteen-story retirement building. The church continues to serve the changing community with a bilingual chapel.

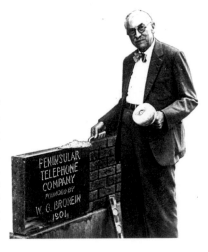

William G. Brorein

Brorein, who usually went by his initials of W.G., is shown in this 1936 photograph placing a cornerstone at the headquarters of the Peninsular Telephone Company. It commemorated the thirty-fifth anniversary of his founding of the telephone company, which absorbed its competition to provide Tampa with quality telephone service. *Courtesy of the Florida Photographic Collection.*

TELEPHONE COMPANY

In 1901 William G. Brorein of Ohio obtained a thirty-year franchise for the operation of the Peninsular Telephone Company, and he served as its president and general manager. Brorein procured financial backing from his friends in Ohio, served as the president of the Florida State Telephone Association, and lobbied the state legislature for regulation as to rates and services, protecting the consumer while running a financially successful company.

Peninsular's main competitor was the local Southern Bell company, and for a time both companies offered phone service in the city. Many homes had phones for both systems, and both were necessary if one wanted to be able to contact everyone. Peninsular eliminated Southern Bell by purchasing it in 1906. By 1915, Tampa became the only city of its size with all dial telephone service. In 1957, Peninsular became the General Telephone Company of Florida.

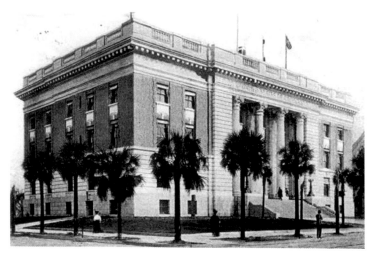

Post Office

Built in 1902–05, this building faced with granite and marble served as Tampa's main post office, custom house and federal courthouse until 1965. It was designed by architect James K. Taylor and is the oldest significant Tampa building originally designed for government use. *Courtesy of the Florida Photographic Collection.*

CENTRO ASTURIANO

This club formed on April 1, 1902, as the North American auxiliary of a Havana organization when the radical Asturian (Northern) Spanish residents left the Centro Español. Its first building was a two-story wooden structure at 1410½ 7th Avenue, replaced by a $75,000 building at the intersection of Palm and Nebraska Avenues. It was dedicated on January 22, 1909, and burned down in 1912.

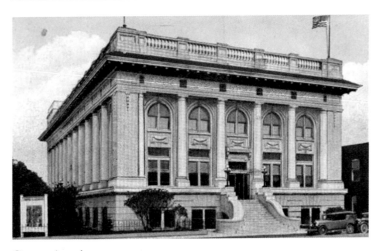

Centro Asturiano

This image from a 1947 postcard shows the Centro Asturiano clubhouse completed in 1914 at a cost of $110,000. The exterior is faced with yellow brick featuring window bays with engaged columns and a balustraded parapet. *Courtesy of the Florida Photographic Collection.*

Bonfoey and Elliott designed the present Beaux-Arts Classical–style structure, using some Mannerist elements. It was completed in 1914 at a cost of $110,000, and is made of yellow brick featuring window bays with engaged columns and a balustraded parapet. Inside is a cantina, library, offices, a ballroom and a 1,200-seat European-style theater with a curved balcony, which was the only Spanish-language theater in the United States. Its intimate bar in the Covadonga Room, extending more than 50 feet, was the world's longest bar made from onyx. The clubhouse served as the headquarters for the New Deal's Federal Theatre Project and was placed on the National Register in 1974. Later, the ballroom was converted to a Latin disco open to the public.

COUNTRY CLUB

The Tampa Yacht and Country Club was founded in 1904 by Tampa business and professional men who wanted a place to sail boats, ride horses and socialize. The first $7,000 clubhouse was built in 1905 at Ballast Point. That clubhouse burned down in 1929, and was replaced by another the following year. A paddock and barn were added in 1931.

The second clubhouse burned down in 1938, and the present one built the following year cost $40,000. It has an address of 5320 Interbay Boulevard and has a reputation for being a family-oriented club with fine dining and entertainment. The 13.5 acres of facilities include a marina, the 20,000-square-foot clubhouse, a tennis complex, a swimming pool and stables.

COLUMBIA RESTAURANT

In 1905 the Columbia Restaurant opened as a cafe for cigar makers. It was founded by Casimiro Hernandez Sr., who took the name from the song "Columbia, Gem of the Ocean." His son took it over in 1927, and members of the fifth generation of the founder's family currently operate it.

The Don Quixote Dining Room was added in 1935, and was the first air-conditioned dining room in Tampa. Two years later, the Patio Dining Room was built to resemble an Andalusian courtyard with a mosaic-tiled fountain. The Siboney Room was added in 1956, providing a three-hundred-seat showroom for Latin talent.

Columbia Restaurant

The Columbia, founded in 1905, is the oldest and largest Spanish restaurant in the country. Its architecture is Spanish and Moorish, and it can handle up to 1,500 patrons in its eleven dining rooms. This souvenir postcard shows one of its courtyards where patrons can enjoy the mild climate as well as excellent food. *Courtesy of the Florida Photographic Collection.*

TAMPA HEIGHTS PRESBYTERIAN CHURCH

The Tampa Heights Presbyterian Church was organized on May 7, 1905, by forty-seven members of the First Presbyterian Church in downtown Tampa, under the leadership of Reverend Dr. John G. Anderson. The Sunday school was established by Henry C. Giddens and Sidney Lenfesty.

The first sanctuary was built at the northeast corner of Palm Avenue and Lamar Street for $7,300 in 1908 while Reverend James F. Winnard was the pastor. The fund drive for the first church was headed by Benjamin Graham, then the superintendent of schools. The present two-story brick church was completed in March of 1923. In 1964 the building was sold to the Faith Temple Baptist Church.

PALMA CEIA

In 1907 the area known as Palma Ceia ("Bay Palm") was platted, but serious development did not happen until the 1920s. James F. Taylor and Earle G. Moore intended the area to be one of affordable custom

homes constructed around the Palma Ceia Golf and Country Club (1601 South MacDill Avenue). The Reasoner Brothers added the Golf View subdivision as an upper-class neighborhood.

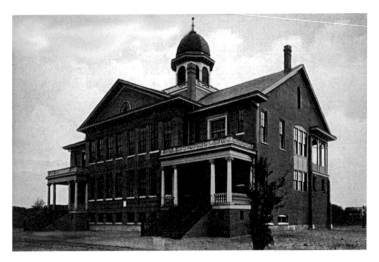

Michigan Avenue Grammar School

This school built in 1906 still shows its distinctive copper dome. Its wood floors, hand-glazed windows and brick walls were made by volunteers who lived in the local neighborhood. It opened while it was still under construction, and initially served a largely Hispanic population. It later was renamed after Robert E. Lee. *Courtesy of the Florida Photographic Collection.*

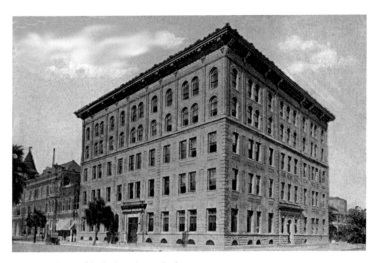

Young Men's Christian Association

Presidential candidate William Jennings Bryan's speech highlighted the 1908 laying of this five-story building's cornerstone at the northwest corner of Florida Avenue and Zack Street. It suffered a major fire in the early 1970s, sat vacant for years and was torn down and replaced by a parking lot. *Courtesy of the Florida Photographic Collection.*

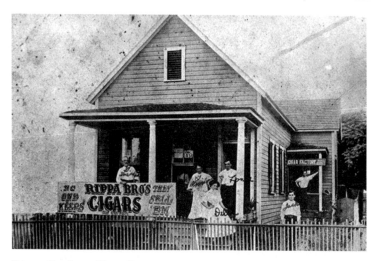

Rippa Brothers Cigar Store

This small cigar factory and store was unusual for Tampa, in that its owners were not Cuban, Spanish or Italian. Brothers David and Toba Rippa moved from Romania to Key West in the late 1880s, then moved to Tampa by the early 1900s, when this photograph was taken. Their being Jewish alone would have placed them in a small minority. *Courtesy of the Florida Photographic Collction.*

YBOR CITY FIRE

At 1914 12th Avenue sat a large (thirty-four- by eighty-eight-foot) wood frame boardinghouse. On March 1, 1908, its wood shingle roof caught fire and the flames spread to the surrounding fifty-five acres. By the time the fire was extinguished, it had destroyed 5 brick stores, 5 cigar factories, 171 cottages and 42 two-story frame buildings. The damage exceeded $1 million.

HOTEL OLIVE

In 1909 the Hotel Olive was built on the southeast corner of Franklin and Washington Streets. Later, it was expanded by the construction of a ten-story annex, and was renamed the Thomas Jefferson Hotel. It was demolished in 1969.

In earlier years, the corner was the site of the John T. Lesley Mercantile Building, a two-and-a-half story wooden structure that housed various businesses, including that of druggist W.A. Givens. For a while, the city hall was located on its second floor. By the 1890s, that building was replaced by the building of the *Tampa Journal*, which had begun publication in 1886.

The 1910s

Port of Tampa

There is a distinction between "Port Tampa" and "Port of Tampa." The former is located on the Interbay Peninsula southwest of downtown Tampa and was an important shipping port in the late nineteenth and early twentieth centuries. Port Tampa developed as a separate municipality, connected to Tampa by the railroad. As Tampa grew in later years, it absorbed Port Tampa.

The Port of Tampa is located downtown, farther from the mouth of Tampa Bay than is Port Tampa, and its development began in 1910. That year, the Ybor and Sparkman Channels were constructed, connecting the Hillsborough River to the main portion of Tampa Bay. That allowed commercial shipping companies to have their facilities much closer to the business districts of Tampa, and eliminated the need to have the spur railroad line running north from Port Tampa as an additional leg in the transportation system.

The Port of Tampa today has a channel that is forty-three feet deep. That accommodates nearly five thousand vessels, which move 50 million tons of cargo each year.

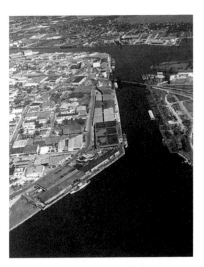

Port of Tampa

This is an aerial view of a portion of the port area of Tampa as they appeared in 1958. The Hillsborough River is shown twisting to the right through the city, with Davis Islands in the distance. Tampa has become a major cruise ship port to supplement its long-time cargo facilities. *Courtesy of the Florida Photographic Collection.*

Second General Strike

Some cigar factories had defaulted on promises to

abide by agreed-upon pay scales, which had been set by the Cigar Manufacturers Association of Tampa and the Cigar Makers International Union. A price war resulted in a lockout of workers, beginning on June 23, 1910. A citizens committee was formed to take action against cigar workers who filed complaints. The *Tampa Tribune* building was burned by rioters in retaliation for publisher Wallace F. Stovall's support of workers who returned to their jobs during the strike.

The bookkeeper of the Bustillo Brothers and Diaz factory was murdered, as were his two alleged killers. Two Italian men were taken from their West Tampa jail cell and lynched. Workers received financial support from cigar workers in Cuba, then voted to return to work. The strike, actually a lockout by the manufacturers, ended on January 26, 1911.

LINCOLN BEACHEY

In Tampa in 1911, Lincoln Beachey made the first night flight in history. Bonfires were lit around the Tampa Bay Hotel, which he circled four times. Smoke from the fires made the landing difficult and Beachey pushed for the use of artificial lighting for any subsequent night flights.

LIBRARY

In 1905 *Tampa Tribune* society editor Louise Frances Dodge began a drive to establish a city library. In 1912 the voters of Tampa passed a referendum to accept funds from the Andrew Carnegie Foundation for construction of a library. In 1914 the first library opened in West Tampa, built with $17,500 from Andrew Carnegie, a close friend of Hugh C. Macfarlane. Located at 1718 North Howard Avenue, it was designed by Fred J. James. The main library was completed in 1915 at 102 7th Avenue. Library services at the main building began in 1917, after two years of the city council's handling of issues regarding books and personnel. A library for the black residents of the area opened in 1919 at the Harlem Academy. It moved in 1926 to the Urban League headquarters.

In 1965 ground was broken for the construction of a new main library at 900 North Ashley Drive. In 1967 it was designated as a depository for documents issued by the State of Florida. Formal dedication took place in 1968, and its West Annex Building was dedicated in 1976. The facility was renamed on November 5, 1999, after John F. Germany, a Tampa judge whose efforts beginning in 1960 resulted in the construction of the modern library.

Hyde Park Branch Library

After serving as a grammar school, a school hot lunch center and then a private kindergarten, this building was moved to Swann Avenue in 1938 to serve as the Hyde Park branch of the library. Until then, that neighborhood's library, which had been established in 1922, was located in other quarters. *Courtesy of the Florida Photographic Collection.*

TAMPA UNION STATION

Tampa's first train station was located in the Waters Street home of Captain John Miller. It was used by the South Florida Railway.

In 1912 the Tampa Union Station was built at a cost of $100,000 using locally manufactured brick, stone and terra cotta. Designed by

Union Station

This is a view of the Union Station in 1922, ten years after it opened to serve jointly the Atlantic Coast Line Railroad, Seaboard Air Line Railroad and Tampa and Gulf Coast Railroad. Beginning in 1971, while it was owned by Amtrak, it served three trains each way each day, one to Chicago and two to New York. *Courtesy of the Florida Photographic Collection.*

J.F. Leitner, it shows an Italian Renaissance Revival architectural style. Structural deterioration caused the station to be closed in 1982.

It was purchased by a nonprofit company, Tampa Union Station Preservation and Redevelopment, Inc., which oversaw renovations beginning in 1991. Its purchase and renovation cost $2.5 million, provided by grants and loans.

The rail freight company, CSX, forgave the nonprofit's mortgage and reacquired the property. It was donated to the city and on May 30, 1998, the Union Station held its grand reopening ceremony. It has been on the National Register since 1974.

ROBERT MUGGE

One of the Tampa hotels erected during the 1910s was the Bay View, owned by Robert Mugge. He moved to Tampa from Germany in 1875 and ran a successful Budweiser beer and wine distributorship, as well as being a watchmaker and saloon operator. He had a small cigar company in Ybor City in 1906, but closed it after a fire.

Mugge constructed the Bay View at 208 Jackson Street, and it passed the Hillsboro Hotel as the largest commercial hotel in Florida. The hotel was imploded in February of 1980 to make room for the present Paragon Complex.

Bay View Hotel

Robert Mugge planned this ten-story building to be a warehouse for his wholesale liquor business, but changed his mind and made it a hotel after construction began in 1912. With a large lounge on each floor, it was described as a cross between a YMCA and a ten-story barroom. *Courtesy of the Florida Photographic Collection.*

ST. PAUL AFRICAN METHODIST EPISCOPAL CHURCH

In 1870 a church was organized as the Brush Arbor Mission by Reverend Thomas W. Long, who walked from Brooksville to start the church. The congregation first met at the corner of Tampa and Harrison Streets, but when winter came it moved into a log house on Harrison Street. The church was renamed as Mount Moriah AME Church in about 1900, and the meetings were held on Marion Street, between Harrison and Fortune Streets. A site at 506 Harrison Street was purchased in 1892 and a frame building was erected.

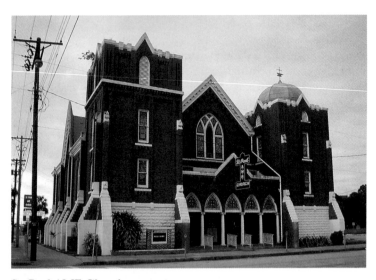

St. Paul AME Church

This is a recent photo of the church which has hosted notables such as Dr. Martin Luther King Jr., who preached here. Future Supreme Court Justice Thurgood Marshall, the then NAACP general counsel, attended strategy meetings there. The church was the planning center for local 1950s and 1960s civil rights activities. *Photo by the author.*

In 1906 a red brick church designed by Albert M. Johnson was begun on the same site. The "lower unit," extending about a half story below the ground level, was finished in 1913. That portion later included the pastor's study, a large meeting room and church offices. The upper portion was completed in 1917 with a Gothic Revival style. St. Paul's, as it was renamed, has served as the mother church for thirteen other AME churches in Tampa. The construction cost was approximately $30,000.

Lykes Brothers Packing Plant

Beginning in the 1880s, the Lykes family was a major participant in Tampa's economy. Cattle, shipping and other interests kept it successful through periods of nation-wide economic problems. Shown here is the interior of one of its meat packing plants as it appeared in 1962. *Courtesy of the Florida Photographic Collection.*

Lykes Brothers

During the 1880s, Dr. Howell T. Lykes was shipping cattle to Cuba, having given up his medical practice. He also married the daughter of Captain James McKay, the king of cattle shipping to Cuba during previous years.

Lykes built his home at Ballast Point, and shipped cattle essentially from his front yard. Eventually, his seven sons (James, John, Frederick, Lipscomb, Howell, Thompson and Joseph) joined in the land, shipping and cattle businesses. The firm of Lykes Brothers, Inc., was chartered in 1910 by the seven, and by the 1940s expanded into planting and citrus groves.

Major League Baseball

On February 26, 1913, Tampa hosted its first baseball spring training game involving a Major League team. The Chicago Cubs beat the Cuban Athletics, an amateur team from Cuba, by a score of 4 to 2 in front of six thousand spectators at Plant Field.

The Grapefruit League was established for Major League clubs to play each other during spring training while in Florida. The first such game in Tampa took place on March 26, 1914, when the Chicago Cubs beat the St. Louis Browns, 3–2. The Major League teams that have made Tampa their spring training home are

Chicago Cubs	1913–16
Boston Red Sox	1919
Washington Senators	1920–29
Detroit Tigers	1930
Cincinnati Reds	1931–42 and 1946–87
Chicago White Sox	1954–59
New York Yankees	1996–

Seminole Heights

In 1913, T. Roy Young and his Seminole Development Company created a new neighborhood when he subdivided land bounded by the Hillsborough River and Dr. Martin Luther King Jr. Boulevard (then known as Buffalo Avenue), Hillsborough and Central Avenues. The land was previously largely agricultural, with three dairy farms and orange groves.

In addition to Young, major developers of early Seminole Heights included Milton H. and Giddings E. Mabry of the Mutual Development Company, Lee and James Dekle of Dekle Investment Company, W.J. Smith and Lillian Hill Probasco, and Krause and Mendel.

Elks' Club

This building at the southeast corner of Florida Avenue and Madison Street was the home of Dr. John P. Wall until 1905, when the Elks purchased and expanded it. This 1909 image shows its appearance before it was torn down four years later and replaced by a four-story red brick clubhouse costing $125,000. *Courtesy of the Florida Photographic Collection.*

During the 1960s, it lost much land and neighborhood character as a result of the construction of Interstate 275.

TONY JANNUS

The world's first scheduled commercial airline flight took place on January 1, 1914. Its pilot for the twenty-three-minute flight was aviation pioneer Tony Jannus, and he flew a wooden Model 14 seaplane manufactured by Tom Benoist. A monument to Jannus stands near

Tony Jannus

Here, Tony Jannus makes his landing near the intersection of Bayshore Boulevard and Platt Street on the first scheduled commercial airline flight. City officials in Tampa and Jacksonville had no interest in their cities being the takeoff point, so Jannus selected St. Petersburg so he could fly over a large body of water. *Courtesy of the Florida Photographic Collection.*

his landing site at Bayshore Boulevard and Platt Street. He was also honored by the naming of the Tony Jannus Administration Building at the Peter O. Knight Airport at 700 West Davis Boulevard.

The federal government had to rule whether a seaplane was an airplane or a boat, since different rules applied to the two types of craft. It was ruled to be a motorboat, and therefore was required by law to carry life preservers, charts, a foghorn and running lights.

Tony Jannus had learned to fly in 1910 and was a test pilot for the Benoist Aircraft Company. In 1914, be became the first American to receive a federal pilot's license. He and his brother Roger for three months flew at least two trips daily between St. Petersburg and Tampa for a one-way passenger fare of five dollars. During their operation, they carried 1,204 passengers.

In April of 1914, the airline ended its scheduled flights. It was the end of the tourist season, World War I was on everyone's mind and Tony Jannus wanted to get started on other adventures. He died in 1916 in a plane crash while training Russian pilots over the Black Sea.

FIRST SAVINGS

On April 28, 1914, a charter was issued to First Savings and Trust Company, which opened its doors to the public on July 1, 1914, with Alonzo C. Clewis as its president. In 1949, it was renamed as Marine Bank and Trust Company. It became Flagship Bank of Tampa in 1974 and Sun Bank of Tampa Bay in 1984.

CITY HALL

In 1915 the Tampa City Hall was built with the design of architects Bonfoey and Elliott. Its style has been described as Eclectic and includes Doric columns, terra cotta details, a balustrade around the main block and an eight-story tower that extends above the three-story main portion. It was constructed on land that had been occupied by an 1842 frame home, which Imboden

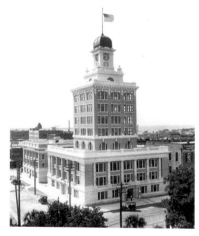

City Hall

Hortense Ford led a group that lobbied the city to install in the City Hall tower a 2,840-pound clock donated by the W.H. Beckwith Jewelry Company. The *Tampa Times* nicknamed the clock "Hortense the Beautiful" and is still known as "Hortense." *Courtesy of the Florida Photographic Collection.*

Stalnaker purchased in 1914. He moved it to 3210 8th Avenue to save it from destruction. The city hall was added to the National Register in 1974.

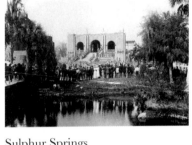

The Birth of a Race

In 1917–18, Tampa sites were used as movie sets for a project intended to be a response to D.W. Griffith's 1915 classic, *The Birth of a Nation*, which depicted former slaves as murderers and rapists, attacking their former masters. Money was raised by

Sulphur Springs

Sulphur Springs had beautiful parklands and water that was believed to relieve ailments of those who swam in it. The picturesque setting was used as the "Cradle of Civilization" in this scene, being filmed in 1917 for the movie *The Birth of a Race. Courtesy of the Florida Photographic Collection.*

producer Emmett J. Scott in an effort to produce an epic film initially called *Lincoln's Dream*. It was directed by John Noble.

Local black residents portrayed Nubian soldiers serving in the army of an Egyptian pharaoh in the movie, which was renamed *The Birth of a Race* before it was completed. The Hillsborough River was used in place of the Nile River.

The individuals who produced the movie were inexperienced, resulting in delays and increased costs. What had begun as a project of Booker T. Washington and the Tuskegee Institute, along with black members of the middle class, turned into a white-financed film criticizing the treatment of German Jews. Technically, the movie was poor and financially, it was a disaster. The movie, which failed to reach its goal of repudiating the racist concepts espoused in Griffith's film, took three years to film and premiered on October 27, 1919, at the Strand Theater.

Strand Theater

At 200 Twiggs Street was the 850-seat Strand Theater. It was built in 1915–17 with a pair of Spanish Colonial–style towers and showed its first movie in 1918. The Strand claimed to be the South's most beautiful theater.

The 1926 opening of the Tampa Theatre, larger and

Strand Theater

The Strand Theater claimed to be the South's "Most Beautiful Theater." It was air-cooled and had twinkling stars and moving clouds in its ceiling. After World War II, after its days of showing movies, it was absorbed into the Maas Brothers Department Store and housed its women's wear department. *Courtesy of the Florida Photographic Collection.*

equipped with real air conditioning, hurt the Strand's business. It finally ended its run as a movie theater in the late 1940s, becoming a part of the Maas Brothers building. The Strand portion of the building was added to the National Register in the late 1970s. Maas closed in 1991 and the block was sold in 1998. Two years later, it was condemned. The Strand and the rest of the block were leveled for the construction of condominiums.

USS *TAMPA*

The USRC *Miami* was commissioned in 1912 as a 190-foot cutter in the Revenue Cutter Service, a predecessor of today's Coast Guard. Not long afterward, as a result of the sinking of the RMS *Titanic*, cutters were ordered to the North Atlantic to patrol the ice zone and warn ships of the limits of danger. After patrols through 1915, while being stationed in Tampa each February during the Gasparilla festival, its name was changed to the USS *Tampa* three days before the 1916 festival.

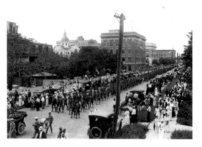

Tampa Home Guards

In anticipation of the entry of the United States into World War I, a draft was conducted. The Tampa Home Guards, a local contingent similar to today's National Guard, are shown here in a 1917 parade on Morgan Street to honor Tampa's draftees. *Courtesy of the Florida Photographic Collection.*

In 1917 the United States declared war on Germany and the USS *Tampa* was one of the cutters transferred to the navy. Armament was installed to transform it into a warship to protect convoys from submarines between England and Gibraltar. On September 26, 1918, after it accompanied a convoy from Gibraltar to the Irish Sea on its way to Wales, it sailed alone toward England and was sunk by German submarine *UB-91* in the Bristol Channel. All 131 aboard, including Captain Charles Satterlee and at least 23 from Tampa, were killed. The USS Tampa Post No. 719 of the American Legion was named for the ship. The World War I monument for the Coast Guard in Arlington National Cemetery is known as the Tampa Memorial.

BABE RUTH

On April 5, 1919, pitcher Babe Ruth, who was beginning to transition to the outfield, played in a game at Plant Field near the Tampa Bay Hotel. He hit a home run off Columbia George Smith, which was measured to have traveled 579 feet. The event is now commemorated

by a historical marker on the campus of the University of Tampa, where Plant Field was located.

Oak Grove Springs

A popular destination for family outings during the 1910s and 1920s was Oak Grove Springs. A major attraction was the large Goldstein's Pool near the Hillsborough River, just south of Sligh Avenue.

Minor League Baseball

Tampa has had several minor league teams over the years:

Year(s)	Team	League
1919–27	Smokers	Florida State League
1928	Krewes	Southeastern League
1929–30	Smokers	Southeastern League
1946–54	Smokers	Florida International League
1957–87	Tarpons	Florida State League
1988	White Sox	Florida State League
1994–	Yankees	Florida State League

The early teams played at Plant Field at the fairgrounds adjacent to the Tampa Bay Hotel. For the first exhibition game of spring training in 1919, a baseball diamond was laid on the fairground's racetrack so the New York Giants could play the Boston Red Sox. In 1922 a stadium was erected for spectators.

The stadium, later known as Pepin-Rood (the track and field for Ed Rood and the stands for Arthur and Polly Pepin), was refurbished several times and finally taken down in 2002, when the University of Tampa replaced it with a temporary 1,500-seat stadium.

THE 1920S

THIRD GENERAL STRIKE

Tampa's third general strike within the cigar industry began on April 14, 1920, bringing the factories to a halt until early 1921. Afterward, relations between management and labor improved and no further citywide strikes have occurred.

WDAE RADIO

The radio station known as WDAE received its license on May 15, 1922. That came one week after a license was issued to WCAN in Jacksonville (which went out of business by October of that year). WCAN may never have begun broadcasting, and if that is the case then WDAE was the first radio station to broadcast in Florida.

WDAE was an innovator, using a remote car to cover live football games, Billy Sunday sermons, the Johnny J. Jones Circus and other newsworthy events. In 2000 WDAE became WHNZ, shifting from sports to mostly infomercials and network talk shows.

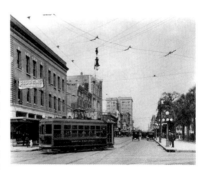

Downtown Tampa

This is a scene from downtown Tampa of the 1920s, including the electric trolleys, which connected the various sections of the city. This one is shown passing by Giddens Clothing Company, located on Franklin Street just north of Kennedy Boulevard. *Courtesy of the Florida Photographic Collection.*

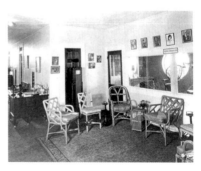

WDAE Radio

This is a 1931 photo of the waiting area and studio of WDAE, which was licensed to the Tampa Publishing Company. It began with broadcasting equipment it had purchased from Harold McClung, who had used it to create his own naval radio station in St. Petersburg. The radio station was set up in the Citrus Exchange Building. *Courtesy of the Florida Photographic Collection.*

TA-MIAMI AIR LINE COMPANY

In the early 1920s, E. Harold Threadgill recognized the need for airline service linking Tampa and Miami, and worked for two years with the Curtiss Aircraft Company to design a plane with wheels and pontoons, which could land on the ground and in the Everglades. The Ta-Miami Air Line Company was chartered in 1923, but was denied a contract to carry airmail in addition to its passengers and freight. That, along with the 1926 hurricane and the late 1920s economic downturn, caused the company to go out of business in 1927.

BEACH PARK

In 1924 development began in the area roughly bounded by B Street, Lois and Watrous Avenues and Old Tampa Bay. The project was undertaken by the Beach Park Company, the principals of which were T. Roy Young, William Trice and Milton H. and Giddings E. Mabry. Its principal architect was Franklin O. Adams, who served on its architectural review board. The 350 acres were developed as an upper class neighborhood with restricted construction.

DAVIS ISLANDS

D.P. Davis had sold newspapers in Tampa as a boy, then developed an island near Miami. With the proceeds from that venture, he returned to Tampa and bought Little Grassy Island and Depot Key for $350,000. His plans were challenged by many living in the Bayshore Boulevard

neighborhood, who claimed that he could not sell submerged bottomlands. The Florida Supreme Court held in favor of Davis and his planned development of 834 acres. Davis hired Frank Button as his landscape architect.

D.P. Davis

After he sold the Davis Islands project in 1926 to raise funds to continue another in St. Augustine, D.P. Davis took out a $300,000 life insurance policy. He set sail for Europe, supposedly to check out another development possibility. He either jumped or fell overboard and was never seen again. *Courtesy of the Florida Photographic Collection.*

He drew maps and made models showing residential lots, many of which at the time were far underwater. As construction of buildings on the islands progressed, more land was added to them to complete the development. He hired the four largest dredges available at the time to do the work of taking sand from beneath the water.

During the first three hours that a section of lots were for sale on October 4, 1924, all 306 were sold. The total price of $1,683,582 exceeded all previous new subdivision sales of lots, anywhere. Apartments and hotels included the Palace of Florence, Mirasol, Venetian and Biscayne. The most common architectural style used was Mediterranean Revival.

Davis built the Davis Islands International Coliseum designed by T.H. Eslick and began the Davis Island Country Club. The Coliseum opened in 1926 and featured a bowling alley, exhibition arena, roller-skating rink and a large ballroom. It burned down during the 1960s.

When the Florida boom ended, Davis was still trying to arrange financing to complete the project. He wound up selling it in August of 1926 in an attempt to keep Davis Shores, his larger project in St. Augustine, from going under. The Boston engineering firm of Stone and Webster took over the development of the islands. When they were done, the islands consisted of about 4,600 lots.

TAMPA GENERAL HOSPITAL

In 1905 Tampa's medical needs were partially met by a two-story building that was designated as a hospital. City leaders realized that

Davis Islands Coliseum

The Davis Islands International Coliseum was designed by T.H. Eslick and opened in 1926. It featured a bowling alley, exhibition arena, roller skating rink and a large ballroom. This is how it looked shortly after it opened. During the 1960s, it burned down. *Courtesy of the Florida Photographic Collection.*

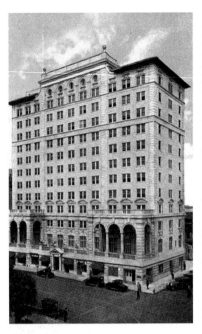

Tampa Terrace Hotel

In 1926 the elegant twelve-story Tampa Terrace Hotel replaced a pair of pre–World War I homes and the Boller livery stable. It was initially financed by forty investors but went out of business during 1965. It was torn down later that year. This postcard is part of a souvenir viewbook printed by the Asheville Post Card Company. *Courtesy of the Florida Photographic Collection.*

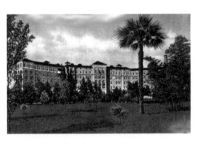

Tampa General Hospital

This postcard printed by the Hillsboro News Co. dates to about 1938, when the hospital was known as Tampa Municipal Hospital. It included the Gordon Keller Nursing School, which moved there from North Boulevard. Control was acquired by the city in 1961, and it was renamed as Tampa General Hospital. *Courtesy of the Florida Photographic Collection.*

a larger facility was needed. In 1910 the city built the thirty-two-bed Gordon Keller Memorial Hospital at 302 North Boulevard, named for an outstanding civic leader, city treasurer and merchant. Its site later became part of the fairgrounds.

In 1924 voters approved a $215,000 bond issue to construct a modern hospital on the north end of Davis Islands in a portion of Marjorie Park. The nine-story patient care wing was named in 1991 after Clara Frye. She was a black nurse in the early 1900s who took black patients into her two-story wood frame house in Tampa Heights and turned it into the seventeen-bed facility known as the Clara Frye Hospital, which she ran for twenty years. It was replaced by the Tampa Negro Hospital at 1615 Lamar Avenue in 1930. There was a city-owned Clara Frye Memorial Hospital in West Tampa from 1938 to 1967.

TAMIAMI TRAIL

In 1915 the State of Florida established a road department to investigate appropriate locations for road construction. Eight years later, a nine-car motorcade left from Fort Myers and headed toward Tampa to prove that the route could be conquered by automobiles. The expedition through cypress forest, soft marl and swamps brought attention to the need for good roads, and the potential for turning wilderness into roadways.

On April 27, 1928, following the arrival in Miami of a motorcade from Tampa, the 249-mile Tamiami Trail was officially dedicated. The $6 million highway was named by L.P. Dickie, secretary of the Tampa Board of Trade.

TAMPA THEATRE

On October 15, 1926, this theater designed by John Eberson opened with a showing of a silent film, *The Ace of Cads*, starring Adolphe Menjou. The ornate theater which cost $1.2 million to build combined Byzantine, Spanish, English Tudor, Baroque, Greek Revival, Florida Mediterranean and Italian Renaissance styles on the outside and a ceiling with ninety-nine twinkling stars and drifting clouds.

A twenty-piece orchestra and 1,200-pipe Wurlitzer organ played by Eddie Ford helped to entertain the 1,446 patrons who relaxed in Tampa's first commercial air conditioning. The enclosed space forms a romantic Mediterranean courtyard with gargoyles, statues and flowers.

The theater was acquired by the city in 1976 and named to the National Register the following year. The city declared it to be a city landmark in 1988, and it is now managed by the Arts Council of Hillsborough County. It hosts 650 events each year, resulting in an average annual attendance of 170,000.

Tampa Theatre

Shown here is the old-fashioned outdoor box office of the Tampa Theatre. It was restored beginning 2000 utilizing surcharges added to the cost of tickets to movies and concerts. The theatre serves as a venue for classic movies, specialty films, musical performances, corporate events, weddings, graduations, tours and the production of film projects. *Photo by the author.*

TAMPA BEACH

Wallace F. Stovall of Kentucky came to Tampa in 1893 and founded the *Tampa Morning Tribune*, which started out as a four-page newspaper printed six days a week. He sold the newspaper in 1925 for $1.2 million. He invested his proceeds in real estate, including several tall downtown buildings including the four-story Tampa Tribune Building, the twelve-

story Wallace S. Building, the seven-story Stovall Office Building and the eight-story Stovall Professional Building. Another project in which he was a major backer was Tampa Beach, a suburb planned for the eastern end of the 22nd Street Causeway. The late 1920s economic bust killed the plans for Tampa Beach and several other residential and commercial developments.

AL LOPEZ

Alfonso Lopez was born in Tampa in 1908 and began playing minor league baseball with the Tampa Smokers in 1924. He also played for the Brooklyn Robins (1928–31) and Dodgers (1932–35), the Boston Bees (1936–40), the Pittsburgh Pirates (1940–46) and the Cleveland Indians (1947). On September 27, 1928, he became the first Tampa native to play in the Major Leagues. He then managed the Indians (1951–56) and the Chicago White Sox (1957–65 and 1968–69), both of which played under him in the World Series.

He was elected to the Hall of Fame in 1977. Just before he died in 2005 at the age of ninety-seven, he was the last surviving man to have played in a Major League game during the 1920s.

TAMPA MUNICIPAL AIRPORT

In 1928 Tampa Municipal Airport opened. It was also known as Drew Field for John H. Drew, who owned adjacent pasture and was allowed to let his cows graze on the portion of the airport not being used by planes. In 1934 the city bought his land and constructed three 7,000-foot long asphalt runways with lights. It was initially thought that seaplanes were the future of aviation, so that the Peter O. Knight Airport on Davis Islands would be Tampa's primary airport. However, when the army arrived, it preferred Drew because it had more landing space, and after World War II more emphasis was placed on Tampa Municipal.

Al Lopez Field

To honor baseball star Al Lopez, Horizon Park was renamed as Al Lopez Park and a statue of him was erected, showing him in full catcher's gear. This photo of the crowd at Al Lopez Field being addressed by President John F. Kennedy was taken on November 18, 1963, just days before his assassination. *Courtesy of the Florida Photographic Collection.*

MASONS

In 1928 the Fellowship Lodge No. 265 F & A.M. was founded

to provide a lodge for the portion of Tampa west of the Hillsborough River. Early meetings were held in the John Darling Lodge No. 154, then in 1929 they were moved to 1527 Grand Central Avenue. In 1944 they moved to 302 Memorial Highway, and during the 1950s they relocated to 2506 Grand Central Avenue. Currently, they meet in a lodge building, which opened in 1965 at 306 Lincoln Avenue.

SEAPLANE BASE

Tampa almost became a seaplane port. City residents in 1929 voted in favor of the construction of facilities on a man-made island to be constructed between Ballast Point and Davis Islands. However, wealthy residents across Hillsborough Bay were able to block it. As a result, Pan American Airways switched its base of operation to Miami, linking that city to South America.

NICK NUCCIO

In 1929 this son of Sicilian immigrants became the first Latin individual to take some of the power away from the predominant Anglo establishment. He served as a city alderman beginning that year, a county commissioner from 1936 to 1956, and mayor of Tampa in 1956–59 and 1963–67.

Air Mail

Air mail connected Tampa with Havana and Miami for the first time in 1926. This photo was taken by the Burgert Brothers and depicts Tampa's postmistress and several dignitaries present at the arrival of air mail on April 1, 1926. *Courtesy of the Florida Photographic Collection.*

The 1930s

Tampa Bulletin

This decade saw the establishment of another newspaper, the *Tampa Bulletin*, edited by M.D. Potter, an active member of the African Methodist Episcopal church. Its target market was Tampa's black population.

Plant Park

In the former Plant Park is the DeSoto Oak, which, according to legend, was the site where Hernando de Soto held treaty discussions with Indians. Some believe that de Soto made no such treaties and instead merely destroyed their villages. A bronze marker was formally dedicated at the tree in 1927.

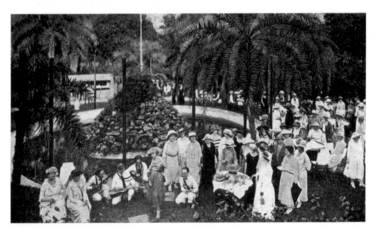

Plant Park

The area between the Tampa Bay Hotel and the Hillsborough River is known as Plant Park, including the city's first zoo and aviary and the beautiful Jewel Box Tea Garden shown in this photograph. It also contained the city's bandshell used for concerts. The park is now part of the university campus. *Courtesy of the Florida Photographic Collection.*

UNIVERSITY OF TAMPA

During the late 1920s, Tampa's high school graduates had difficulty finding jobs, so the principal of Hillsborough High School, Frederick H. Spaulding, began setting up plans for a junior college. A charter was granted on March 13, 1930, and organization and faculty recruitment took place in 1931. Tampa Junior College's classes began on October 5, 1931, in the Hillsborough High School.

In 1933 the school moved to the former Tampa Bay Hotel, renamed as Plant Hall and became the University of Tampa. The university, which began a football program in 1932, acquired its own stadium in 1937. The University of Tampa received accreditation from the Southern Association of Colleges and Secondary Schools in 1951.

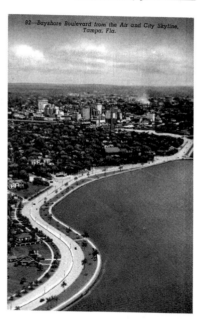

Bayshore Boulevard

Eugene Holtsinger and Alfred Swann bought mud flats along the edge of Hyde Park, erected a seawall and covered the mud with dredged sand. What resulted is expensive and desirable waterfront property, the nation's longest bayfront boulevard and the longest continuous sidewalk. *Courtesy of the Florida Photographic Collection.*

DAVIS CAUSEWAY

A causeway crossing Tampa Bay was constructed by Captain Ben T. Davis and opened on June 28, 1934. During World War II, the causeway became a popular picnic site, and picnic shelters were erected at intervals along it. In 1948 it was renamed for Courtney Campbell of Clearwater Beach, a member of the road department who was involved in its postwar development. The name Davis remains on the Ben T. Davis Beach, located along the Tampa end of the causeway and still a popular destination for sun seekers.

St. Joseph's Hospital

The Franciscan Sisters of Allegany, New York, led by Mother Mary Alice Gallagher, came to Tampa to establish a real hospital for the residents of Tampa. They acquired a partially completed four-story building from Dr. W.H. Dyer at the corner of 7th Avenue and

Peter O. Knight Airport

This airport at the south end of Davis Islands was Tampa's major airport for commercial traffic until, after World War II, the use of four-engine transport planes necessitated a shift to what is now Tampa International Airport with its longer runways. The Art Deco–style Knight buildings were demolished in 1964. Courtesy of the Florida Photographic Collection.

Morgan Street. Construction to finish the building as a hospital was begun in 1933 and the new 40-bed facility opened in 1934. During September of 1935, Children's Hospital on Rome Avenue closed and its patients were transferred to St. Joseph's. By 1959 St. Joseph's had been expanded to 215 beds. A new building for St. Joseph's Hospital opened in 1967 at the corner of Habana Avenue and Dr. Martin Luther King Jr. Boulevard.

DOUGLAS BAKER

Tampa native Douglas Baker in 1934 became the youngest person to fly an airplane solo. At age seven, he flew from Drew Field to the southern end of Davis Islands. Baker later became a test pilot and accumulated 47,700 flight hours.

PETER O. KNIGHT AIRPORT

The airport at the south end of Davis Islands was dedicated in 1936. It was Tampa's first WPA project and handled both airplanes and seaplanes. It was named after Colonel Peter O. Knight, who had moved to Tampa in 1889, and who was responsible for the addition of additional fill to extend the length of Davis Islands to accommodate the airport.

THE 1940S

DREW FIELD

Tampa's first airfield was located on the property of John H. Drew since the early 1920s. The runways were too short for takeoffs, so planes were launched by pushing them off a fifty-foot-tall mound of dirt. In 1928 the city signed a lease for the property, then acquired an option on 160 acres and constructed a flying park. Drew received $500, concessions from on-site sales, a percentage of the fees collected for plane rides and a contract to clear the land.

In 1934 Tampa purchased Drew Field for $11,654. As Tampa Municipal Airport, it was leased to the army for twenty-five years at a cost of $1 per year. The Army constructed barracks, warehouses and improved runways. Also known as Drew Field, it was renamed Drew Army Air Force Base for use during World War II. It served as the headquarters of the Third Fighter Command.

Drew Field remained independent from, but coordinated with, the larger MacDill base. Dale Mabry Highway was opened in September of 1943 to link the two. It was named for Captain Dale Mabry of Tallahassee, a World War I hero who was killed when the army dirigible *Roma* crashed in Norfolk, Virginia, on February 21, 1922, on its maiden voyage.

Franklin Street

This photo was taken of North Franklin Street on October 29, 1943, while the State Theatre in the center was still a popular venue for first-run movies. To the left of the picture is the Burtch Building containing Bennett's Cut Rate Drugs. To the right is the Albany Hotel. All but the Burtch are, or soon will be, gone. *Courtesy of the Florida Photographic Collection.*

Drew Field was returned to the city in 1946, and has grown since then into the large Tampa International Airport, so renamed in 1947. The base theater is still showing movies, but as the Playhouse Adult Theater located northeast of the main portion of the airport.

Frequent fliers in 1971 voted Tampa International Airport to be the best American airport. It was the first to use electrically propelled, double-tracked shuttles to carry passengers to and from satellite terminals. It serves more than 40,000 passengers on over 550 flights to more than sixty cities per day.

MacDill Army Airfield

The National Defense Act of 1935 authorized the construction of six new airfields, one to be located in the Southeast. Tampa was chosen because of its waterfront location and its schools, stores and clubs that could accommodate the needs of military families. Construction of the airfield began in 1939 at a flat sandy area between Hillsborough Bay and Old Tampa Bay called Catfish Point. It was originally known as Southeast Air Base and renamed for Colonel Leslie MacDill, a fighter pilot who was killed on November 9, 1938, while test flying a BC-1 plane at Anacostia Base in Washington, D.C. Troops began arriving at MacDill on March 11, 1941, from Barksdale Field.

Runways were built by WPA crews. MacDill was formally dedicated on April 15, 1941, and became the largest Florida training area for bomber pilots. The base also served as a POW camp for captured German soldiers in 1944–45.

Following the war, MacDill served as a base for the Strategic Air Command. In 1947, when the Air Force became separate from the Army, the area became known as MacDill Air Force Base. In 1961 the United States Strike Command was established at MacDill, which became a Tactical Air Command base in 1963. In 1996 the base entered a new phase of existence, with involvement in air refueling activities in support of military actions around the world.

MacDill Field

This postcard image of Hangar No. 2 is from 1942, the year MacDill Army Airfield was the setting for the movie *Air Force*. The base later served as a prisoner of war camp. After the war, the base officer's club was converted into an apartment complex and a barracks building became a community recreation center. *Courtesy of the Florida Photographic Collection.*

Cigar Industry

By the early 1940s, the handmade cigar industry in Tampa had already begun to decline, and World War II dealt it a double blow. The need for men on the battlefields took them out of the factories, accelerating

the introduction of cigar-making machines as their replacements. Also, American soldiers were provided with cigarettes, reducing the demand for cigars. The industry was further hurt by the ban on travel and trade with Cuba imposed on February 3, 1962.

BENJAMIN FIELD

This airfield served for a time as the headquarters of the Third Army Air Force. The land was later the site of Fort Homer Hesterly, the National Guard armory.

HENDERSON FIELD

Henderson Army Air Field (originally known as Hillsborough Army Air Field), with three paved 5,200-foot runways and several hangars located off of Bougainvillea Avenue, served as an auxiliary airfield for Drew and MacDill. It also was used as a physical fitness center. The Henderson site closed in early 1945 and was for a time used as a civilian airport into the early 1950s. When the planes left, the long runways were used as illegal drag strips. Thereafter, it became the Tampa Industrial Park including the Schlitz and Busch breweries, and the cantonment area immediately to the south is now Busch Gardens. The last surviving airport building was used as Mel's Hot Dogs restaurant at 4136 East Busch Boulevard.

NEWSPAPERS

Two newspapers for Tampa's black citizens were established during the mid-1940s. The *Tampa Florida Bulletin* was printed during 1944. The following year, the *Florida Sentinel Bulletin* began publication and continues today from an office at 2207 21st Avenue.

SS *AMERICAN VICTORY*

On June 20, 1945, the United States Navy launched the SS *American Victory*, constructed by California Shipbuilding and named after American University in Washington, D.C. It was used to haul cargo in the Pacific Ocean at the end of World War II, then hauled military equipment back to the United States. In the late 1940s, it was used for shipping machinery and food to Europe under the Marshall Plan, then was chartered by commercial shipping interests in the early 1950s. It saw action during the Korean and Vietnam Wars.

In 1985 the former victory ship completed a $2.5 million renovation program, sailed for a total of twenty-six hours, and then was relegated

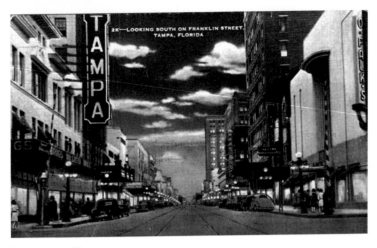

Downtown Tampa

The text on this postcard from about 1948 states that "Tampa is one of the most thriving and prosperous cities in Florida. Located at a junction of a network of excellent paved roads and railroads, it is within easy reach of every point of the state and has rightfully been named 'Florida's Convenient Center.'" *Courtesy of the Florida Photographic Collection.*

to the mothball fleet and scheduled for demolition. In 1998 it was removed from the list of ships to be eliminated and was sailed to Tampa in 1999 where it is now moored as a museum ship and memorial at 705 Channelside Drive, Berth 271. It is listed on the National Register.

JIM WALTER HOMES

This homebuilding business was started in Tampa in 1946 by Jim Walter with money he borrowed from his father. His first transactions, the purchase and sale of a home, made him a profit of $300. By the 1960s, the business expanded to the point where Walter was featured in major financial publications and the company's stock was listed on the New York Stock Exchange. The company diversified from its original activity of home construction to include coal mining, the manufacture of paper, ductile iron pipe, carpeting and marble products. Mortgage financing was added in 2001.

THE 1950S

FUN-LAN DRIVE-IN

This drive-in movie theater owned by Floyd Theaters opened for business at 2302 East Hillsborough Avenue on January 10, 1950. Its single-screen could be viewed by 700 cars, and the initial admission price was forty-eight cents to see Cary Grant and Ann Sheridan in *I Was a Male War Bride*. For children there was a playground and train ride.

A flea market was moved from the Skyway Drive-In Theatre in 1981 and renamed the Fun-Lan Swap Shop Flea Market. A second movie screen was added in 1985, and a third was added later that decade. Its fourth screen was erected in 2004.

WSUN

On Memorial Day weekend in 1953, WSUN Channel 38 began broadcasting in the Tampa Bay area. For nearly two years, it was the only local television station on the air.

WFLA

On February 14, 1955, WFLA television began broadcasting from a studio located at 905 East Jackson Street under

WFLA-TV

This photograph of the WFLA television studio was taken on April 5, 1955, less than two months after it began broadcasting from a tower located in Riverview. The first telecast was a live presentation of the Gasparilla Pirate Festival, and it has covered the event every year since. *Courtesy of the Florida Photographic Collection.*

general manager George Harvey Sr. WFLA was the first station in Tampa to broadcast in color and the first to have a color film lab. It also had the area's first videotape and remote airborne unit. It was renamed WXFL-TV in 1983 when its parent company, Media General, Inc., sold its WFLA radio station. The television station again became WFLA in 1989. It is Tampa's NBC affiliate.

ORGANIZED CRIME

Gambling was popular among the workers of Tampa, especially those in Ybor City who engaged in illegal bolita lotteries. The game of bolita was brought from Cuba by Manuel "El Gallego" Suarez during the 1880s. Typically, one hundred numbered wooden balls were placed in a bag, shaken and one was chosen. The winner, if any, was paid eight times the amount he bet. Often, the game was rigged by having more than one ball with the same number, increasing the chances that number would win. Sometimes a ball would be hollowed out and filled with lead, weighing it down to the bottom of the bag and making it easy to grab. Nevertheless, members of the worker class were drawn to the game because as little as a penny could be bet. By 1927 there were approximately three hundred bolita houses in Ybor City alone.

During Prohibition, bootlegging was also popular, and the profits from these activities supported several organized crime factions within the city. Its repeal and the increased enforcement of anti-prostitution laws pushed many criminals into bolita, which by the 1940s had become a multimillion-dollar business.

Tampa's first "crime boss" was Charlie Wall, son of Dr. John P. Wall. He was the undisputed head of Tampa's illegal gambling in the 1920s through the 1940s. Eventually, control over most of the organized crime in the city was consolidated by Santo Trafficante Sr. of Sicily during the 1950s. He died in 1954 as a result of cancer, and his place was taken by his son, Santo Trafficante Jr. He allied with crime families in New York and expanded the scope of illegal activities into the rest of the state and into Cuba.

University of South Florida

This photo was taken in 1960, the year the first classes were held. Depicted is the Administration Building named for John S. Allen and his wife, Grace. Dr. Allen served as the university's first president and designed the campus layout and curriculum. *Courtesy of the Florida Photographic Collection.*

The 1950s hearings led by U.S. Senator Estes Kefauver exposed the amount of crime that was present in Tampa, and its links with government officials. Charlie Wall testified against the local mob, and was found in 1955 with his throat cut from ear to ear, blunt trauma to the back of his head and nine knife wounds to the left side of his face. With the urging of the local newspaper, local politicians worked for decades to improve Tampa's image.

UNIVERSITY OF SOUTH FLORIDA

This university was founded on December 18, 1956, ground was broken on a former airfield in 1958, and classes for nearly two thousand students began on September 26, 1960. The school led by John S. Allen started with just five buildings. It was the first major state university in the country planned and built entirely during the twentieth century. It is also the first public university created to serve one of the state's expanding urban centers.

In 1965 the university added a campus in St. Petersburg and accreditation was granted. The student population passed 10,000 in 1967. During the following year, the University of South Florida became a member of the NCAA.

Busch Gardens

This 1980 photo of a boat ride at Busch Gardens shows a stage of its development which combined the earlier emphasis on natural scenery with the later thrill rides. This ride took tourists on a ride through the "Dark Continent" and included images and sounds which mimicked what one might expect to see in Africa. *Courtesy of the Florida Photographic Collection.*

A college of medicine was founded during the 1970s and Sarasota's New College became a part of the university. A graduate school was established during the 1980s, as was a campus in Lakeland and the H. Lee Moffitt Cancer Center and Research Institute. During the 1990s, the university continued to grow and earned a reputation as a major research school.

BUSCH GARDENS

This park opened on March 31, 1959, as a low-key attraction to supplement its brewery tours. It began with gardens similar to the original Busch Gardens which had operated in Arroyo Seco Canyon in Pasadena, California, from 1905 until 1937, around the home of Adolphus Busch. The focus in Tampa later shifted to bird shows and rides, and until Walt Disney World opened in 1971, Busch Gardens' Dark Continent was the state's leading tourist attraction.

Today, Busch Gardens is still a major tourist destination. Its rides include Edge of Africa, Rhino Rally, Kumba, Montu, Python, Gwazi, Scorpion and SheiKra. There are more than 2,700 animals to view, most in essentially natural habitats.

THE 1960S

LOWRY PARK ZOO

The first zoo in the city was located at Plant Park, between the University of Tampa and the Hillsborough River. Most of the animals on display were native to the area, such as alligators and raccoons, or were exotic birds that were housed in an aviary. As the original facilities became crowded, the zoo was moved to Lowry Park.

General Sumter L. Lowry Jr. in 1961 donated an eighteen-month-old elephant named Sheena, and that spurred on the zoo to undertake an expansion program. During the 1970s, animal habitats were shifted from cages to more natural settings. The Lowry Park Zoo Association was established in 1982 to raise it to the level of a first class zoological park.

In 1984 Design Consortium, Ltd., was hired to develop a twenty-four-acre master plan. New construction included the Free-Flight Aviary, administrative offices, a children's village and petting zoo, the Asian Domain and Primate World. The Zoo Association evolved into the Lowry Park Zoological Society, and the new and improved Lowry Park Zoo reopened to the public in 1988. Since that time, other facilities have been added to enhance it to a level that has resulted in its being named the number one family-friendly zoo in the United States. It also has the only licensed nonprofit manatee rehabilitation hospital.

Curtis Hixon Hall

In 1964 this six-thousand-seat indoor arena was built on an eighteen-acre site on the east shore of the Hillsborough River. It was a popular venue for rock concerts and basketball games. It was named after Curtis Hixon, a former druggist who served as mayor from 1943 until his death in 1956. It was razed in 1993. *Courtesy of the Florida Photographic Collection.*

MUSEUM OF SCIENCE AND INDUSTRY

In 1962 the county approved the establishment of a youth

museum, which became known as the Museum of Science and Natural History. In 1967 it was renamed the Hillsborough County Museum and expanded throughout the rest of the 1960s and 1970s. In 1982 a portion of its present building (now known as the East Wing) opened across the road from the University of South Florida at 4801 Fowler Avenue.

The museum began a seventeen-year plan of expansion in 1984, including construction of the West Wing, renovation of the East Wing, the addition of the Butterfly Garden and The Back Woods Nature Center. MOSI received accreditation from the Association of Science-Technology Centers and the American Association of Museums. MOSI is the only museum in the world to display two Diplodocus dinosaur skeletons together.

TAMPA STADIUM

In 1966 the Tampa Sports Authority spearheaded the construction of a 47,000-seat stadium at 4201 North Dale Mabry Highway at a cost of $4.1 million, on land that formerly was a hog farm. Tampa Stadium hosted its first National Football League game on August 10, 1968. After the Buccaneers football franchise was awarded in 1974, the end zones were filled in to bring the capacity to 72,000.

The stadium, since 1995 known as Houlihan Stadium for the restaurant chain owned

Tampa Stadium

Because of its shape, this stadium was nicknamed "The Big Sombrero." It was built on the site of a former hog farm and began as the home football field of the University of Tampa until 1974, when the school discontinued that sport. The stadium was demolished and replaced in 1998. *Courtesy of the Florida Photographic Collection.*

by the holder of the Buccaneers franchise, was used for games until 1998, when it was replaced by the 65,657-seat Raymond James Stadium, named for Raymond James Financial, the company which has paid for the naming rights through 2015. Tampa was the host city of Super Bowls in 1984, 1991 and 2001, and will be the site of the game in 2009.

THE 1970S

THE FLORIDIANS

In 1968 the American Basketball Association team known as the Muskies moved from Minnesota to Miami to become the Miami Floridians. After two seasons in Miami, they became simply the Floridians and played two more seasons, with several "home" games at Curtis Hixon Hall.

FRANKLIN STREET

In 1973 a five-block section of North Franklin Street was closed to vehicular traffic, with the expectation that foot traffic on a brick street would be attractive to shoppers and bring them back from suburban malls. After about a decade, it was obvious that the plan did not work. Most of the stores went out of business and were boarded up.

YBOR CITY

On August 28, 1974, the Ybor City Historic District was named a U.S. National Historic Landmark District. With 956 historic buildings in an area of 3,690 acres, it is bounded by 6th Avenue, 13th Street, 10th Avenue, 22nd Street and Broadway Avenue.

ROWDIES

Major League soccer arrived in Tampa in 1975 with the creation of the Tampa Bay Rowdies. It was the sixteenth franchise established by the North American Soccer League and the team won the first Soccer Bowl championship game by defeating the Portland Timbers by a score of 2–0. They also won five Eastern Division championships before the NASL terminated in 1984. The Rowdies also won two NASL indoor championships.

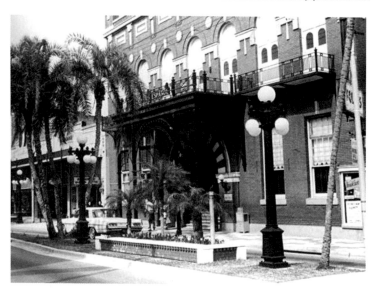

Ybor City

After the decline of the cigar industry and the high-crime era of the mid-twentieth century, much of Ybor City became an area that many avoided at night. After much effort and money, the neighborhood was transformed into a safe, beautiful and fun area with an active bar and restaurant scene. *Courtesy of the Florida Photographic Collection.*

Despite the demise of the NASL, the Rowdies continued as an independent team for two years, then joined the American Indoor Soccer Association for the 1986–87 season. In 1988 the team joined the American Soccer League, which became the American Professional Soccer League, and finally disbanded following the 1993 season.

BUCCANEERS

In 1976 the Tampa Bay Buccaneers began play in the National Football League, bringing Tampa into the world of major league professional sports. Although the team led by coach John McKay began poorly with a string of twenty-six losses (still an NFL record), they made it to the playoffs quickly in 1979. That year, the Buccaneers won their first of four division championships, and in 2002 they became the Super Bowl champions.

THE 1980s

BANDITS

The Tampa Bay Bandits of the United States Football League began play in Tampa in 1983. The team was coached by Steve Spurrier, starred quarterback John Reaves and made it into the playoffs in the

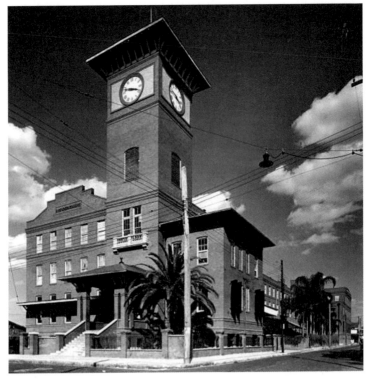

El Reloj

This cigar factory was given the nickname of El Reloj which means "The Clock" because of its clock tower that dominates its area. An interstate highway separates it from the larger portion of Ybor City, but it also affords thousands of drivers a quick look at one of the two fully functioning original cigar factories in Tampa. *Courtesy of the Florida Photographic Collection.*

final two of its three seasons. The Bandits folded when the league did, following the 1984–85 season.

WEST TAMPA

On October 18, 1983, the West Tampa Historic District was added to the National Register. It consists of 2,730 acres with 908 historic buildings and is bounded by Cypress and Ivy Streets and Fremont and Habana Avenues.

HYDE PARK

On March 4, 1985, the Hyde Park Historic District was designated as a U.S. National Landmark District. Roughly bounded by the Hillsborough River, Hillsborough Bay, Howard Avenue and Kennedy Boulevard, it covers 5,600 acres. Within the district are 1,264 buildings. The district was designated for its architecture, particularly for the period from 1875 through 1949. Styles included are Late Victorian, late nineteenth- and early twentieth-century American movements and late nineteenth- and twentieth-century revivals.

DAVIS ISLANDS

On August 3, 1989, the following buildings were added to the National Register as a Multiple Properties designation:

84 Adalia Street (house)
97 Adriatic Avenue (house)
36 Aegean Avenue (house)
53 Aegean Avenue (house)
59 Aegean Avenue (house)
124 Baltic Circle (house)
125 Baltic Circle (house)
132 Baltic Circle (house)
202 Blanca Avenue (house)
220 Blanca Avenue (house)
418 Blanca Avenue (house)
161 Bosphorous Avenue (house)
190 Bosphorous Avenue (house)
301 Caspian Avenue (house)
36 Columbia Drive (house)
200 Corsica Avenue (house)
16 East Davis Boulevard (Villa de Leon Apartments)
45 East Davis Boulevard (Palace of Florence Apartments)
115 East Davis Boulevard (Palmarin Hotel)
238 East Davis Boulevard (Burt Business Block)
100 West Davis Boulevard (house)
116 West Davis Boulevard (house)
131 West Davis Bouevard (house)

The 1990s

Storm

The Tampa Bay Storm was an original member of the Arena Football League in 1990. The team has won more league championships, known as the ArenaBowl, than any other franchise with victories in 1991, 1993, 1995, 1996 and 2003. The Storm plays its games in the St. Pete Times Forum.

Lightning

Tampa became a part of the National Hockey League with the creation of the Tampa Bay Lightning, which began play in 1992–93 with games

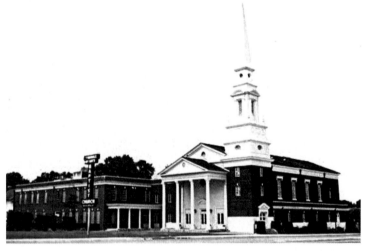

Seminole Heights Baptist Church

This is a pre-1980 photograph of the Seminole Heights Baptist Church with its tall white steeple. It is located in the center of the national historic landmark district, and is easily the most familiar building in Seminole Heights because of its location at the junction of heavily traveled Hillsborough Avenue and Interstate 275. *Courtesy of the Florida Photographic Collection.*

in Expo Hall. The next three seasons were played in the Thunder Dome, and thereafter the team's home ice has been the St. Pete Times Forum. The team name was chosen because the city of Tampa is known as the lightning capital of the world. In 2003 and 2004, Tampa Bay won division championships, and in 2004 it won the Stanley Cup.

SEMINOLE HEIGHTS

On August 5, 1993, the Seminole Heights Residential District was designated as a U.S. National Historic Landmark District. Its 325 historic buildings are located in an area bounded by Osborne, Florida, Hanna and Cherokee Avenues. The 1,700-acre district was selected for its Bungalow/Craftsman and Gothic Revival architectural styles, especially for construction during 1900 to 1949.

TAMPA HEIGHTS

On August 4, 1995, the Tampa Heights Historic District was added to the National Register. The two-thousand-acre area with 289 historic buildings is bordered by Adalee Street, Interstate 275, 7th Avenue and Tampa Avenue. It is deemed historic for its buildings constructed in the period from 1875 until 1949, including those exhibiting Bungalow/Craftsman and Queen Anne styles.

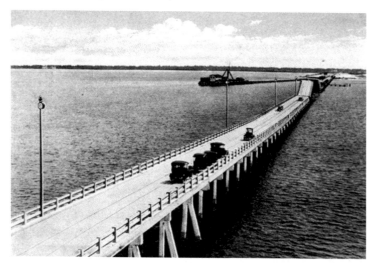

Gandy Bridge

This is an early image of the bridge that opened in 1924. During World War II, at the urging of U.S. Senator Claude Pepper, President Franklin Roosevelt exercised his war powers to eliminate its tolls so military personnel could more easily use it. The original bridge was replaced by another in 1956. *Courtesy of the Florida Photographic Collection.*

GANDY BRIDGE

On November 30, 1924, the $3 million Gandy Bridge over Tampa Bay opened, shortening the driving distance from Tampa to St. Petersburg by thirty-three miles. It was at the time the longest automobile toll bridge in the world, and was built by George S. "Dad" Gandy. It was supposed to be part of the streetcar route and tracks were laid along it, but streetcars never ran on them. The bridge was replaced in 1956.

In 1997 the 1956 bridge was scheduled for demolition, since an adjacent 2.6-mile bridge had opened. Plans included the saving of 1,500 feet of bridge at each end to serve as fishing piers, and the dumping of rubble into Tampa Bay to create an artificial reef. Funds of $6.7 million were allocated for the project.

The Committee to Save the Gandy was formed by citizens who wanted to save the old bridge for walking, jogging, bicycling, fishing and skating. The Florida Department of Transportation set June 19, 1997, as the date the demolition contract would be awarded. The committee had a petition drive and lobbied the governments of Pinellas and Hillsborough Counties and their municipalities in an attempt to take over ownership of the bridge. The two counties agreed to each accept ownership of half the bridge, making their final decision just seventeen hours before the demolition contract was scheduled to be awarded.

On December 11, 1999, the former Gandy Bridge reopened as the Friendship TrailBridge. The multiuse trail is expected to tie into other trails on the land such as the Pinellas Trail to connect with Picnic Island, Weedon Island and the Tampa and Hillsborough County Greenways.

HAMPTON TERRACE

On January 27, 1999, the Hampton Terrace Historic District, also known as the Hollywood Manor Subdivision, was designated as a U.S. National Historic Landmark District. Containing 304 historic buildings over an area of 1,150 acres, it is bounded by 15th Street and Hanna, Hillsborough and Nebraska Avenues. It was so designated for its architecture and engineering, chiefly for construction between 1900 and 1949.

The Twenty-first Century

North Franklin Street

On March 28, 2002, the North Franklin Street Historic District was designated as a U.S. National Historic Landmark District because of its architecture from the period of 1900 to 1924. Its eight buildings are located on thirty acres bounded by Florida Avenue and by Fortune, Tampa, Franklin and Harrison Streets.

Hillsborough County Courthouse

The first county courthouse, following the creation of Hillsborough County in 1834, was a log cabin. It may have been located at the southeast corner of Madison and Franklin Streets, and was burned down by the Seminoles in 1836. Another was erected on that corner in 1848 at a cost of $400. A third wooden courthouse was built on the same corner in 1855 at a cost of less than $5,000, and served the county for more than thirty years. That building was moved to Florida Avenue and became the city's first hospital.

In 1891–92, a large red brick courthouse was built and had a large silver "onion" dome similar to those atop the Tampa Bay Hotel, also designed J.A. Wood. It was torn down and replaced by a 525-room courthouse erected in 1952, which in turn was replaced by the present George E. Edgecomb Courthouse, which opened in 2003.

The land occupied by the 1952 courthouse had some

Hillsborough County Courthouse

From 1892 until 1952, this building served as the venue for Hillsborough County's judicial functions. This 1898 photo clearly shows the large silver "onion" dome which was similar to those atop the Tampa Bay Hotel. Architect J.A. Wood designed both buildings. *Courtesy of the Florida Photographic Collection.*

notable prior occupants. At the corner of Kennedy Boulevard and Jefferson Street sat the home of Judge Joseph B. Lancaster. He served as Tampa's first mayor, but he died in 1856 after serving in that position for only a few months.

Also located on the block was the Orange Grove Hotel, built in 1859–60 as the home of Indian fighter Colonel William B. Hooker. He arrived in Tampa during 1843 and became known as the "Cattle King" of South Florida, with an ownership of over 10,000 head. His two-story wooden home located in an orange grove at the corner of Madison and East Streets was used as Confederate headquarters during the Civil War, and was later converted to a thirty-three-room hotel which served as the social center of early Tampa. While living there, poet Sidney Lanier wrote *Florida Robins* and *A Florida Sun*. The building was moved to 806 Madison Street and during the 1950s was used as the Seaboard Railway office.

TAMPA BAY CENTER

In March of 2005, the large Tampa Bay Center mall located near the Raymond James Stadium, at the corner of Himes Avenue and Dr. Martin Luther King Jr. Boulevard, was torn down. It had opened in 1976, and its major stores included Burdines, Sears and Montgomery Ward. The mall was removed to make room for a training facility and team offices for the Tampa Bay Buccaneers football team.

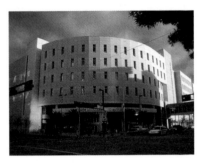

George E. Edgecomb Courthouse

This is the present Hillsborough County Courthouse, taking over from the 1952 building that served for over half a century. It is named for George E. Edgecomb, who in 1973 became Hillsborough County's first black judge. *Photo by the author.*

CIGARS

Tampa is no longer the cigar producer it once was, with hundreds of cigar factories and thousands of workers hand-rolling some of the most popular brands in the country. Few operating cigar factories remain, and several storefront operations continue to produce small numbers, largely to attract passersby into the store and for sale on the premises. Cigar-related images are still seen in certain portions of the city, but in most cases they are reminders of the area's history rather than indications of current activity.

Part II

STREET GUIDE

Following is a list of sites, historically important because of what was built there, what happened there or who lived there. Included are buildings and other features that still remain, plus a few others that are merely memories. Those that no longer exist are marked with asterisks.

This guide covers several historic Tampa streets, focusing on those in the neighborhoods of Ballast Point, Beach Park, Davis Islands, Downtown, Hyde Park, Palma Ceia, Palmetto Beach, Port Tampa, Seminole Heights, Sulphur Springs, Tampa Heights, West Tampa and Ybor City. They are grouped here according to their historical neighborhoods, although all are a part of today's Tampa. Most structures are private residences, commercial establishments or governmental buildings, closed to general public access. Although they may be enjoyed from the outside, grounds and interiors are not available without the owners' prior permission.

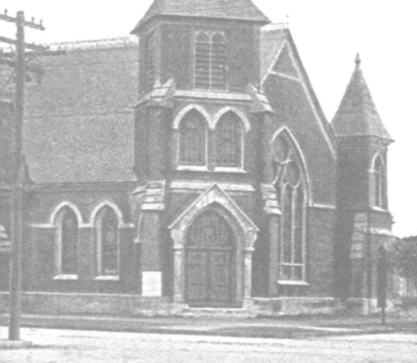

BALLAST POINT

BAYSHORE BOULEVARD

4607 BAYSHORE BOULEVARD

Home of Chester Chapin. A home was built here by 1892 for Chester W. Chapin, the owner of the Tampa Electric Company and the first Tampa streetcar line, which ended at the home's back door. Since there was no city water that reached this property, a 39,000-gallon cistern was constructed. Access to all rooms was by outside stairways until the 1930s, when then-owner Mrs. Broneer had a major modification made. The kitchen and servants' quarters, a small house attached to the main house by a trotway, was permanently joined and an inside stairway was built. The home was replaced by modern construction in the early 1980s.

4621 BAYSHORE BOULEVARD

Home of Wallace Stovall. On March 11, 1893, Wallace F. Stovall arrived in Tampa by train. Twelve days later, his first issue of the *Tampa Morning Tribune* was printed. He was sued by owners of the *Tampa Tribune*, a tri-weekly newspaper that had gone out of business, but the court ruled that so long as the former newspaper was not in publication at the time, Stovall could appropriate the name. Stovall was known by outsiders as miserly and by employees as generous, earning him loyalty during times of financial problems. Stovall himself occasionally put in twenty-hour workdays. It was built in 1909 with a Neoclassical Revival style and until 1915 was the home of L.T. Tousdale, the general manager of the Florida Brewing Company. It was added to the National Register in 1974.

BEACH PARK

A STREET

4611 A STREET

Home of Lambert Friederich. Also known as the Tampania House and the Kirkeby House, this one-story home was placed on the National Register in 1985. It was built in 1927 and is one of only five Tampa Bay–area homes built in the Prairie style. The use of stained glass is also distinctive.

KENNEDY BOULEVARD

4830 WEST KENNEDY BOULEVARD

Cammarata Cigar Co. This is one of Tampa's last cigar companies, and its brands include Bustillo, Cammarata, La Flor de Armando Mendez and Tampa Tropics.

DAVIS ISLANDS

ADALIA AVENUE

27 ADALIA AVENUE
Home of Frank Lyons. This 1926 house has a Mediterranean style with a
Spanish parapet and extensive balconies. It was the home of Frank
Lyons, owner of the Lyons Iron Works.

ADRIATIC AVENUE

116 ADRIATIC AVENUE
Home of Jack DeLysla. This house with the large square tower was built
in 1926 for Captain Jack DeLysla, publisher of *Southern Highways*
magazine.

AEGEAN AVENUE

31 AEGEAN AVENUE
Catholic Womens Club. This clubhouse was built in 1926 and was later
converted to a residence. It features interesting frieze work.

32 AEGEAN AVENUE
Home of D.P. Davis. This house, located across the street from D.P.
Davis' office, was likely his residence.

36 AEGEAN AVENUE
Home of Montanye Family. This home built in 1926 was the residence of
the advertising manager for Davis Islands and his family.

38 AEGEAN AVENUE
Home of John Fitzwater. Built in 1926, this was the residence of John
Fitzwater, who served as president of the Charles Bell Real Estate
firm.

ALBEMARLE AVENUE

53–55 ALBEMARLE AVENUE

Home of Roy Martin. This is an L-shaped Mediterranean-style home with a tower and balconies, built in 1927. It was the residence of Roy Martin, whose tile company supplied much of the building material for the Davis Islands Spanish-style homes.

61 ALBEMARLE AVENUE

Home of James Barrett. This stuccoed home was built in 1928 with a tower for James D. Barrett, the founder of the Poinsettia Dairy.

COLUMBIA DRIVE

36 COLUMBIA DRIVE

Home of Herbert Draper. This L-shaped home was built in 1926 with an open three-story campanile and transom windows. It was the home of realtor Herbert Draper.

40 COLUMBIA DRIVE

Home of Obert Washington. This home was built in 1926 for the chief salesman for the Davis Islands project, Obert Washington.

46 COLUMBIA DRIVE

Home of Frederick Bixby. Built in 1926, this was the home of Frederick Bixby, the advertising manager for George Merrick's development of Coral Gables.

81 COLUMBIA DRIVE

The Garden Center. The Davis Islands Garden Club was founded in 1936, then disbanded during World War II. It was reorganized and rechartered on April 26, 1946, and held meetings in members' homes until the present clubhouse was built in 1957.

115 COLUMBIA DRIVE

Marjorie Park. D.P. Davis donated this fifty-five-acre park to the city and named it after his deceased first wife. The gatehouse constructed in 1925 still stands. The park's marina includes seventy-eight wet slips and a public fueling dock.

154 COLUMBIA DRIVE

Roy Jenkins Pool. This recreational facility was built in 1928 as the Davis Islands Pool and was later renamed for Roy E. Jenkins.

Danube Avenue

124 Danube Avenue

Merrymakers Club. This two-story building erected in 1926 housed a young adults' club established in the early 1920s.

Davis Boulevard

16 East Davis Boulevard

Spanish Apartments. The asymmetrical maze of balconies and parapet roofs forms a small village around a courtyard fountain. It was constructed in 1925, and later was renamed as the Villa de Leon Apartments.

30 East Davis Boulevard

Administration Building. Built in 1925, this was used by developer D.P. Davis and his salesmen during the construction of Davis Islands. Each morning, Davis gave them and anxious newsmen a pep talk. In later years, it was used by the Sea-Born Day School.

43 East Davis Boulevard

Palace of Florence. M. Leo Elliott of Tampa designed this three-story apartment building version of Florence's Palazzo Vecchino. The features of the high square tower and the grand central stairway were conceived by Athos Menaboni.

115 East Davis Boulevard

Palmarin Hotel. This three-story hotel designed by Martin L. Hampton was built with a Mediterranean style in 1926. It features a three-entrance archway leading to a covered courtyard. It was once the home of the Casablanca Café, honoring actor Humphrey Bogart, who stayed here after filming *Key Largo*. It has also been known as the Davis Islands Motor Hotel, the Hudson Manor Hotel and the Hudson Manor Retirement Residence.

238 East Davis Boulevard

Bay Isle Commercial Building. This building has also been known as the Burt Business Block, and was completed in 1925 utilizing a design by M. Leo Elliott.

84 West Davis Boulevard

Mirasol Hotel. This eight-story resort was built in 1925, along with its backside marina basin and great arcade. In 1962 it was sold by Lykes Brothers, Inc., to A.B. Grandoff Sr., who rehabilitated the property, converted it to luxury apartments, and renamed it as the Davis Islands Towers. It was once known as "Tampa's Most Distinctive Address."

116 WEST DAVIS BOULEVARD

Home of D.P. Davis. This 1926 L-shaped Mediterranean-style home has been known as the residence of D.P. Davis, and his young widow after he disappeared. However, it is likely that it was owned by Davis' company for use by other company officials.

Downtown Tampa

Ashley Drive

400 North Ashley Drive

Rivergate Tower. This thirty-one-story office tower was built in 1986–88 and has been known as the 400 North Ashley Plaza and the NCNB Plaza. It was designed by Harry Wolf and the building's measurements are based on the Fibonacci series. Locals often refer to it as the "beer can building" because of its shape.

600 North Ashley Drive

Tampa Museum of Art. The museum was established in 1979 to provide a broad range of art-related experiences. Collections include Greek and Roman antiquities, twentieth century and contemporary art, and a variety of examples in between. It aims to display works in art forms of regional, national and international importance.

601 North Ashley Drive

Huntington Bank Plaza. This twelve-story bank building was originally completed with a beaux-arts style and brick façade in 1925 for Wallace F. Stovall. Two prominent elevator shafts were added during the 1960s. It was renovated and restored in 1998 at a cost of $4.5 million by a company that had purchased it that year for $2 million. It is also known as the Gold Bank Plaza.

1000 North Ashley Drive

The Times Building. This ten-story structure was completed in 1972 and houses the Tampa offices of the *St. Petersburg Times* newspaper.

Channelside Drive

401 Channelside Drive

St. Pete Times Forum. Formerly known as the Ice Palace, the land on which it sits was sold to the city in 1924 by author Rex Beach. It included an old Indian mound on which Confederate soldiers had

constructed breastworks during the Civil War. The land was called Rex Beach Park, but the city sold it in 1953. It is now the venue for hockey (19,758 seats), basketball (20,500 seats) and concerts and stage events (up to 21,500 seats). The 1996 facility was designed by Ellerbe Becket, Inc.

701 CHANNELSIDE DRIVE
Florida Aquarium. Since 1995, this water-themed attraction has amazed visitors with displays including Sea Hunt, Swim with the Fishes, Dive with the Sharks and Dragons Down Under.

ESTELLE STREET

1407 ESTELLE STREET
Booker T. Washington Elementary School. This school opened in 1925 on 3rd Avenue in Ybor City as Tampa's first black junior high school. Soon after, it expanded to include a high school. During the 1930s, principal Howard W. Blake convinced the state to consider it to be a standard high school, equivalent to others throughout the state. As part of the desegregation of schools in 1971, it was converted to a junior high, and then to a seventh grade center. It became an elementary school in 2005.

FLORIDA AVENUE (FORMERLY KNOWN AS MONROE STREET)

411 NORTH FLORIDA AVENUE
**Tampa Terrace Hotel.* Located here from 1926 until 1965 was the twelve-story Tampa Terrace Hotel.

507–09 NORTH FLORIDA AVENUE
Sacred Heart Catholic Church. This church was built in 1900–05 at a cost of $275,000. Sacred Heart was the first Roman Catholic church established on the west coast of Florida.

512 NORTH FLORIDA AVENUE
**Hillsboro Hotel.* The original Hillsboro Hotel was three stories tall and made of brick. J.L. Tallevast served as the proprietor. In 1912 it was replaced by a modern nine-story hotel with 320 rooms. Wings were added on the south side in 1916 and 1920. It was converted to offices in 1964 and condemned in 1979. In the hotel were the studios of WINQ radio, which began transmitting in the early 1960s with a middle-of-the-road format, then switched to talk radio, then country music and Christian rock, before the station moved to Seffner.

601 NORTH FLORIDA AVENUE

Post Office. This four-story structure designed by James K. Taylor was built in 1902–05 as the main Tampa post office and federal courthouse, and served as such until 1965. It is Tampa's oldest building erected for government purposes and was added to the National Register in 1974.

702–04 NORTH FLORIDA AVENUE

**YMCA.* The large building erected here in 1908 remained vacant for years following a fire during the 1970s, and was eventually torn down, leaving this parking lot.

801 NORTH FLORIDA AVENUE

Sam Gibbons Federal Courthouse. Formerly on this site was the Palmetto Hotel, from 1884 until about 1960. This courthouse was designed by Hellmuth, Obata and Kassabaum. Although it has seventeen stories, it is the height of a normal thirty-six-story building because its courtrooms have a ceiling height of sixteen feet. It opened in 1997.

902–04 NORTH FLORIDA AVENUE

Florida Avenue Hotel. This building was operated as the Florida Avenue Hotel beginning in 1923. Its first proprietors were Amos L. Morse and David Nixon.

905 NORTH FLORIDA AVENUE

Floridian Hotel. This eighteen-story hotel designed by F.J. Kennard and Son and owned by developer A.J. Simms was begun in 1925 and opened on January 15, 1927. At the time, it was the tallest building in Florida. Previously, the corner on which it is located was the site of the two-story Electric Service Company, which sold balloon automobile tires. The Floridan was a luxurious hotel into the 1950s, then provided less expensive lodging until it closed in 1987. It was added to the National Register in 1996.

1001 NORTH FLORIDA AVENUE

First United Methodist Church. A sanctuary was built here in 1968 for the First Methodist congregation, which was superceded by the present one, dedicated in 1983. Just to the north of the sanctuary is the Tom Henderson Memorial Chapel, constructed in 1948.

1119 NORTH FLORIDA AVENUE

**Goody Goody.* A diner was established here in 1929 and remained popular for decades. In its later years, there was no curb service, but the diner motif was preserved with a shiny interior, aluminum chairs, formica tables, a counter and green and yellow walls. Goody Goody sold its last hamburger on November 30, 2005.

Fortune Street

At the Hillsborough River

Fortune Street Bridge. A bridge was completed here in 1892 by Hugh C. Macfarlane, who then presented it to the city. It allowed easy access to his new two-hundred-acre subdivision in West Tampa. Macfarlane had considered entering the cigar manufacturing industry in that area as early as 1886, but had to wait until the bridge was built to have adequate access to attract development.

Approximately 300 East Fortune Street

**Saratoga Bar.* In 1939, located here was the Saratoga Bar, a popular hangout for winos and derelicts. That year, twenty-year-old William Franklin Graham Jr., known to all as evangelist Billy Graham, began a lifetime of worldwide evangelism by preaching to the men who were here. He had previously attended the Florida Bible Institute in Temple Terrace.

Franklin Street

201 North Franklin Street

One Tampa City Center. This thirty-eight-story office building was the tallest building in Florida from 1981 to 1984 and the tallest in Tampa from 1981 to 1986. It was designed by Welton Becket Associates. Previously on the site were a series of hotels beginning with the Almeria Hotel in 1886.

Approximately 400 North Franklin Street

**Giddens' Corner.* During the 1880s, the two-story building located here was the home of the boot and shoe store of Emery, Simmons and Emery. For many years afterward, this was known as Giddens' Corner because it was the site of the three-story building housing the Giddens Clothing Co.

411 North Franklin Street

Tampa Police Museum and Police Memorial. Tampa established a police force in 1886, consisting of six men. In 1895 one of its members lost his life in the line of duty and his name, along with about two dozen others, are displayed on a marble monument at this museum. Inside, there is a police cruiser and helicopter, as well as weapons, implements and other artifacts collected in over a century of Tampa law enforcement.

414–16 North Franklin Street

**First National Bank.* This was the site of First National Bank beginning in 1886. It is now part of the Lykes Gaslight Square.

514 NORTH FRANKLIN STREET

Commercial Hotel. This building opened as the Commercial Hotel operated by Mike Markes. It was renamed the New Commercial Hotel in 1913, and by 1917 the Rex Billiard Parlor was also located in the building. It was substantially remodeled to cover the brick facing and modernize the windows, housed the Madison Drug Store, then was owned by Walgreens.

606 NORTH FRANKLIN STREET

**Alcazar Theatre.* On May 26, 1911, the Alcazar opened with a single screen and a Greek Revival entrance. It stopped showing movies in 1921, as more elegant modern theaters drew its patrons away. The building sat vacant until 1928, when Mangel's Ladies Wear opened a store in it. It closed in 1978 and was soon absorbed into the Maas Brothers Department Store. Maas closed in 1991 and the buildings were abandoned. The former Alcazar was condemned in 2000. By 2006 the razing of the entire city block was completed to make room for the construction of condominiums.

610–16 NORTH FRANKLIN STREET

**Maas Brothers Building.* An eight-story building was erected here in the early twentieth century to house the large Maas Brothers Department Store, which remained in business until 1991. The building closed that year and was purchased in 1998 by a company that planned to restore it, but decided in 2004 that such a move would not be economical. It constituted a major portion of the Jackson Block, demolished in 2006 to make room for condominiums.

611–33 NORTH FRANKLIN STREET

Exchange National Bank. This was the home of Exchange National Bank, established in 1894. The tall annex to its two-story building was designed by John Trice, who organized it with Edward Manrara and Peter O. Knight. When the ten-story building was erected, it was the tallest building in Tampa. It later became the home of Solutions General Contractors.

616 NORTH FRANKLIN STREET

**American National Bank.* In 1917 the Bank of Commerce opened on this corner. It was renamed American National Bank two years later. Also in the building was Twomey's Millinery. Eventually, the building was absorbed into the Maas Brothers store.

655 NORTH FRANKLIN STREET

Franklin Exchange Building. This twenty-two-story tower was completed in 1966, and passed the Floridian Hotel as the city's tallest. It was designed by the MacEwen Group, Inc. On the side of the building is a large mural entitled *Mona Lisard.*

701 North Franklin Street

Citizens Bank and Trust Company. Citizens Bank was founded in 1895 by
John Trice and opened for business on October 7, 1895. Its new
home at this location was completed in 1913 at a cost of $600,000.
In 2007 the building was occupied by the Lydian Bank and Trust.

709–11 North Franklin Street

Tampa Theatre. John Eberson designed this nine-story building with
Italian and Spanish Renaissance Revival stylistic elements. Built in
1926, it is an example of his "atmospheric theatre" design concept
and the auditorium is extremely ornate. During the 1930s in the
same building were the dentistry office of Dr. Steigerwald on the
second floor and J.M. Merritt's Hale Drug Co. store on the first
floor. The building was placed on the National Register in 1978.
Presently, it shows movies and plays in a Hispanic-Latin setting.

719 North Franklin Street

The Hub. During the 1930s, Walgreens Drug Store occupied this store.
It is now a bar and liquor store.

801 North Franklin Street

Woolworth Building. This Art Deco building was constructed in 1927 and
was the home of F.W. Woolworth and Co. It has a terra cotta front
and a much simpler rear of brick. The rear of the store and offices
were in the adjacent three-story brick building fronting on Florida
Street, constructed in 1920. By 2007 the building was abandoned.

811 North Franklin Street

Kress Building. This building was erected in 1929, utilizing a design
created by New York architect G.E. McKay, replacing a 1908
building. It was one of over 250 dime stores in the chain founded by
Samuel Kress in 1896. He collected art and his buildings generally
showed artistic details, the ones from this era having an Art Deco
appearance. It was one of the last major building projects in Tampa
before the Great Depression. It shows a Renaissance Revival style,
and it is constructed of brick with glazed and polychrome terra
cotta on two sides. Its skeleton was claimed to be fireproof, and
the floors were made of concrete poured in place. The first floor
housed the store, and the upper floors were offices. It was added to
the National Register in 1983. By 2007 it was abandoned.

815–19 North Franklin Street

J.J. Newbury Building. This three-story building was designed by B.M.
Frenze with a Moderne style and was built by R.E. Clarson, Inc.
It also housed the Haddad Department Store. In 2002 it was
added to the National Register. It replaced the Curry Building
(also known as the Schulte-United Building), a five-story red brick

building that in 1910 included tenants such as the Economical Drug Store and the W.J. Chambers Shoe Company. It also replaced the Poinciana Theatre, located at the Florida Avenue end of the building, which during the 1910s was advertised as the most attractive and coolest theater in the South. In 2007 Newbury's is abandoned.

901 NORTH FRANKLIN STREET

W.T. Grant. A 1937 fire which did $200,000 damage destroyed the downtown W.T. Grant store on this corner, which was then rebuilt. A later use of the building has been as a nightclub.

1100–04 NORTH FRANKLIN STREET

Albany Hotel. Previously on this site was the Buckeye Hotel. In 1926, this building was constructed of brick. Later, it was remodeled with a beautiful Mediterranean Revival appearance. In 2004, it was determined that it would be cheaper to tear it down and build something new than it would be to restore it. By 2007, it was still standing, boarded up and fenced.

1211–27 NORTH FRANKLIN STREET

Arlington Hotel. Recently remodeled for retail space, this brick building served as the Arlington Hotel beginning in 1913. It first proprietors were John D. and Catherine Rushing.

222 SOUTH FRANKLIN STREET

Tampa Bay History Center. This six-thousand-square-foot facility within the Convention Center Annex preserves and interprets the cultural heritage of the people of Tampa and Hillsborough County. Permanent and traveling exhibits are open to the public, and are planned to move in 2008 to a new facility to be built at Cotanchobee-Fort Brooke Park along the Garrison Channel.

333 SOUTH FRANKLIN STREET

Tampa Convention Center. This building includes 600,000 square feet of space for exhibits, meetings and events. Outdoor areas can accommodate events for up to 7,500. It is the home of many conventions, trade shows and special events.

GOVERNOR STREET

1202 GOVERNOR STREET

St. James Episcopal Church. This church was built in about 1921. As of 2007, it was vacant and owned by the city's housing authority. It and its surroundings are within the Central Park Village Housing Project.

1401 Governor Street

St. Peter Claver School. Built in 1929, this is the oldest parish school within the Diocese of St. Petersburg. It is also the oldest black school of any kind still serving students in Hillsborough County.

Harrison Street

504–06 Harrison Street

St. Paul African Methodist Episcopal Church. The upper portion of the church, that most visible from the outside, was completed in 1917 of red brick. It completed the church building begun in 1906 with a lower portion partially below the ground level.

India Street

1225 India Street

Meacham Early Childhood Center. This facility is named after Christina Meacham, a teacher for forty years and the first black female principal of a Tampa school. Her father was Robert Meacham, a leader of the post-Reconstructionist period.

Jackson Street

401 Jackson Street

SunTrust Financial Center. Formerly known as the SunTrust Tower and the SunTrust Financial Centre, this thirty-six-story office tower was designed by Cooper Carry.

Jefferson Street

1215 North Jefferson Street

Greater Bethel Missionary Baptist Church. This congregation was formed in 1893, when its members pitched a tent and called it Ebenezer Missionary Baptist Church. It was later known as Bethel Baptist Church, and then Greater Bethel Missionary Baptist Church. The present building was erected in 1948–49 adjacent to the walled-in cemetery, and at that time it was the second-tallest building in Tampa. It had a sound system which was loud enough to be heard two miles away, making it easy to let the neighborhood know of services or deaths within the congregation.

2314 North Jefferson Street

Good News Baptist Church. This church was built in 1925 as the Tampa Gospel Tabernacle. During 1938, when it was the Alliance Church,

one of its associate pastors was Billy Graham, who later earned a worldwide reputation as advisor and evangelist.

KENNEDY BOULEVARD

101 EAST KENNEDY BOULEVARD
Bank of America Plaza. This forty-two-story office tower was designed by HKS, and at 577 feet became the tallest building in Tampa when it was completed in 1986.

201 EAST KENNEDY BOULEVARD
Fifth Third Center. While it was known as SouthTrust Plaza, this twenty-story office tower was sold to the California State Teachers Retirement System in 2000, and again to Terrace Tower Group USA in 2005, the same year it was renamed as Fifth Third Center.

315 EAST KENNEDY BOULEVARD
City Hall. This Eclectic-style building was erected in 1915 to serve as the home of Tampa's government. It includes a clock nicknamed Hortense, which weighs nearly three thousand pounds. The city hall was added to the National Register in 1974.

500 EAST KENNEDY BOULEVARD
Scottish Rites Building. This building was designed by M. Leo Elliott and was constructed with textured brick in 1921. It later became offices for attorneys.

508 EAST KENNEDY BOULEVARD
Masonic Lodge. Tampa's first Masonic lodge was organized in 1850, making it the oldest Masonic lodge on the west coast of Florida. A two-story frame lodge building was constructed in 1852, replaced by a three-story brick building. In 1865, future governor Henry Mitchell had two of its members expelled for serving as members of the Union army. The lodge moved to this site in 1912 and held its meetings in a two-story wooden building. This Florida Mediterranean Revival style building was designed by M. Leo Elliott, and was built in 1928 of brick and glazed ornamentation on the walls and ceilings to be a composite of three medieval Italian cathedrals. The lodge room is supposed to be a replica of the interior of King Solomon's temple. The building was added to the National Register in 1986.

601 EAST KENNEDY BOULEVARD
Hillsborough County Center. In 1853 John T. Givens of South Carolina built his home on this corner. A carpenter, he became Tampa's first undertaker after getting into the business by constructing coffins. In 1913 a new building opened on the corner as the Knights of Pythias Hall, with a two-

story brick tower. That building in 1925 became the headquarters of the Greater Tampa Chamber of Commerce. It and the Stovall Professional Building were replaced by the twenty-eight-story Hillsborough County Center, originally known as the Two Mack Center and purchased by Hillsborough County in 1992. It was renamed in 2000 as the Fred Karl County Center to honor a former county commissioner.

MADISON STREET

215 MADISON STREET

Lykes Gaslight Square. On this site previously sat the office of Lykes Brothers, a company that was chartered in 1910 by the seven sons of Dr. Howell T. Lykes. It engaged in the land, shipping, cattle, planting and citrus businesses.

220 MADISON STREET

220 Madison Building. This twelve-story building was completed in 1964. It contains a variety of offices and retail spaces.

MARION STREET

505 NORTH MARION STREET

St. Andrew's Episcopal Church. This sanctuary was erected in 1904–07. It was designed by Miller and Kennard with a Mediterranean Revival style.

701 NORTH MARION STREET

**DeSoto Hotel.* Located here was a 150-room hotel constructed in 1892–93 by Walter Parker and Captain R.F. Webb. It was designed by J.A. Wood and, unlike many Florida hotels, was open year-round. It was demolished in about 1955, and on the site now stands the Robert L. Timberlake Jr. Federal Building.

1308 NORTH MARION STREET

Museum of African Art. Housed here is the Barnett-Aden Collection of African-American Art, depicting the history, lifestyle and culture of black Americans. With one piece dating back to 1851, it is one of the oldest collections of its kind, and includes works by Edward Bannister, Romare Bearden and Henry Tanner.

NEBRASKA AVENUE

601 SOUTH NEBRASKA AVENUE

Union Station. This is the train station which served Tampa's railroad needs beginning in 1912. It closed in 1982 and was reopened in

1998 as an Amtrak station for the Silver Star line. The station was added to the National Register in 1974.

SCOTT STREET

1112–16 SCOTT STREET

Paradise Missionary Baptist Church. About 1912, this church was built at a cost of $15,000 for the Allen Temple AME Church. Its pastor at the time was Reverend J.J. Heath and construction was supervised by Reverend Thomas J. Williams. The Allen Temple congregation moved to 2101 Lowe Street in about 1990, and Paradise Missionary Baptist Church acquired the building in 2000. It is known for its large towers with set-off buttresses and intricate details and craftsmanship.

1212 SCOTT STREET

Ebenezer Missionary Baptist Church. This church building was erected in 1922 for the city's first congregation of black Seventh-Day Adventists. It was acquired by the Ebenezer congregation in 1970. This church has been an advocate of community outreach programs and has led the movement for the designation of it and other nearby churches as local landmarks, which would facilitate capital improvements by providing exemptions from tax.

TAMPA STREET

100 NORTH TAMPA STREET

AmSouth Building. This forty-two-story office tower was constructed in 1990–92, and when it was new, it was Tampa's tallest building. Its exterior is Rosa Dante granite from Spain and pewter-tinted glass.

400 NORTH TAMPA STREET

Park Tower. This thirty-six-story office tower was completed in 1972 and was Tampa's tallest building from then until 1981. At the northeast corner of the site formerly sat the Stovall Building, a seven-story building developed by Wallace F. Stovall in 1920.

TWIGGS STREET

201 TWIGGS STREET

Florida Citrus Exchange. In 1919 this two-story brick building was erected to house the Florida Citrus Exchange, an organization founded in 1910 to be a selling agency controlled by citrus growers. It now houses restaurants and retail stores.

800 TWIGGS STREET

Hillsborough County Courthouse. This modern courthouse was built in 2000–03 at a cost of $43 million.

TYLER STREET

212–14 TYLER STREET

Allen Hotel. The top two stories of this three-story brick building were operated as the Allen Hotel beginning in 1912. Its first proprietor was Celia M. Hoffman, and a bakery was located on the first floor. Today, it is the home of Cutro's Music Shop.

W.C. MCINNES PLACE

1010 W.C. MCINNES PLACE

Tampa Bay Performing Arts Center. This 300,000-square-foot complex is the largest performing arts center in the Southeast. Constructed for $57 million, it includes the 2,500-seat Carol Morsani Hall, the 1,000-seat Ferguson Hall, the 300-seat Jaeb Theater, the 250-seat TECO Energy Foundation Theater and the 130-seat Shimberg Playhouse.

ZACK STREET

412 ZACK STREET

First Presbyterian Church. The First Presbyterian Church, organized in 1854, has had its sanctuary at this location since 1900, when it moved from 310 Zack Street.

720 ZACK STREET

Tampa Firefighters Museum. Included within its permanent and traveling exhibits are many photographs depicting the early days of firefighting in the Tampa Bay area.

808 ZACK STREET

Fire Station One. This is the headquarters of the Tampa Fire Department, established in 1895 with just twenty-two firefighters to cover five fire stations throughout the city.

858 ZACK STREET

Old Union Depot Hotel. Also known as the Union Hotel and Café, this building was added to the National Register in 2000. It was built in 1912 and operated until 1921. Its first proprietor was Mrs. George Gibbs, the wife of the owner.

Hyde Park

Bayshore Boulevard

901 Bayshore Boulevard

Home of Watson Dorchester. This is a two-story Spanish-style masonry home built in 1912. It was the residence of Watson E. Dorchester, a Tampa doctor and realtor.

907 Bayshore Boulevard

Home of Isaac Maas. Built in 1923–24 with a design of Franklin O. Adams, this was the home of Isaac Maas who, with his brother, founded Florida's largest chain of department stores. Isaac came to the United States from Germany in 1877 and in 1885 established a clothing and merchandise store in Ocala. Three years later, he came to Tampa to enter business with his brother in the Maas Brothers department store.

1005 Bayshore Boulevard

Home of Frank Bentley. This is a Georgian style masonry house built in 1924. It was the home of Frank Bentley, president of Bentley-Grey Dry Goods.

1101 Bayshore Boulevard

Home of J. Brown Wallace. This mansion was constructed in 1914. It was the residence of Dr. J. Brown Wallace, who had a real estate office in the Citizens Bank Building.

1201 Bayshore Boulevard

Home of George Booker. This three-story brick house was built on three-fourths of an acre in 1924. Francis J. Kennard designed it for George and Ruth Trice Booker. Mr. Booker was the president of the building materials firm of Booker and Company, Inc.

1501 Bayshore Boulevard

Home of Alonzo Turner. This clapboard house was built in 1910 for Alonzo G. Turner, a partner with the Knight, Thompson and Turner law firm.

1503 BAYSHORE BOULEVARD

Home of Giddings Mabry. This home was built in 1925 for Giddings E. Mabry, who came to Tampa in 1901 and served as city attorney in 1910–13, county attorney in 1917–23 and a board member of the Old People's Home and the YMCA. He was a member of the law firm of Mabry, Reaves and Carlton, with an office in the Stovall Building.

1815 BAYSHORE BOULEVARD

Home of William Ferman. In 1923 this house was designed by Frank Winn and built for William F. Ferman, who moved to Tampa from Minneapolis in 1863. He opened an automobile agency in 1902, the first in Tampa, which became the Ferman Motor Company. He was also one of the organizers of the Greater Tampa Chamber of Commerce. The home was loaned to the University of Tampa to be used as a home for its president.

1925 BAYSHORE BOULEVARD

Home of William Webb. This house was built in 1923 for William I. Webb. He was the president of the J.M. Martinez and Company cigar manufacturing firm in West Tampa.

BREVARD AVENUE

707 SOUTH BREVARD AVENUE

Home of Justus Schreiber. This dark brick and shingle–style home was constructed in 1913 for Justus M. Schreiber, the secretary of the Bayshore Development Company. It has been described as resembling an English cottage.

725 SOUTH BREVARD AVENUE

Home of Pat Whitaker. This home built in 1914 blends Gothic and Spanish styles and features a steeply pitched gable, a stone chimney and an octagonal tower on the waterfront side.

BUNGALOW TERRACE

701–19 BUNGALOW TERRACE

Bungalow Terrace. This block is a mini-subdivision consisting of nineteen bungalows developed by Alfred Swann and Eugene Holtsinger for winter residents in 1913–16. The first one sold for $4,500. Most are "airplane" style homes, facing each other across sidewalks with parking on rear alleys. The terrace was shaded with a long wooden pergola from 1918 until 1924.

CRESCENT PLACE

UNIVERSITY OF TAMPA CAMPUS

Old School House. This Greek Revival private school building was constructed near the bank of the Hillsborough River in 1855 by General Jesse Carter for his daughter, Josephine, and other children who lived nearby. Although Henry B. Plant bought this land for hotel construction, the school was allowed to remain. It features a pedimented tetrastyle portico and is covered with clapboarding. For a time, the building was used as an apothecary for the Tampa Bay Hotel, and the Parks Department used it as a tool shed. In 1932 palm trees were planted on each side of the schoolhouse to commemorate the two hundredth anniversary of the birth of George Washington. The schoolhouse was placed on the National Register in 1974.

UNIVERSITY OF TAMPA CAMPUS

McKay Auditorium. This large building was erected in 1925–26 behind the Tampa Bay Hotel as the City of Tampa Municipal Auditorium. After the 1960 death of Donald B. McKay, a publisher of the *Tampa Times* who served as mayor in the 1910s, 1920s and 1930s, the facility was renamed in his honor. The auditorium was gutted by a 1993 fire, rendering it unusable. Local computer entrepreneur John Sykes donated $10 million to the University of Tampa, which used most of the money to expand and refurbish the auditorium. It reopened in 2000, and was rededicated as the John H. Sykes College of Business.

DAKOTA AVENUE

902 DAKOTA AVENUE

The Seville. Francis J. Kennard designed this six-story apartment building, originally known as the Bailey-Erler Apartments, which was constructed of masonry in 1925. During the 1920s, it was highly regarded for its basic design.

DELAWARE AVENUE (FORMERLY KNOWN AS 12TH AVENUE)

801 SOUTH DELAWARE AVENUE

Home of William Himes. This three-story brick Greek Revival-style home was built in 1911 for lawyer William F. Himes, a partner in the law firm of Whitaker, Himes and Whitaker. It has a Palladian dormer window, stone and brick detailing, and symmetrical massing of windows.

902 SOUTH DELAWARE AVENUE

Home of Leo Weiss. This two-story English Tudor home was designed by Christopher Robinson and was built in 1929 by W.E. Harris. It was the residence of Leo Weiss, president of Anchor Construction Company.

903 SOUTH DELAWARE AVENUE

Home of Howard Macfarlane. This clapboard-exterior house was built in 1923. It was the home of Howard Macfarlane, son of the founder of West Tampa and a partner in the Macfarlane and Penningill law firm. Macfarlane also served as president of the Tampa Community Chest.

DeLEON STREET

705 DeLEON STREET

John B. Gorrie Elementary School. Originally located at 702 Platt Street, the original portion of the school dates to 1889. In 1915 it was renamed from the Hyde Park Grammar School to honor the medical doctor who invented the first ice-making machine. The school was renovated in 1977, modernized in 1995 and obtained a new media center in 2002.

DeSOTO AVENUE

1304 DeSOTO AVENUE

DeSoto Building. The Bayshore Baptist Church began on March 29, 1926, with 105 charter members. The construction of a four-story cream-colored brick educational building at the east corner of Howard, Dekle and DeSoto Avenues in 1927 was largely due to the efforts of Dr. George Hyman. The congregation sponsored the establishment of the Macfarlane Park Church in 1939 and the Manhattan Baptist Mission in 1954. In 1958 the congregation moved to a new sanctuary at 3111 Morrison Avenue. The former church building is now an office building known as the DeSoto Building.

GRAND CENTRAL AVENUE

408 GRAND CENTRAL AVENUE

First Church of Christ, Scientist. This congregation organized in 1904. Its early meetings were held in the Tampa Beach Building and the Mechanics Building, both in downtown Tampa. A church was constructed in 1913 at the corner of Henderson and Florida

Avenues. This Greek- and Byzantine-style church with large Corinthian columns, constructed of concrete and pressed brick, was completed in 1926. Its first architect was W.S. Schull, but when he died with the building incomplete, Franklin O. Adams took over the project.

HORATIO STREET

617 HORATIO STREET

Home of Doyle Carlton. This frame house built in 1920 was the home of Tampa attorney Doyle Carlton before he was elected as governor of Florida in 1929. Prior to that, he served as a state senator from 1917 until 1919 and as the city attorney from 1925 until 1928.

701 HORATIO STREET

Federated Woman's Club. This Mediterranean-style building was erected in 1926 for the woman's club and little theater group. It was a social center for Hyde Park's youth. It is also known as the Friday Morning Musicale.

HYDE PARK AVENUE

245 HYDE PARK AVENUE

Home of Peter Knight. This Queen Anne– and Colonial Revival–style cottage was built in 1887 by Colonel Peter O. Knight, who had moved to Tampa from Fort Myers the year before. A lawyer, he served as the president of the Tampa Electric Company from 1924 to 1946. He also organized in 1892 the city's first electric street railway company, the Tampa Suburban Railway. He is credited with starting the Exchange National Bank and the Tampa Gas Company. This home was the site of social activities for soldiers and supporters in the days preceding the Spanish-American War. This building in 1977 became the headquarters of the Tampa Historical Society, founded in 1971.

305 HYDE PARK AVENUE

Home of Thomas Taliaferro. This two-story Classical Revival–style frame house was designed by Grable, Weber and Groves of St. Louis, and was built in 1890 for banker Thomas C. Taliaferro and his wife, Stella M. Taliaferro. Its significant features are balustraded balconies and the pedimented portico supported by paired Ionic columns. The Taliaferro family founded the First National Bank, and Thomas served as its head from 1903 to 1927. This house was added to the National Register in 1974 and later housed the Center for Women.

315 HYDE PARK AVENUE

Home of Selwyn Morey. Built in 1905, this Classical-style home was the residence of Selwyn R. Morey, the president of the Morey and Company Cigar Company with a factory in Ybor City. He also founded the first resort on Pass-A-Grille Beach, known as Morey Beach. The house was converted to business use during the 1970s.

350 HYDE PARK AVENUE

First Christian Church. This church, affiliated with the Disciples of Christ, organized in 1900. The present sanctuary designed by the R.H. Hunt Company was constructed in 1926 at a cost of $250,000.

KENNEDY BOULEVARD

302 WEST KENNEDY BOULEVARD

First Baptist Church. This church facility covers three blocks with several buildings. The Education Building has classrooms, a dining room and kitchen, business offices and a choral practice room. The Carlton Activities Building has the Preschool, Youth, Banner and Activities Ministries. In the Culbreath Chapel are held smaller worship activities. The 320 Office Building includes local businesses. The Baptist Manor is a senior citizen home. The large sanctuary dates to 1925.

401 WEST KENNEDY BOULEVARD

University of Tampa. Formerly known as Tampa Junior College when it was located in the Hillsborough High School building in 1931-33, this university's main building is the former Tampa Bay Hotel, constructed in 1888-91 by Henry B. Plant. The Student Center is located on the former site of the 1894 Tampa Bay Hotel Casino, which had a huge ballroom on a removable floor which covered an indoor swimming pool. It served as Tampa's first movie house and burned on July 20, 1941. The university's Student Library is located in what used to be the hotel's grand dining room.

428 WEST KENNEDY BOULEVARD

Falk Theatre. This theater was built as the Park Theatre in 1927 and opened in 1928. It housed both live shows and movies into the 1930s and became part of the Wometco chain in 1949. The movie theater closed and was renamed the David Falk Memorial Theatre in 1962, after a member of the family which owned O. Falk's Department Store on Franklin Street. Restored in 1981, it is part of the University of Tampa and is used as a one-thousand-seat lecture hall and venue for drama department productions.

Magnolia Avenue

301 Magnolia Avenue

Fire Station No. 3. This two-story brick building was erected in 1911 while W.M. Matthews was the fire chief. It was responsible for the area north to and including the Tampa Bay Hotel. In 1997–98, it was converted to a private residence.

607 Magnolia Avenue

Home of Isbon Giddens. This 1910 Prairie-style house was the residence of Isbon B. Giddens and his wife, Ruby. Mr. Giddens was the president of the H.G. Clothing Company and had been a member of the first Tampa city council in 1897. It was later the home of the Hyde Park Cosmetic Surgery Center.

Morrison Avenue

1301 Morrison Avenue

Home of Harry Watrous. This large clapboard house was built in 1911 with five fireplaces. Designed by M. Leo Elliott and contractor B. Frank Walker, it was the home of Harry J. Watrous, the secretary and manager of the Henry and Knight Company. He acquired the site from his father, who lived next door.

1307 Morrison Avenue

Home of James Watrous. This house was built in about 1878 with railroad track rails sunk into the footings, reinforcing the concrete that ran up to the second floor so that the house would withstand hurricane winds. This was the home of pioneer fruit grower James M. Watrous, who erected it behind an old log cabin he purchased when he moved from Michigan in 1876. The house was later used as the rectory of St. John's Episcopal Church. It has been substantially modified by the addition of stucco and a large porch.

Newport Avenue

710 South Newport Avenue

Home of M. Leo Elliott. This house was the residence of well-known architect M. Leo Elliott, who designed many of the buildings along the west coast of Florida including the Tampa City Hall and Sarasota High School. This Dutch Colonial–style house was built in 1921. Elliott had moved to Tampa from New York in 1907 and partnered with Bayard C. Bonfoey. That partnership dissolved in 1917 and M. Leo Elliott, Inc. was founded. In 1946, the firm name was changed to Elliott and Fletcher, and Elliott retired in 1954.

716 SOUTH NEWPORT AVENUE

Home of Henry Leiman. M. Leo Elliott designed this U-shaped Prairie-style home, built in 1916. It features an enclosed raised patio and a hipped roof with eaves, and is built of stucco over a wooden frame. Henry Leiman came to Tampa in 1894 to open a branch of the William Wicke Company. In 1906, he established the Tampa Box Company with five acres in Ybor City and six on the Hillsborough River, planted with imported Cuban cedar trees which were used in the manufacture of cigar boxes. This house was a center of social activity during the 1920s and was added to the National Register in 1974.

717 SOUTH NEWPORT AVENUE

Home of Laura Overton. This two-and-a-half-story home, faced with clapboard, was built in 1911 for widow Laura E. Overton. It features a large dormer projecting from near the top of the hipped roof.

721 SOUTH NEWPORT AVENUE

Home of Harry Hamner. Benjamin F. Walker built this two-story clapboard home in 1921–22 for attorney Harry C. Hamner. It was designed by Frank Winn.

845 SOUTH NEWPORT AVENUE

Home of Owen Lowther. This Queen Anne–style house was built in 1912 and was the home of Owen H. Lowther, Tampa's largest dealer in naval stores.

847 SOUTH NEWPORT AVENUE

Home of B. Roy Hinson. In 1927 this large home was built of yellow brick in an Italian villa style. The massive porch is supported by imposing columns.

850 SOUTH NEWPORT AVENUE

Home of William Morrision. Built in 1885, this is the oldest house in Hyde Park. It has an Italianate style and was once surrounded by orange groves. The homemade foundation blocks are reinforced by trolley rails. This was the home of William A. Morrison, and this portion of Hyde Park was known as Morrision's Grove. It was later the home of state Attorney General Thomas Watson.

901 SOUTH NEWPORT AVENUE

Home of Grenville Henderson. This Greek Revival–style home with beveled glass was built in 1910. Grenville T. Henderson—a realtor, state senator and manager of the Tampa Real Estate and Loan Association—lived there.

ORLEANS AVENUE

809 ORLEANS AVENUE
Home of John Anderson. M. Leo Elliott and contractor A. Van Eyck designed this clapboard house, which was built in 1916. It was the residence of John G. Anderson Jr., the secretary-treasurer of the Tampa Coal Company.

824 ORLEANS AVENUE
Home of Donald McKay. This clapboard house with Corinthian columns was built in 1922 for Donald B. McKay. At age fourteen, he began as a printer for the *Tampa Tribune*, and published it as the *Tampa Times* from 1893 until 1923. He served as mayor in 1910–20 and 1928–31. He was the county historian from 1949 to 1960 and founded the Hillsborough County Historical Commission.

PLANT AVENUE

304 PLANT AVENUE
Home of Currie Hutchinson. This Second Empire–style brick home was built in 1908 by local merchant and city councilman Currie J. Hutchinson. The house features tall Corinthian columns on the large porch and a high mansard roof. It was later converted to an office building by Tampa Preservation, Inc. The bricks left over from the construction of this house were used to build the one at 602 South Boulevard. This has also been known as the Pi Kappa Phi fraternity house and was placed on the National Register in 1977.

315 PLANT AVENUE
Home of Louis Spafford. This Colonial Revival–style house was built in about 1880 for O.J. Spafford, and it was inherited by Louis J. Spafford, an owner of the Gunby, Spafford and Company insurance firm. The Tampa Woman's Club used this as its clubhouse from 1922 until 1971.

332 PLANT AVENUE
Home of Marshall Field. This 1891 house began as a fishing lodge for civic leader Marshall Field and was converted into a residence by Albert Johnson. He and his wife, Fannie M. Johnson, owned the lumber firm of Johnson-Cole Company. This was later the home of Bernice F. Bullard, president of the Hillsborough Grocery Company.

333 PLANT AVENUE
Home of Sumter Lowry. This three-story clapboard home was built in 1895 for Sumter de Leon Lowry, a city councilman. Lowry came to

Tampa from York, South Carolina, to open an insurance firm. He organized the Commission Government Club which worked to get a commission form of city government, and later served as a city commissioner. He ran for the office of governor during the 1940s and helped start St. Andrew's Episcopal Church and the Lowry Park Zoo. The house is now used for law offices.

341 PLANT AVENUE

Home of James Anderson. This two-and-a-half story Colonial Revival–style house was built in 1898 for James B. Anderson, a banker. Architect Francis J. Kennard designed it. It is constructed of brick and Stone Mountain granite, and is wrapped by a veranda with Ionic columns and a turned balustrade. It has six fireplaces (one in a bathroom) and a ballroom on the top floor. Later, it was owned by the Frank family. The house was added to the National Register in 1982.

PLATT STREET

500 PLATT STREET

Hyde Park United Methodist Church. In 1900 Reverend Henry Hice and twenty-nine charter members founded this church. Early services were held in a furniture store at the intersection of Hyde Park Avenue and Cleveland Street. This land was bought and a small wood-frame church was built for $1,400 and used from 1901 until 1907. It was moved to the rear of the lot when a new church was built in 1907 for $24,000, plus $6,000 for furnishings. That sanctuary was remodeled in 1953 and the fellowship hall and chapel were added the following year. The church was substantially renovated and rededicated in August of 2003.

SWANN AVENUE

705 SWANN AVENUE

Art Center. This building was constructed in 1899 as the Hyde Park Grammar School and then served as a hot lunch center while the school was known as Gorrie Elementary School. In 1968 the building was converted to an art center known as the Tampa Realistic Art Center, and later was known as the Old Hyde Park Art Center.

1005 SWANN AVENUE

Woodrow Wilson Middle School. This is oldest middle (junior high) school building in Tampa, having been built in 1915. It opened with 10 teachers and 229 students under the leadership of principal J.R.

Monahan. The $40,000 building was designed by D.F. Hagy and built by Logan Brothers and was expanded by the addition of wings in 1920, physical education and art buildings by 1928 and additional space in 1958. After completion of a $2.4 million renovation, the junior high school was rededicated in 1987. It became a middle school in 1992.

WILLOW AVENUE (FORMERLY KNOWN AS 15TH AVENUE)

800 SOUTH WILLOW AVENUE
Home of Angel Cuesta Sr. This craftsman style bungalow was built in 1912 and was the home of Angel Cuesta, founder of Cuesta-Rey and Company. It was later owned by Curtis Hixon.

901 SOUTH WILLOW AVENUE
Home of Angel Cuesta Jr. This two-story rough stucco house was built in 1921 and was the residence of Angel L. Cuesta Jr., the treasurer of Cuesta-Rey and Company.

Palma Ceia

Bay to Bay Boulevard

3723 Bay to Bay Boulevard
Palma Ceia United Methodist Church. In 1946 this church was organized by navy chaplain Paul J. Wagner, and a small congregation held its first service on Easter that year. Early services were held in the Palma Ceia Theater (which later became the Palma Ceia Masonic Lodge) on MacDill Avenue. A multipurpose building was completed in 1948. A sanctuary designed by Frank Patterson was built in 1951–53.

Bayshore Boulevard

2629 Bayshore Boulevard
Fred Ball Park. A major feature of this park is the Palma Ceia Spring, a popular swimming spot from the early days. A fountain there is engraved with the date "1906." A large Venetian swimming pool was constructed behind the spring about 1928, but was eliminated when the flow from the spring became insufficient to keep it filled. During the 1980s, the Tampa Garden Club spent more than $12,000 to improve the surrounding grounds, including the erection of a gazebo. Today's park is named for a member of the local government for twenty-four years and executive secretary of the West Coast Inland Waterway Commission, who in 1942 headed a movement to have the county purchase the spring.

3319 Bayshore Boulevard
Academy of the Holy Names. This Catholic school was founded in 1881 and moved to this location in 1928.

FERDINAND AVENUE

3205 FERDINAND AVENUE

Roosevelt Elementary School. Built in 1925, the school is named for Theodore Roosevelt. According to legend, the school's campus was used as a camp for Roosevelt and his Rough Riders as they awaited deployment to Cuba at the beginning of the Spanish-American War. The building was designed by Bayard C. Bonfoey.

HIMES AVENUE

2415 SOUTH HIMES AVENUE

Plant High School. This school opened in 1927 and is named for Henry B. Plant, the developer of the Tampa Bay Hotel and the Plant System of transportation. A bronze plaque was erected at the high school in 1987 to commemorate Henry Plant's centennial of progress in Tampa. The school consistently ranks on *Newsweek*'s list of the top one hundred high schools in the country. The Plant Panthers won their first state football championship on December 9, 2006.

SAN CARLOS STREET

3013–15 SAN CARLOS STREET

LeClaire Apartments. Fred J. James designed this masonry vernacular apartment complex that was completed in 1926. It consists of two two-story "mirror image" buildings connected by a passage on the second floor. The arcade is covered with stucco and each second floor features a full porch. It was added to the National Register in 1988.

Palmetto Beach

Corrine Street

2618 Corrine Street

DeSoto Elementary School. This red brick school across the street from DeSoto Park was designed by C. Frank Galliher and constructed in 1925 with a Spanish style, including tile and a terra cotta entranceway. In 1946 a cafeteria was added. It was originally called East Tampa Elementary School (which was in existence by 1900) and was later given its present name. It replaced a wooden 1913 building which was damaged by a severe 1921 storm.

Harper Street

2214 Harper Street

Home of Jose Escalante. This two-story home was constructed in 1906 for Jose Escalante, the general manager of Jose Escalante and Company, a cigar company that moved to Ybor City from New York. He was formerly the foreman at the Cornia factory of the Cuban-American Manufacturing Company.

Stuart Street

2601 Stuart Street

DeSoto Park. In 1898 this park became one of Tampa's seven campsites for soldiers preparing to sail to Cuba for the Spanish-American War. Later, it became a popular site for tourists to camp, and the Tin Can Tourist Club was organized there in 1919.

22ND STREET

110 SOUTH 22ND STREET

Home of Agnes Granger. This two-story bungalow, built in about 1910 for Agnes Belle Granger, was sold in 1918 to Alonzo J. White, superintendent of the Tampa Water Works.

202 SOUTH 22ND STREET

Jose Escalante Cigar Factory. This building was erected in 1893 by the Vicente Guerra Cigar Company and the Tampa-Palmetto Beach Railroad Line. The three-story structure was used from 1910 until 1940 by the Jose Escalante and Company. For a time, it was also the home of the Diaz Havana Cigar Company.

402 SOUTH 22ND STREET

Salvadore Rodriquez Cigar Factory. This building erected in about 1898 was the home of Garcia, Pando and Company. In 1930 the Berriman Brothers, after selling their cigar company in Ybor City, opened a new one in this building. In later years, the plain building with a small portico and plain façade was the factory of MacLean Industries and then Pilgrim Permacoat, a manufacturer of marine and industrial coatings.

26TH STREET

201 SOUTH 26TH STREET

Vicente Guerra Cigar Company. This three-story cigar factory was built in 1899 for the Vicente Guerra Cigar Company. From 1910 into the 1940s, it was occupied by Guerra V. Diaz and Company owned by Joseph Guerra. During the 1940s, it was shared by Tampa Tiger Cigars, the Haas Cigar Company and John Marrian Cigars. It served as navy barracks and a training facility during World War II. In the 1970s, it was occupied by the V. Guerrieri Cigar Company.

PORT TAMPA

COMMERCE STREET

4902 COMMERCE STREET

First Bank of Port Tampa City Building. In 1924 the First Bank of Port Tampa City opened at the northwest corner of Ingraham and Juniata Streets, with James G. Yeats as its president. Two years later, he moved the bank to a new building on this corner, constructed of Italian marble at a cost of $125,000. The bank closed on July 17, 1929, reopened on August 24, 1929, was robbed on February 26, 1932, and closed for good in 1933. The building was bought by the Toffaletis, who operated the Toffaleti Brothers Grocery and General Merchandise Store in it until 1954. The bank vault was converted to use as a refrigerator. The business was sold in 1954 to Ernie Toffaleti and V.T. Clark, who later moved it to another location. The bank building sat vacant for many years and then was renovated to be the Port Tampa City Library (dedicated as such on June 14, 1998), with the upstairs conference room named for James G. Yeats.

DeSOTO STREET

6823 DeSOTO STREET

Home of Henry Johnson. This Masonry Vernacular home was built in 1885 with a Spanish style, second-story balcony and a flat roof. The Plant Steamship Company built it and other one-story homes for workers, with front and back porches. In 1893 the home was acquired by Norwegian seaman Captain Henry L. Johnson, who remodeled it by removing the balcony and adding a New England–style hipped roof and front and side balustraded porch. Johnson had the first automobile in Port Tampa in 1901, and used it to take malaria patients to Tampa during a major outbreak. He caught the disease and died. This home was placed on the National Register as the Johnson-Wolff House in 1974.

6914 DeSoto Street

Port Tampa United Methodist Church. This church building was erected in 1894 by Northern Methodists and was called the Port Tampa Mission, especially for the use of workers in the area who were laying the railroad line from downtown Tampa. Its first pastor was Reverend J.H. Michler. The building was also used by congregations of Baptists, Episcopalians, Presbyterians and Southern Baptists. In 1902 the Port Tampa Methodist Church purchased the building from the Northern Methodists.

7111 DeSoto Street

Home of the McKinney Family. When this house was built in 1897, it was the only one in Port Tampa with a main entrance at a forty-five-degree angle to the street. That made some of the rooms six-sided. Originally, the house had four entrances.

FITZGERALD STREET

Approximately 6900 Fitzgerald Street

**Home of James Fitzgerald.* Captain James W. Fitzgerald, superintendent of the Plant Steamship Company and an early promoter of Port Tampa, lived at this location. Like many other Egmont Key pilots, he preferred a two-story frame home with high ceilings and extensive porches upstairs and downstairs. He had one here which fit that description, but it burned down in 1931.

IDAHO STREET

4910 Idaho Street

Mount Zion AME Church. This church was founded in 1889, and its first sanctuary opened in 1907 at the corner of Kissimmee and Richardson Streets. Its first pastor was Reverend J.H. Johnson. The present church building opened at this location in 1943, after the congregation moved from Trask Street. An annex was constructed in 1992.

INGRAHAM STREET

4916 Ingraham Street

Fire Station. This fire station was built in 1961 at a cost of $16,862.50. It replaced one built on Kissimmee Street in 1894 for $50. That wooden one was sold in 1961 for $25.

INTERBAY BOULEVARD

8306 INTERBAY BOULEVARD

First Baptist Church of Port Tampa. This congregation organized on
November 25, 1901, with eleven charter members. Until about
1905, it held its services in the First Methodist Church, then erected
its own building. The present sanctuary dates to 1959.

KISSIMMEE STREET

APPROXIMATELY 4915 KISSIMMEE STREET

**Brick Corner.* On this corner was located the Davis Building, the site
of Port Tampa's first city council meeting on June 30, 1893. In
the building was the office of C.E. Hoadly and R. Bowen Daniel,
who was chosen to be the first mayor of the town. This was Port
Tampa's main business district, known as the Brick Corner. Roy
Davis bought the building to be used as a dry goods store, then
renamed it as Davis' Corner. In it was the Rinsley Drug Store,
then a restaurant operated by Thomas Gomez. Beginning in about
1927, the Gomez family operated Tommy's Place in it for about
twenty-five years.

7101 KISSIMMEE STREET

Fitzgerald Building. This two-story structure was one of only two business
buildings (the other being the Brick Corner) to survive Port Tampa's
devastating fires of 1908–10. For a time, this was the post office. It
was a small store when Albert F. Delbaugh bought it from G.O.
Buie, then enlarged it and moved the Keystone Market here from
Davis' Corner. Delbaugh closed the store in 1940.

LOIS AVENUE

6311 SOUTH LOIS AVENUE

Robinson High School. This school opened in 1959 and is named for
Thomas Richard Robinson, who arrived in Hillsborough County
as a teacher in 1917.

MONTGOMERY AVENUE

4704 MONTGOMERY AVENUE

Lanier Elementary School. This school opened in 1959 and is named for
American poet Sidney Lanier.

4716 MONTGOMERY AVENUE

Monroe Middle School. This school opened in 1957, and in 1991 became
the city's first junior high to convert to a middle school.

SHAMROCK STREET

6821 SHAMROCK STREET

Home of W.H. Mudge. This home was built in 1893, wrapped with
verandas. It was soon acquired by Dr. Roland F. Altee, who won
it in a poker game. The same year, it was purchased by Dr. W.H.
Mudge for fifty dollars. Mudge was the Port Tampa city physician
in 1905 and its mayor from 1913 until 1915.

SHERRILL STREET

7218 SHERRILL STREET

St. Mark Missionary Baptist Church. This church organized in 1892 with
Reverend Dukes as its first pastor. Its first sanctuary was donated
by the First Advent Christian Church and moved to this location.
It was remodeled in 1905 and replaced by the present sanctuary in
1961.

WEST SHORE BOULEVARD

6902–08 WEST SHORE BOULEVARD

Hanks' Corner. In about 1920, this brick building, which also has an
address of 8612–16 Interbay Boulevard, was erected by H.J. Hanks
to replace the Warner Building which was located on this corner.
The new structure included a store and filling station and was called
Hanks' Corner. It later housed Keeton's Drug Store, which opened
on September 15, 1939. The filling station was enclosed in about
1945 and converted to a restaurant, then became a beauty parlor
and barbershop.

7110 WEST SHORE BOULEVARD

West Shore Elementary School. The school erected here in 1926 began as
West Shore High School. Later, it became a junior high and then an
elementary school. Before the school was built, what was here was
the Old Printery, also known as the Graham Lottery Building. Built
in 1893 for $48,000, it housed the country's largest manufacturer of
lottery tickets. The lottery had moved here after it was chased out
of Louisiana. The winning numbers were drawn in Honduras, then
printed here. The operation was closed by the federal government
in January of 1895, and the town leased the building to the St.

Louis Catholic Benevolent Association of New Orleans for use as a Catholic school. During the Spanish-American War, it was used as a supply base and then was returned to use as a private school until 1906. The building then served as a public school until it was razed in 1926 to make room for the present school building.

Seminole Heights

Central Avenue

4702 Central Avenue

Memorial Middle School. This school was constructed in 1925 and served as a junior high, an adult education center and then as a middle school. It underwent a major renovation in 2000 and was rededicated on March 31, 2001.

5000 Central Avenue

Hillsborough High School. In 1885 this school was established on Franklin Street with nineteen students and one teacher in a room over a livery stable as the first public school in the county. During 1889 it printed the state's first high school newspaper. In 1906 Hillsborough High School moved into a $5,000 two-story wooden school at the corner of Jefferson and Estelle Streets. In 1911 it moved to a $60,000 masonry building at the corner of Highland and Euclid Avenues, and that same year it produced the state's first high school yearbook. At the time, it was the most modern and best-equipped school in Florida. The present large red brick school for two thousand students was built in 1927–28, using the Gothic Revival design of Francis J. Kennard. Walls, spires and buttresses framing stained-glass windows are decorated with cast stone. The stained-glass windows in the auditorium depicting Euclid, Einstein and others were added during the 1950s.

5103 Central Avenue

St. Paul Lutheran Church. This property was the site of a farmhouse and orange grove until the church purchased it in 1927. This church building was begun 1930 and completed in 1950. The original brickwork of the previous farmhouse is preserved in back of the sanctuary. The building is known for its colorful stained-glass windows, and in 1988 a major refurbishing project was undertaken.

5810 Central Avenue

Seminole Heights Garden Center. Also known as the Seminole Community Center, this city-operated facility is a popular venue for weddings, corporate retreats and business meetings.

6111 Central Avenue

Seminole Heights United Methodist Church. This church designed by local architect Frank Winn was constructed in 1927 with a modified Gothic Revival style. It has three stories and is made of yellow brick. It features a steeply pitched gable roof, triangular parapet and three tiers of steps that lead to the main entrance. The building also has pilasters resembling two-story buttresses, which are topped by details of cast concrete. The congregation began a major historic restoration project in 2001.

6201 Central Avenue

Seminole Heights Elementary School. This school, when it opened in 1915, was located at the southeast corner of Central and Hanna Avenues, the present site of the Seminole Heights United Methodist Church. It was moved across the street to its present location in 1922.

Curtis Street

808 East Curtis Street

Home of William Curtis. This two-story home was built with a Dutch Colonial style in about 1906, as one of the first residences in Seminole Heights. It was the home of nurseryman William E. Curtis. It is also known as the John F. Durack House and was added to the National Register in 1987.

Florida Avenue

5103 North Florida Avenue

Seminole Theater. In the early days of talking motion pictures, this theater showed first-run films for ten cents. When it opened in the 1920s, it had an elaborate marquee announcing the current movies. It has since been replaced by a much smaller movie board and is the home of Praise Cathedral.

Osborne Avenue

400 West Osborne Avenue

Broward Elementary School. This school is named for Napoleon Broward, who served as Florida's governor beginning in 1904. The school was designed by Frank Dunham and opened in September of 1927.

SULPHUR SPRINGS

NEBRASKA AVENUE

8029 NORTH NEBRASKA AVENUE

Springs Theatre. In 1938 this three-hundred-seat theater was built with an Art Deco style, and was part of the resort and shopping area serving the Sulphur Springs swimming area. Later, it was converted to the Springs Theatre Recording Studio for audio and video recording, soundtrack scoring, audio mixing, audio editing and production.

TAMPA HEIGHTS

AMELIA AVENUE

509 EAST AMELIA AVENUE
Home of Wilbur Hall. The design of this home shows a variation on the Late Victorian style, having an L-shape, a clapboard exterior and a pitched roof. It was built in about 1909 for postman Wilbur L. Hall.

302 WEST AMELIA AVENUE
Home of Adolph Katz. This is a one-story Mediterranean Revival style house built in about 1927, made from golden brick with stucco being used only for decorative accents. The roof is made from green tile and the chimney is double-vented. Windows have a variety of wood casement combinations. Adolph and Fannie Katz owned a dry goods store on 7th Avenue in Ybor City known as "El Gatito" by the local residents, and had a reputation for offering distinctive fabrics. After Adolph died in 1945, Fannie continued to live in the house until 1969.

AVON AVENUE

3305 AVON AVENUE
Robles Park. This park was known as Adams Park until 1928, when it was renamed to honor Joseph P. Robles, a pioneer who had his homestead here. He was born in Spain and jumped ship in 1832 in St. Marys, Georgia, and moved to Florida where he took part in the Second Seminole War. He married Mary Ann Garrison and they homesteaded land on the west coast of Florida in the 1840s, then moved to Tampa in 1850. They grew oranges, avocado pears and chestnuts and manufactured salt at Rocky Point along Old Tampa Bay. When he was approached in 1864 by thirty Union soldiers in boats, he hid either inside or behind a salt kettle or trees until the soldiers came ashore. Helped by a shotgun, he shouted orders to other armed men, who he pretended were hiding nearby and convinced the soldiers to surrender. Robles marched them to the Orange Grove Hotel where he turned them over to Confederate officials.

CENTRAL AVENUE

1901 CENTRAL AVENUE

Friendly Missionary Baptist Church. In 1918 this building became the home of Schaarai Zedek, a Liberal Jewish congregation. It moved to another building during the mid-1920s, and this became the Hebrew Free School. Later occupants included the Christian Fellowship and the Friendly Missionary Baptist Church.

2003 CENTRAL AVENUE

Home of J.N. Nutt. This rectilinear design two-story frame house with clapboard siding was built during the late 1890s. In 1899 it was occupied by J.N. Nutt.

2007 CENTRAL AVENUE

Home of Paul Lalane. This one-story wood clapboard home was built with a rectangular box design in 1902 for solicitor Paul B. Lalane.

2008 CENTRAL AVENUE

Home of Charles H. Moorhouse. This single story house was built in 1904 with a Greek Revival appearance. Its first occupant was Charles H. Moorhouse of the Williams and Moorhouse grocery store.

2708 CENTRAL AVENUE

St. James House of Prayer. When black cigar workers from Key West (and from Cuba before that) were not allowed to worship in the white St. Andrew's Episcopal Church, they gathered in each other's homes for services by 1891. That year, they built their first sanctuary on India Street and Reverend Matthew McDuffie served as their first priest. In 1892 the congregation started an educational academy, later known as the St. James Parish School. In 1922 the congregation built this sanctuary designed by Louis A. Fort. It is made from rubble stone dredged from the Hillsborough River and donated by Harry P. Kennedy. St. James Episcopal Church in 1996 merged with the House of Prayer to form the St. James House of Prayer Episcopal Church. This building was added to the National Register in 1991.

COLUMBUS DRIVE (FORMERLY KNOWN AS MICHIGAN AVENUE)

305 EAST COLUMBUS DRIVE

Lee Elementary School of Technology. This school was established as the Michigan Avenue Grammar School. In 1943, Michigan Avenue became Columbus Drive and the school became Robert E. Lee Elementary School. It was renovated in 1989 and converted in 1993 to be the county's first elementary magnet school, now known as

Lee Elementary School of Technology, with a focus on computers, video production and other technical subjects.

509 EAST COLUMBUS DRIVE

St. Paul Pentecostal Church of God. El Bethel Primitive Baptist Church was founded in 1899, and in 1921 had this brick sanctuary built. Later, El Bethel moved to 6611 15th Street and this became the home of St. Paul's.

105 WEST COLUMBUS DRIVE

Home of Arthur Turner. This two-story frame house built in 1911 shows elements of both Late Victorian and Neo-Colonial styles. It was the residence of Arthur F. Turner, who served as the president of Triumph Mills in downtown Tampa, and later as the general secretary of the YMCA. The house was substantially altered when it was converted to a duplex.

201 WEST COLUMBUS DRIVE

Home of James Clarke. Built during the late 1890s, this was the home of grocer James D. Clarke who owned a store at 1101 North Florida Avenue. The house originally had a Victorian style with a frame-covered driveway. In 1936 the house was converted into the filling station of Theodore R. Koestline. Later, it was the home of Don's Auto Service and then Avelar's Body Shop.

202 WEST COLUMBUS DRIVE

Home of Charles Pippen. This home with a Queen Anne façade was built by 1903 with a wraparound veranda and a hipped roof. It was the home of Charles R. and Ida Pippen, who lived in it from its construction until 1958. Mr. Pippen was involved in real estate and owned the C.R. Pippen Dry Goods store located at 916 North Franklin Street.

315 WEST COLUMBUS DRIVE

Villa Madonna School. In 1936 this school was established by the Salesian Sisters of St. John Bosco to educate the young girls (and later, the boys) of working-class families of Tampa. Two years later, prominent Tampa Heights resident Alicia Neve willed her home to be used for the school. The large modern campus presently serves over five hundred students, many from inner-city neighborhoods.

FLORIDA AVENUE

1805 NORTH FLORIDA AVENUE

Palm Avenue Baptist Church. This congregation formed in 1900 and erected this building in four stages from 1901 to 1912. The back

auditorium was completed in 1912 and the educational front section was rebuilt and remodeled in 1957. Prior to the erection of the church, Dr. Hiram J. Hampton owned and operated the Tampa Heights Sanitarium at this location. It was regarded as one of the most extensive hospitals of its type in Florida. His letterhead advertised him as a physician and surgeon for whom chronic diseases were a specialty. He claimed to cure rupture and piles and "positively cure" cancer. His office was on the electric trolley line, or he could be reached at telephone number 90.

1910 NORTH FLORIDA AVENUE
Fire Station No. 5. The first fire station on this site was built during the 1890s. In 1925 another was built as a reproduction of the prior design. Its five second-story windows, end windows and arches are identical to the original. The two fire engines housed here were responsible for the area from 7th Avenue to Dr. Martin Luther King Jr. Boulevard, and from the Hillsborough River to Nebraska Avenue.

2201 NORTH FLORIDA AVENUE
First Congregational Church. On October 28, 1885, the First Congregational Church formed downtown and dedicated its sanctuary in the name of early pioneer Obadiah H. Platt in 1906 when the surrounding land was still an orange grove. In 1956 the First Congregational Church moved to this location. In 1976 the congregation moved out and the building became the home of the Polish-American Democratic Club.

3302 NORTH FLORIDA AVENUE
Old Tampa Children's Home. In 1887 Carrie Hammerly moved to Tampa and five years later began caring for abandoned and orphaned children. She purchased a home at 502 Washington Street for $3,000. In 1892 the Children's Home of Tampa was founded. This former location of the Tampa Children's Home was built in 1922. It currently takes care of children who lack permanent homes or families at 10909 Memorial Highway. Also known as the Good Samaritan Inn, this building was placed on the National Register in 1999.

3515 NORTH FLORIDA AVENUE
Sacred Heart Academy. This school building opened in 1931 as the Jesuit parish school of Sacred Heart Catholic Church, constructed on grounds of eight acres. It covers pre-kindergarten through eighth grade.

FRANKLIN STREET

1621 NORTH FRANKLIN STREET

Rialto Theater. This building was constructed of brick in 1926, based on the design of F.J. Kennard and Son. It served the performing arts until the 1940s with 375 seats, and later became an auto repair shop. After 2000, it was considered for use once again as a professional theater, since the proscenium, fly house and balcony were still in existence in the empty structure.

HIGHLAND AVENUE

2330 HIGHLAND AVENUE

Park Villa. When this two-story Mediterranean Revival–style structure was built in 1925, it was known as the Park Villa and included nine apartments and three businesses. Since the streetcar looped around the park, the businesses in the Park Villa offered services and goods to streetcar commuters. Originally, the businesses were a confectionery, a textile shop and the Community Gift and Needlework shop. Later, the occupants of the Park Villa included barbers, grocery stores, dressmakers, drugstores and, in the 1930s and 1940s, the Mayfair Beauty Salon. A much later commercial tenant was the Serralles Real Estate Group.

2704 HIGHLAND AVENUE

D.W. Waters Career Center. This three-story masonry block building replaced a previous building, which had been constructed as the first high school building in Hillsborough County. The 1911 replacement cost $60,000. The first section was designed by William Potter and M. Leo Elliott designed the 1920 addition. The building was the home to Hillsborough High School and later to Jefferson High School, and now is used for vocational and technical education programs. To make the conversion, it was necessary to replace about 80 percent of the interior of the 90,000-square-foot building. Students served by the facility attend eight different Tampa high schools.

MASSACHUSETTS AVENUE

2915 MASSACHUSETTS AVENUE

Graham Elementary School. This school was built on 4.5 acres during 1922 and was named for Benjamin C. Graham, a principal and county school superintendent.

Mitchell Avenue

1806 Mitchell Avenue

Home of Herman Porter. This two-story house was built with a square plan during the late 1890s. It likely was first occupied by Herman P. Porter, president of the Caruthers Produce Company.

Ola Avenue

3412 Ola Avenue

Woodlawn Cemetery. This was the second major cemetery created in Tampa, opening in 1888 and being platted in late 1895. It had picturesque vistas and meandering paths, consistent with the late nineteenth-century development of rural cemeteries. Adjoining it to the south was Potter's Field and on the east by the Schaarai Zedek Cemetery. The cemetery includes sections for Union (twenty-four graves) and Confederate (thirty-one graves) veterans and two large Italian sculptures atop crypts for Dr. Hiram J. Hampton and his wife, Emma. Because of a dispute he had with city officials, Dr. Hampton had the seated sculptures erected with their faces turned away from downtown Tampa.

Palm Avenue

212 East Palm Avenue

Home of Wallace Stovall. This was an early home of Wallace F. Stovall, founder and president of the Tribune Publishing Company and editor of the *Tampa Morning Tribune.* It was built in 1895 and was the Stovall home from then until 1909, when the family moved to 4621 Bayshore Boulevard. This home was then converted to a duplex.

400 East Palm Avenue

Home of Facundo Arguelles. This Neocolonial-style home with a compact rectangular plan was built in 1905–06. It was first owned by cigar manufacturer Facundo P. Arguelles of the firm of Arguelles, Lopez and Brother, with a factory located at the corner of 21st Street and 15th Avenue. The home served as the headquarters for visiting Cuban dignitary Juan Pumariega when he came to Tampa in 1909 for the opening of the Centro Asturiano. Later owners included Angelo Massari and his family.

405 East Palm Avenue

Home of Calvin Barnard. News dealer Calvin B. Barnard had this Victorian style home built in 1906 with hipped and gabled roofs. Later owners included the Spenuso family.

407 EAST PALM AVENUE

Home of Nevin McLeran. When this home was built in the late 1890s, it was the easternmost home on Palm Avenue. It belonged to Nevin M. McLeran, a bookkeeper for the C.B. Witt Grocery.

602 EAST PALM AVENUE

Faith Temple Baptist Church. This 1923 brick sanctuary was purchased by the Faith Temple Baptist Church from the Tampa Heights Presbyterian Church in 1964. In 2006 the Faith Temple congregation moved to 2910 Orient Road.

209 WEST PALM AVENUE

Home of Isaac Gardner. This home was built in 1924 for Isaac Gardner Sr., who came to Tampa in 1905. Businesses he owned included the Royal Palm Lounge, the Palace Drug Store and the Georgette Hotel. He was a co-founder of the Central Industrial Insurance Company, now known as Central Life Insurance. The two-story wood-frame Colonial Revival–style home was designed by R.B. Gambier. It was added to the National Register in 2003.

PARK AVENUE

212 WEST PARK AVENUE

Home of William Hunter. William Hunter was born in Illinois in 1857, studied law in Tennessee and came to Florida to practice law in 1882. After ten years near Dunedin, he moved to Tampa and partnered with E.R. Gunby and served as Tampa's city attorney. From 1902 to 1914, he was a bankruptcy referee and he also served as the president of The Florida Bar and the local bar association. William and his wife, Dora, lived in this house with their four children. Next door at 2207 Ola Avenue, they built a duplex. At 2205 Ola Avenue, they also built a house for their children.

ROSS AVENUE

504 EAST ROSS AVENUE

The Sanctuary. This church building was erected in 1947 for the Tampa Heights Methodist Church, after its previous building burned down. Beginning in 1969, it was the Tyler Temple United Methodist Church. After that congregation moved out, it was turned into The Sanctuary, a complex of urban loft apartments and offices.

TAMPA STREET

2222 NORTH TAMPA STREET

Henry W. Brewster Technical Center. This school was founded in 1925, the year it moved into a new facility at this location. The land was donated by Florence Brewster after the death of her husband, Dr. Henry W. Brewster. It was known as the Opportunity School because it focused on career and vocational training. The three-story building, constructed by Carl R. Couch, Franklin O. Adams and J.M. Hamilton, was completed on August 4, 1925. Today, Brewster provides adult secondary programs, programs for adults with disabilities, business and industrial technology and consumer science, medical/health science and English for speakers of other languages.

7TH AVENUE

102 7TH AVENUE

Carnegie Library Building. Built in 1915–17 with a design by Fred J. James, this served as the city's main library until 1968. It is a T-plan masonry building faced with brown and yellow brick atop a rusticated granite basement, topped by a barrel tile roof. Also known as the Old Tampa Free Public Library and the Exceptional Children Education Center, it was added to the National Register in 1991. It now serves as the home of Tampa's Business and Community Services Department.

312 7TH AVENUE

Home of Vicente Guerra. This house has a T-shape and Queen Anne and Neoclassical elements. It was built during the mid-1890s for Vicente Guerra, vice president and general manager of the Cuban-American Manufacturing Company. He was also the president of Guerra V. Diaz and Company and the Centro Español. During the 1920s, the house was converted into a rooming house.

WEST TAMPA

ALBANY AVENUE (FORMERLY KNOWN AS FRANCIS AVENUE, GASPAR AVENUE)

2001 ALBANY AVENUE

Miracle Temple Church of God in Christ. This land was sold by the Macfarlane Investment Company for the construction of the first church school in West Tampa. Sponsored by the Order of the Sisters of the Holy Names, it opened on September 14, 1896. During the Spanish-American War, classes ceased and the building was used as a hospital. It was taken over by the Salesian Order, which renamed the school St. Joseph's and moved it to the corner of Cherry Street and MacDill Avenue in 1955. This building was later converted to use by Morning Glory Missionary Baptist Church, and then by the present church.

2111 ALBANY AVENUE

Preferred Havana Company. Located here is the cigar factory built for the Preferred Havana Company. In 1903 the Bustillo Brothers and Diaz moved in. The building, vacant for five years, became the home of Karl Cuesta's Antonio Cigar Company (which he moved from 1316 Spring Street) in 1958. In 1967 he ceased doing business and sold the Rey del Mundo and Charles the Great brands to the Villazon Cigar Company.

2301 ALBANY AVENUE

Tampa Tarp. This three-story 1895 cigar factory was the home of the Pendas and Alvarez Cigar Company, founded in 1867 in New York by Ysidro Pendas, Miguel Alvarez and Faustino Lozano, which closed in 1919. It also housed Lozano-Pendas and Co. In the 1950s, the Hillsborough Box Company occupied it, and it is now the home of Tampa Tarp and Florida Umbrella, Inc.

ARMENIA AVENUE (FORMERLY KNOWN AS ARMINA AVENUE, YSARAEL AVENUE)

1906 NORTH ARMENIA AVENUE

A. Santaella Cigar Factory. Antonio Santaella from Seville, Spain, and Sol Hamburger from Bavaria owned this company, which opened a factory here by 1908. It did well in the 1920s and 1930s, and opened another facility in Clearwater in 1946. It was sold in 1955 to the Universal Cigar Corporation. The factory here shut down in 1989, and the business moved to New Jersey. For a time the building was occupied by Southern Millwork Products Co. and is now the home of Brandon Restaurant Supply and Equipment.

2001 NORTH ARMENIA AVENUE

Arenas Building. This small one-story brick building dates to 1932, during the decline of the cigar industry in West Tampa. It is now the home of Vivia's Kitchen restaurant.

3102–04 NORTH ARMENIA AVENUE

Garcia and Vega Company. In 1907 Alvaro Garcia and Jose Vega opened a factory under the name of Garcia and Vega Company. They produced brands Austino, El Mas Noble, La Flor de Alvaro Garcia Longo, Garcia y Vega, La Rosa de Mayo, Duguesita, La Perla Espanola, Flor de Garcia y Vega and Flor de P.F. Carcaba. In 1971 the Villazon Cigar Company (which had been founded in 1922 in Ybor City) moved in to produce brands Villa de Cuba, El Cerdo, Villazon and La Docilla. It is now the home of Oliva Tobacco Company, having moved from 2008 18th Street in Ybor City. The wall has the date of 1882 and some believe the Bonded Havana Cigar Company occupied the building during that year, but it has not been verified since the state first granted the land to Antonio Perria on March 10, 1884, before the subdivision was established by John H. Drew, who sold it to Garcia and Vega in 1907.

4303 NORTH ARMENIA AVENUE

Rodriguez and Menendez. This is one of Tampa's last cigar companies, selling brands Conchita de Zarate, Rodriguez and Menendez, Zarate and Old Havana.

BOULEVARD (FORMERLY KNOWN AS WEST 10TH AVENUE)

1701 NORTH BOULEVARD

Howard W. Blake High School. This school opened in September of 1956, and is named for a Tampa native who attended Florida A&M University and Atlanta University, and throughout his life of education guided young men and women to their optimal potential

in education and vocations. He had served as the principal of Booker T. Washington Junior High School.

CYPRESS STREET

1006 CYPRESS STREET

Beulah Baptist Institutional Baptist Church. This church was founded in 1865. Its present sanctuary was built in 1969 and replaced one constructed in 1935 at the corner of Pierce and Tyler Streets.

4401 CYPRESS STREET

Jefferson High School. This school, now a magnet school for international studies, opened in 1939 with principal D.W. Waters in what is now the D.W. Waters Career Center building in Tampa Heights. That building closed in 1967 and this new Jefferson High School opened in 1973. It counts on its list of alumni a former governor of Florida, Olympic athletes and other dignitaries. Its location in the Westshore Business District provides opportunities for community and business outreach.

HABANA AVENUE

2701 NORTH HABANA AVENUE

**West Tampa Junior High School.* A junior high school was built here in 1927 by F.J. Kennard and Son. A year later, it was named Macfarlane Junior High School. It became West Tampa Junior High School in 1949, and West Tampa Middle School in 1979. It was torn down in 1988 and its site is part of the campus of West Tampa Elementary School.

3024 NORTH HABANA AVENUE

Fitzgerald Building. This commercial building completed in January of 1909 was owned by J.W. Fitzgerald. The Cypress Cigar Company, after producing cigars at 1627 13th Avenue in Ybor City, moved to this location. In 1971, it merged with the Tampa Cigar Company and moved to 3024 North Nebraska Avenue.

3102 NORTH HABANA AVENUE

Church of Scientology. John H. Drew built a four-story cigar factory here for Andres Diaz and Company, which occupied it beginning on May 15, 1908. The company produced brands Tereno, Flor de A. Diaz and La Flor de Scott. It closed in 1925. The building was later the home of Francisco Arrango Company and the Tampa-Cuba Cigar Company. After that, it was sold to Hoffman, Incorporated, a company dealing in rubber goods. During the 1960s, it was purchased by Amevoit Company. It was vacant from 1976 to 1980,

and was then bought by Image Advertising and converted to an office building before it became a church.

HOWARD AVENUE (FORMERLY KNOWN AS PINO AVENUE)

522 NORTH HOWARD AVENUE

Fort Homer Hesterly. In 1898 Theodore Roosevelt and his Rough Riders camped on this site while awaiting transportation to Cuba. Roosevelt's 1,200 troops included ranchers, hunters, socialites, polo players, Indians, cowboys, lawmen, trappers and others. In 1940 the 78,000-square-foot National Guard Armory was built on this ten-acre site, and was later named for the first commander of the 116th Field Artillery Armory, who died in 1957. The armory was a popular venue for concerts and speeches, including appearances by Elvis Presley, the Doors and, four days before his assassination, President John F. Kennedy. A 1980 agreement provided that if the military stopped using the site, the land would revert to the city. That occurred in 2005, when the National Guard moved to Pinellas Park. As of 2007, the site was sought both by developers and preservationists.

900 NORTH HOWARD AVENUE

Cuesta-Rey Cigar Factory. This empty cigar factory was built for Samuel I. Davis and Company between 1900 and 1910 with an unusual octagonal tower. It contained a water tank and sprinkler system for fire protection. It was later the home of Cuesta-Rey and Company, formed in 1895 by Angel L. Cuesta Sr. and Peregrino Rey. In 1959, the company sold the Cuesta-Rey Brand to M&N Cigar Manufacturers and ended business at this site. Later, the building housed the Sunstate Sportswear Company.

1202–04 NORTH HOWARD AVENUE

Empire Mercantile Building. In 1924 the Tampa Grande Cigar Company moved in with the Tampa-Cuba Cigar Company owned by F.E. Schmidt, then moved out in 1928. In 1927 to conserve on costs, the Eimerbrink Company owned by Harry C. Eimerbrink, also moved in with Tampa-Cuba. It underwent substantial renovation in 2007.

1307–13 NORTH HOWARD AVENUE

Orient Building. This building was constructed in the early 1900s and housed the Progresso Importing Company.

1403 NORTH HOWARD AVENUE

Berriman Brothers Cigar Factory. This company built the present factory in 1903–04 and moved its New York operation into it. Brands Don Cosme, Jose Vila, La Sinceridad, La Evidencia, Marc Anthony and Light It were produced by four hundred workers. The

building was sold in 1910 to the Morgan Cigar Company, which in 1914 expanded it to accommodate one thousand workers. They produced the brands Juan de Fuca, Independente, F. Lozano, Wall's Court and Don Sebastian. The building underwent a substantial renovation and restoration in 2007.

1611 NORTH HOWARD AVENUE

Bank of Tampa. This building was erected in 1905 and was the home of the Bank of Tampa, established in 1906 by the Macfarlane group headed by Alonzo C. Clewis. It later housed a restaurant.

1707 NORTH HOWARD AVENUE

Leira Building. This two-story masonry building was constructed in 1900. It sits on the eastern portion of a proposed plaza which Hugh Macfarlane intended to be the center of West Tampa. It would have extended west through Howard Avenue to Adele Street, which was eliminated when Howard was later widened.

1718 NORTH HOWARD AVENUE

West Tampa Public Library. Beginning in 1888, the area now known as West Tampa was inhabited almost exclusively by Cubans and was called Pino City, founded by brothers Manuel and Fernando J. del Pino. They established their first cigar factory at this site in June of 1892 with sixty workers. Because of lack of access, housing and transportation, it shut down in 1893. Later that year, O'Halloran Cigar Company moved from Chicago into the vacant building. That company was the only one to remain open during the Spanish-American War when tobacco from Havana was unobtainable. The O'Halloran factory burned down in 1901 as a result of arson during a workers' strike. In July of the following year, Fernandez Hermanos and Company opened a factory here for its three hundred workers. It produced the brands Independente, Key West, Fastido and Vanderbilt. That business closed in 1909, and the building burned down in May of that year. In 1913, this became the site of the West Tampa Public Library, a Carnegie project.

1814–22 NORTH HOWARD AVENUE

Macfarlane Investment Company. This building was erected in about 1903 to house the Prisciliens C. Fernandez Cigar Company. It later became an office of the Macfarlane Investment Company. An annex for the Alessi Bakery was added to the rear of the building in 1931.

1902–08 NORTH HOWARD AVENUE

Macfarlane Building. This two-story Italian palazzo brick building was erected in 1904–05 by the Macfarlane Investment Company. The first floor portion at 1902 was a restaurant for over fifty years, 1904 was a hotel on the second floor, 1906 was a series of small shops and 1908 was primarily a drugstore.

2001 NORTH HOWARD AVENUE

Sicilia Club. This club had its home on Main Street for about twenty
years before moving to this address when the present building
was completed in 1930. Inside were the Cazin Theatre and the
Community Boxing Gym.

2202 NORTH HOWARD AVENUE

C.M. Gil Cigar Company. The factory occupied by San Martin and Leon
was one of the major facilities built before 1910. In 1927 the C.M.
Gil Cigar Company moved in to share expenses. In 1945 the Gallo
and Baer Company began making cigars here. The Adrian Cigar
Company moved in during 1949. Later, the building became the
home of Frayne Sportswear.

2306 NORTH HOWARD AVENUE

El Centro Español de West Tampa. This clubhouse was built in 1912 and
dedicated on January 11, 1913, for the members who lived in West
Tampa. El Centro was the oldest of the city's Latin clubs. This
building, designed by Fred J. James, has a Mediterranean Revival
style with Moorish details of yellow-and-red brick. Other features
include the wrought-iron balcony, terra cotta and brick cornice, and
a gable and hip tile roof. This building was placed on the National
Register in 1974. As of 1975, the organization had about 2,000
members, but by the mid-1980s the building was no longer used
for club activities. The Centro Español Society in 1989 bought the
West Tampa Convention Center at 3005 West Columbus Drive.

2802 NORTH HOWARD AVENUE

Advanced Promotional Concepts. The Morgan Cigar Company moved in
1905 from Seattle to Tampa at the corner of Fremont Avenue and
Arch Street, and in 1907 moved to this location. The company
produced only bonded cigars, with brands Juan DeFuca, Don
Sebastian and F. Lozano. It was later sold to the Gradiaz and Annis
Cigar Company. During the early 1920s, the Marsicano Cigar
Company was located here. In February of 1923, Louis Golvino
moved in and produced brands Mi Sombrino, Zembra and Noble
Comrade until 1926 when he moved elsewhere, and then went out
of business. The following year, Golvino founded the West Coast
Cigar Company, a distributor. In 1991 the building was restored by
its then owner.

LA SALLE STREET

1747 LA SALLE STREET

Mount Olive AME Church. The first church building for this congregation
was erected in 1909. The present building dates to 1940.

MacDill Avenue

1700 North MacDill Avenue
Macfarlane Park. The original pavilion in this park was opened by the City of West Tampa on April 25, 1909, the year the land was donated by Hugh C. Macfarlane. The park (which used to have a golf course) was dedicated in 1924 and named after the head of the Macfarlane Investment Company, which attracted over two dozen large cigar firms and fifty small companies to West Tampa in the 1890s to 1920s. The original Macfarlane development began in 1892 with eleven blocks intended to be the core of West Tampa. It consisted of two hundred acres previously called Pino City.

Main Street

2530 Main Street
Home of Estauislas O'Halloran. This one-and-a-half story frame home was built in 1904 by Estauislas F. O'Halloran. One of its residents was Blas F. O'Halloran, manager of the O'Halloran Cigar Factory.

Rome Avenue (formerly known as 19ᵗʰ Avenue)

2002 North Rome Avenue
Mount Pleasant Missionary Baptist Church. This church was organized on September 12, 1926, by Reverend Aron and Sister Frances Burney. The sanctuary was rebuilt in 1962 while Reverend George Wesley Mitchell was the pastor.

Spruce Street

1125 West Spruce Street
Garland V. Stewart Middle School. In 1945 this school opened as Don Thompson Vocational High School, and in 1971 was transformed into a seventh-grade center. In 1996 it became a middle school. It is named for the city's first black assistant superintendent and before that the principal of Robles, Dobyville, Dunbar and Cleveland Elementary Schools and Middleton High School.

Union Street (formerly known as Antonio Street)

1730 Union Street
Dunbar Elementary School. Built in 1927, this school was named for poet Paul Laurence Dunbar. In 1997 it became a mathematics, science and technology magnet school.

YBOR CITY

COLUMBUS DRIVE

1407 EAST COLUMBUS DRIVE

Academy Prep Center. This school opened in 2003, and is an affiliate of the Academy Prep Center for Education founded in St. Petersburg in 1996. It is located in the former Ybor City Grammar School building, erected in 1908 and abandoned by the city in 1971.

1601 EAST COLUMBUS DRIVE

Sanchez and Haya Building. This building was erected in 1910 by the Sanchez and Haya Real Estate Company, one of the two original developers of Ybor City, whose offices were located on the first floor. The 16,650-square-foot building stood vacant for decades and is now being considered for a major restoration and renovation.

2700 EAST COLUMBUS DRIVE

**George Washington Junior High School.* Located here was a three-story red brick school constructed in 1915. It was one of the first three-year junior high (middle) schools and closed in 1979. It unfortunately sat in the path of planned interstate highway expansion and was torn down in late 2004, when cost estimates of moving it turned out to be prohibitive. The site is marked by a monument with a commemorative marker, made from materials salvaged from the building. As a bus shelter, the monument includes one of the school's original cupolas. Other materials, including wood flooring and interior doors, are now part of Woodrow Wilson Middle School, which had the same original design as Washington.

NEBRASKA AVENUE

1505 NORTH NEBRASKA AVENUE

Ybor City Branch Library. In 1934 a branch of the Tampa Library opened at 1729 7th Avenue. It moved to this location in 1969. In 2003 it was renamed the Robert W. Saunders Sr. Public Library to honor a longtime civil rights advocate who directed the county's Office of Equal Opportunity from 1976 until 1988.

1913 NORTH NEBRASKA AVENUE

Centro Asturiano. This clubhouse for Asturian Spanish residents was
 built in 1914, replacing an earlier one which burned down. In 1901
 Centro Español declined to establish a private hospital, motivating
 several hundred Spanish immigrants to form Centro Asturiano. In
 1903 they leased the old St. James Hotel (built in 1884) on Tampa
 Street as a temporary hospital. That was followed in 1905 by a
 permanent hospital built for $15,000, which closed in 1990. The
 clubhouse was placed on the National Register in 1974.

2105 NORTH NEBRASKA AVENUE

German American Club. This building was occupied by its namesake club
 from 1909 to 1919, and thereafter by several other organizations. It
 is now the city's Ybor Service Center.

PALM AVENUE

APPROXIMATELY 1415 EAST PALM AVENUE

Marti Assassination Attempt. In a house near here in 1893 two Spanish
 agents plotted to poison Jose Marti. However, Marti suspected and
 the agents failed when he quickly spat out the poison. Marti was
 cared for by Dr. Eduardo Barbarosa and Ruperto and Paulina
 Pedroso. The attempted assassins asked for forgiveness, and after
 Marti forgave them they joined his cause.

2ND AVENUE

1908 2ND AVENUE

Philip Shore Elementary School. This school opened on September 18,
 1922, and is named for a long-time member of the Hillsborough
 County School Board. It was designed by M. Leo Elliott and
 underwent substantial restoration and expansion in 1983.

2001 2ND AVENUE

Tampa Box Company. This one-story rusticated block building was
 constructed in 1906 and was originally owned by Wilfred and Guy
 Clarkson, who owned the San Martin P. and Company. On January
 24, 1907, the building was sold to the Tampa Box Company, which
 manufactured cigar boxes. It was acquired by the Leiman-Weidman
 Box Company in 1931.

4ᵀᴴ AVENUE

1701 4ᵀᴴ AVENUE

Home of Ygnacio Capitano. This house was built in 1902 for dairyman Ygnacio Capitano. It was rebuilt as a commercial structure, and in 1912 was turned into a duplex by Joseph DiBetta. During the 1920s, Michele and Antony DiBetta operated a grocery store in it called the Mike and Tony Grocery. Lately, it has served as Cepha's Hot Shop Restaurant.

5ᵀᴴ AVENUE

1220–34 5ᵀᴴ AVENUE

Florida Brewing Company. In the days of the Indians, the spring located at this site was a shrine to the Timuquan water gods. The early Spanish and other settlers used it, then it was the water supply for Fort Brooke known as the Government Spring. In 1884 H.A. Snodgrass opened a ten-ton ice plant here but, because of competition from other ice firms, he moved his plant to Cedar Key. Florida Brewing Company, the first brewery in the state, incorporated in 1896 and that year erected this plant, designed by August Maritzen. It is six stories tall and when built, it was the tallest building in Tampa. The water from the spring was the main ingredient in its La Tropical Beer. It was modeled after the Castle Brewery in Johannesburg. The beer was termed the "finest in America" by the *Tampa Times* in 1900. The brewery shipped more beer to Cuba than any other in the United States. The large building is now a collection of offices.

1623 5ᵀᴴ AVENUE

Home of Joseph Licata. This home, built in about 1918, was the home of Joseph A. Licata who rebuilt it into the J.A. Grocery in 1924. He operated it for ten years, and later it became a tavern and restaurant. Its current occupant is the El Puerto Argentine Grill.

7ᵀᴴ AVENUE (FORMERLY KNOWN AS GEORGIA AND BROADWAY AVENUES AND ALSO KNOWN AS LA GRAN SEPTIMA AVENIDA)

1226 7ᵀᴴ AVENUE

La Union Marti-Maceo. La Union organized in 1904. It was the second Cuban club, started by the Afro-Cuban community while Florida laws prohibited integrated social clubs. It is named for the white Jose Marti and the Afro-Cuban Antonio Maceo (who died December 7, 1896, at Punta Brava), leaders of Cuba's war for independence. In 1907 it merged with the Society of the Free Thinkers of Marti and Maceo to form La Union Marti-Maceo. The first clubhouse at the corner of 6ᵗʰ

Avenue and 11ᵗʰ Street—built in 1909 with a dance hall and theater for three hundred—was razed in 1965. The club then acquired this sheet metal workers' union hall built in 1950 to replace it. The tiles with the likenesses of Marti and Maceo were installed in 1985.

1300 7ᵀᴴ AVENUE
El Liceo Cubano. Cubans founded a social and political club in 1886, and Vicente Ybor donated a wooden tobacco stripping house as an incentive for them to remain in Tampa. It was converted to a social center referred to as the "Cradle of Cuban Liberty," used by Jose Marti for his organizing of Cuban freedom fighters in 1891. On November 26 and 27 of that year, Marti delivered two speeches and drafted resolutions that became the program of the United Cuban Revolutionary Party. On the second floor of this clubhouse was located the Sans Souci Theater.

1333 7ᵀᴴ AVENUE
El Malecon. Located here was one of Ybor City's first stores. Beginning in the 1890s, Francisco Carrera sold toys here.

APPROXIMATELY 1425 7ᵀᴴ AVENUE
Site of Duel. In 1885, two cigar makers, Teclo and Matancero, had a duel as a result of both desiring the same woman. One died instantly. His was the first violent death in Ybor City.

1430 7ᵀᴴ AVENUE
Las Novedades Restaurant. This restaurant, later renamed as El Goya, was founded in 1890. This building was erected in 1891, after the previous one burned down. In 1929 a longshoreman's bar was located here, and in 1947 Angelo Cacciatore opened the Silver Ring Café here. In 1996 high rent caused then-owner Timothy Booth to move the café to downtown Tampa, but it returned to its original Ybor City location in November of 2006. It is renowned for its Cuban sandwiches.

APPROXIMATELY 1501 7ᵀᴴ AVENUE
Revolutionary Meetings. During 1895, the southeast corner of 7ᵗʰ Avenue and 15ᵗʰ Street was a meeting place for Cuban patriots and others who supported the Cubans in their fight for independence from Spain. One such supporter was Italian revolutionary Orestes Ferrara. Later, this corner was the location of the Second Hand Suits store of Sam Hartzman.

1503–05 7ᵀᴴ AVENUE
Ritz Theatre. In 1917 the Ritz Theatre was built here with an interior resembling a Spanish plaza and later became a nightclub. Renamed as the Masquerade, it was turned into a 1,004-seat concert venue.

1517 7TH AVENUE

Francisco Mayo Building. This building was designed by cigar manufacturers Ignacio Haya and Serafin Sanchez for the Spanish Theater. It was erected in 1912 and in 1946, the second floor balconies were removed and the windows were modernized. It was again remodeled in 1995.

1526–36 7TH AVENUE

El Centro Español. This club was chartered on September 7, 1891, with president Ignacio Haya, and dedicated this clubhouse in 1912, replacing an 1890s wooden one destroyed by fire. Unlike some other societies, not all of the members had to be born in Spain—only the president and vice president. It offered the country's first socialized medical care plan, and remained active until 1983. The third floor ballroom had a balcony for an orchestra. El Centro Español had a strong interest in the medical needs of its members and, although it rejected a proposal to build a private hospital in 1900, six years later it dedicated its Sanatorio del Centro Español along Bayshore Boulevard, designed by architect Alfred H. Parslow. Dr. Jose Ramon Avellanal served as its first director. The hospital closed in the mid-1960s and no trace of it was left by the early 1970s. The clubhouse was placed on the National Register in 1988.

1603 7TH AVENUE

Gutierrez Building. This two-story rooming house was built by Gavino Gutierrez, the Spanish-born engineer who suggested Tampa as the location of the cigar industry. A New York food broker, he was on his way home through Key West when he met Vicente M. Ybor and two other cigar manufacturers. He convinced them that they should move their businesses to Tampa. Upstairs was the Dixie Hotel and downstairs was the Pathe Theater. Also in this building at other times were Gregory and David Waksman's Corona Brush Co., Miami Jewelry and the City Building and Loan Association.

1610–12 7TH AVENUE

B.F. Marcos Building. This two-story structure was built in 1908 with a design of Francis J. Kennard. Owned by Baldomero F. Marcos, it had two shops on the first floor and a residence on the second. Tenants included the Bank of Ybor City (1909–24), the La France shoe store (1932–73) and the D'Elia Jewelry Store (1940s).

1702–06 7TH AVENUE

Circolo di Studi Sociali. In the early 1900s, a variety of Socialist groups met in Ybor City. The Circolo di Studi Sociali met in this building, which was erected in 1910, under the sponsorship of publisher Vincente Antinori. In 1911 the group sponsored a consumer cooperative. This building later was the home of the Dayan Linens

store, owned by Victor Dayan, and later was the Bank of Ybor City, which moved out in 1955.

1725–31 7TH AVENUE

L'Unione Italiana. This was a mutual aid society established for Italian immigrants, most of whom came from the western Sicily towns of Santo Stefano Quisquina, Bivona, Alessandria della Rocca and Cianciana. It was organized with 124 members and president Bartolomeo A. Filogamo as La Societa Italiana di Mutuo Soccorso in 1894 and was given its present name in 1906. The first $40,000 clubhouse was built across the street in 1912 with an athletic room and theater. It burned in 1915 and was replaced by the present one in 1917–18 at a cost of $80,000. It was constructed with an Italian Renaissance style with classic columns, terra cotta relief details and marble, with the goal that it should be a cathedral for the workingman. The building was substantially renovated in 1962. From 1906 until 1924, the organization was led by Filippo F. Licata, who owned a grocery store.

1728 7TH AVENUE

El Sol Cigars. This is Ybor City's oldest remaining cigar shop, having been in business since 1929. Its brands Smok-A-Cuba and El Sol are manufactured in both Tampa and the Dominican Republic.

1901 7TH AVENUE

Scozzari Building. This brick building was erected in 1893 by Pietra and Jose Scozzari to be the home of the original La Tropicana Restaurant and, beginning in 1905, the Bank of Ybor City. It was later the home of American Life Corporation (1910), Charles Haimovitz Mens Store, Columbia Bank (1934) and the First Savings and Trust Company of Tampa (1941).

2028–32 7TH AVENUE

Columbia Bank. This bank was founded by John Grimaldi, and the building was erected in 1918.

2117–27 7TH AVENUE

Columbia Restaurant. This is the largest and oldest Spanish restaurant in the United States. It was founded in 1905 by Casimiro Hernandez Sr.

8TH AVENUE

1303 8TH AVENUE

Parque Amigos de Marti. This park on the site of the boardinghouse of Ruperto and Paulina Pedroso contains soil from every Cuban

province. It was deeded to Cuba in 1956 and was formally dedicated on February 28, 1960.

1313 8ᵀᴴ Avenue

Fire Station. Here was the Mirta Hook and Ladder Volunteer Fire Station, established in 1888. It was named after the youngest daughter of Vicente M. Ybor and was led by Captain Frank Puglisi.

1514 8ᵀᴴ Avenue

Llano Building. This was built in 1903 by Antonio de Rio. The first floor was occupied by Stein Furniture Company in the 1920s, Weber's Uniform and Dresses in the 1930s, Tony Pizzo's liquor distributorship and Frank Badia's neon sign company in the 1940s. The second floor was residential. In 1966 the face of the building was remodeled and sandblasted.

3210 8ᵀᴴ Avenue

Home of Brown Family. This is the oldest structure in Tampa, having been built in 1842 by the grandfather of Dr. Sheldon Stringer. It sat on the south portion of the present site of the city hall, and was purchased by Imboden Stalnaker in 1914. He disassembled it and moved it east of Ybor City, reassembling it according to the original plans. The only modification was the installation of a gable in the front roof in place of two dormer windows. The area near this home was known as Gary, and for a time constituted a separate municipality.

3510 8ᵀᴴ Avenue

Home of Leo Stalnaker. In 1910 this house and two small country bungalows across the street at 3507 and 3509 (since demolished) were built. The surrounding area was chiefly orange groves. This house was owned by the Stalnakers, and for many years was the residence of circuit judge and civic leader Leo Stalnaker.

9ᵀᴴ Avenue

1318–30 9ᵀᴴ Avenue

Cherokee Club. "El Pasaje" was the second brick building in Ybor City, erected in 1886–88 with money donated by Vicente Ybor. It was popular with the elite and famous visitors. Jose Marti slept here on November 25, 1891. The Cherokee Club upstairs was founded in 1895 to promote social intercourse among its members, including many prominent Tampa businessmen and cigar manufacturers. Included in the building were a hotel and gambling casino. Included on the list of the hotel's guests are Theodore Roosevelt, Winston Churchill and artist Frederic Remington. Also in a portion

of this building was a department store, one of more than thirty Jewish-owned businesses that were operating in Ybor City by 1920. The Cherokee Club building has an Eclectic style with Italian Renaissance elements, and is modeled after an Italian Renaissance villa. It later was the home of Café Creole and the El Pasaje Club, and was added to the National Register in 1972. "El Pasaje" means "passage" or "passageway" and refers to its ground-floor arcade and colonnade generally modeled after Renaissance Italian palazzos.

1800–04 9TH AVENUE

Cigar Workers' Houses. These homes are typical of those lived in by cigar workers from 1895 until about 1920. These were originally built at other locations, then were moved here in 1976 and restored as part of the Ybor City State Museum. They follow a long, narrow Spanish-style floor plan, with rooms lined up next to a long hallway along one side. These houses were built from Florida pine with hand-split cedar or cypress shakes. They had no heat, running water or electricity. Shutters were on the inside. After the major fire of March 1, 1908, roofs were covered with tin.

1818 9TH AVENUE

La Joven Francesa Bakery. In 1896 Francisco Ferlita from Santo Stefano, Sicily, opened a bakery here in a wood-frame building, and sold bread for three and five cents a loaf. That structure burned down in 1922 and was replaced by this yellow brick building constructed around the old brick ovens. After Francisco died in 1931, his five sons continued the business here until 1973. The building now houses the Ybor City State Museum.

11TH AVENUE

1711 11TH AVENUE

Our Lady of Perpetual Help Catholic Church. The present sanctuary of the church was built in 1937. The academy, which was affiliated with the church, was torn down long ago. The church school was built in 1921, the parish house in 1940 and the convent in 1942.

14TH STREET (ALSO KNOWN AS AVENIDA REPUBLICA DE CUBA)

APPROXIMATELY 1901 14TH STREET

**El Chino-Pajarito Restaurant.* This is a parking lot, but in 1895 the restaurant located here was a popular meeting place for Cuban exiles for the plotting for independence. It was owned and operated by Antonio Menendez. Some of the freedom fighters leaving for

Cuba had machetes and knives from the kitchen of this restaurant. Hillsborough County's first legal hanging took place near here on May 17, 1850. Jose Perfino, known as "El Indio," was executed for the murder of Thomas Cline.

1902 14TH STREET
La Liga Patriotica de Instruccion. A night school for Cuban émigrés was operated here in 1889. The teacher was Don Jose Guadalupe Rivero. Later, the building housed the Louis Wohl Household Supplies store, and The Palace, operated by Louis and Mark Shine.

1912 14TH STREET
Ybor Cigar Factory. The Spaghetti Warehouse restaurant founded in 1972 is located in Ybor Square, which includes the 1886 cigar factory of Vicente Ybor, around which Ybor City was created. Over the years, the block has been the home of many businesses, including the Blue Ribbon Supermarket owned by the Bobo families, the David Stein Furniture Co., which opened in 1917, the David Kasriel Department Store, the Jewel Box (owned by Buddy Levine and then by Dave Kartt), Tillye Simovitz's Adorable Hat Store, the Isadore Davis Department Store, Abe Herscovitz's Liberty Men's Store, the Ozias Meerovitz Men's Store, the Weissman Clothing Store and Louis Wolf and Sons Restaurant Supply. As the Ybor Factory Building, it was added to the National Register in 1972. The complex is made up of three buildings—the three-story 1886 cigar factory (which was the tallest Tampa building when it was new), the two-story 1920 Ybor warehouse containing the Spaghetti Warehouse and the three-story Stemmery Building (1801 13th Street) erected in 1902.

1915 14TH STREET
El Bien Publico. This building was erected in 1895 and was the home of the Ybor Land and Improvement Company, the development arm of Ybor's enterprises. It later housed the A.A. Gonzalez Clinic, a healthcare facility, until 1980. A more recent use has been as a luxury bed and breakfast known as the Don Vicente Inn.

2010 14TH STREET
Circulo Cubano de Tampa. This four-story clubhouse dates to 1917–18 and is constructed with yellow brick with stone trim. It was designed by M. Leo Elliott and features over the main door a stained glass Diocletian window with Cuba's coat of arms and flag. It was placed on the National Register in 1972. It was the home of an ethnic men's club chartered in 1902, an outgrowth of El Club Nacional Cubano which began on October 10, 1899.

15ᵀᴴ Street (formerly known as California Street)

1814–18 15ᵀᴴ Street

El Encanto Building. This building erected in 1904 started out as a wholesale grocery and grain store. Local legend states that Theodore Roosevelt stabled his horses next to the building. For a time, there was a casino in the basement. The building became the home of a family-owned dry cleaners in 1930.

2009 15ᵀᴴ Street (also known as 1505 East Palm Avenue)

United Secret Orders Hall. This two-story building constructed in 1929 was known as Las Logia Unidas because five separate lodges met here. It was later the place where *La Gaceta* newspaper (founded in 1922 by Victoriano Manteiga and Dr. Jose Avellanal) was published initially in Spanish. In 1953 columns in English and Italian were added, making it the only such trilingual newspaper in the country at the time. The building was later the home of the Star Grocery, owned by Max Star. This building is also known as La Benefica.

2800 15ᵀᴴ Street

Cuscaden Park Swimming Pool. This pool was designed with an Art Deco style by civil engineer Westley Brintz and built by the WPA in 1937. It opened in 1940, measures 120 feet long and 80 feet wide and accommodates 2,500 people year-round. It was dedicated as a local historic landmark in 2003.

16ᵀᴴ Street

2004 16ᵀᴴ Street

Labor Temple. This two-story brick building was the command post of the labor movement and the headquarters of the union of cigar makers and restaurant waiters. It was constructed in 1930 for the Castillo Cristobal Colon Association. The previous Labor Temple, El Centro Obrero at 1612 8ᵗʰ Avenue, was a two-story wooden building that was torn down in the 1920s.

2701 16ᵀᴴ Street

J.C. Newman Cigar Company. The Pendas and Alvarez Cigar Company was doing business since 1897 at 1416 Spring Street in Tampa, then moved here in May of 1909 into a new cigar factory designed by Fred J. James. Known as El Reloj, it has clocks on all four sides of its seven-story water tower and accommodated seven hundred workers. The factory closed during the general strike in 1910, reopened in January of 1911 and closed in December of 1918. It

produced brands La Mia, Webster, Farragut, Flor de Y Pendas and Alvarez. The building was then purchased by E. Regensburg and Sons on May 20, 1920. The Hillsborough Box Company bought it in 1946. The J.C. Newman Cigar Company was founded in 1895 in Cleveland, Ohio, when there were about three hundred cigar companies there. By 1927, it and Mendelsohn were the only two left, and they merged to form M&N Cigar Manufacturers. The Standard Cigar Company, a subsidiary of M&N, moved into this building in 1945, and in 1954 was followed by the remainder of the parent company's Cleveland operation, then four years later acquired the Cuesta-Rey brand from Angel and Carl Cuesta. The company was renamed the J.C. Newman Cigar Company in 1997, and continues in business with brands Arturo Fuente, Arturo Fuente Anejo, Cuesta-Rey, Cuesta-Rey Centenario, Diamond Crown, Don Carlos, Fuente Fuente Opus X, La Unica, La Unica Cameroon, Montesino, Rigoletto Handmade and Hemingway.

2808 16TH STREET
Perfecto Garcia Cigar Factory. This three-story brick cigar factory was built in 1914 for the Perfecto Garcia and Brothers Cigar Company.

17TH AVENUE

2615 17TH AVENUE
Home of Frank Cook. This house was built in 1905 by Frank Cook, foreman of the Tampa-Sarasota Transportation company. It was later converted into a duplex.

18TH STREET (ALSO KNOWN AS ANGEL OLIVA SR. STREET)

2311 18TH STREET
Berriman Brothers Cigar Company. In 1910 the Berriman Brothers Cigar Company moved from West Tampa into this factory, which had been built in 1908 to replace the building occupied by Gonzalez Mora and Company in 1901. The Berriman Brothers firm was sold in 1930 to Wengle and Mandell. The company switched from cigars to undercoating products in 1950. This factory was also occupied for a time by Sanchez and Haya. This building was later occupied by the cigar manufacturing firms of Marcelino Perez Company and then M. Bustillo and Merriam. The latter company moved to another location and then closed after Moises Bustillo died in 1943. The Gradiaz and Annis Cigar Company was founded in Ybor City, moved in 1929 to the former Samuel I. Davis factory at the corner of Howard Avenue and Nassau Street and moved into this building in 1933. Gradiaz and Annis purchased the Morgan

Cigar Company in 1961, then was absorbed into the General Cigar Company in 1964. The company ceased doing business in 1971. The former cigar factory is now the home of U-Haul.

19ᵀᴴ STREET

1302–06 19ᵀᴴ STREET

Corral, Wodiska and Co. This two-story building was constructed in 1908–09 for the Esberg-Gunst Cigar Company. In 1910 it was sold to the Alta Cigar Company. In 1922 it was bought by the General Cigar Company and the New York-Tampa Cigar Company. Corral-Wodiska and Company purchased it in 1925 and produced the Julia Marlow brand. The building later became the home of a garment manufacturing business.

20ᵀᴴ STREET

2205 NORTH 20ᵀᴴ STREET

Ybor City Brewing Company. This is the second-oldest cigar factory in the city, built here between 1895 and 1898 for Seidenberg and Co., and then occupied by the Havana-American Cigar Company. Later, it was the home of the Ybor City Brewing Company which produces 60,000 barrels of beer annually, with brands that include the popular Ybor Gold.

21ˢᵀ AVENUE

1302 21ˢᵀ AVENUE

Centro Place Apartments. This site has been redeveloped with 160 apartments in four buildings, and the renovation of an abandoned historic hospital building into a clubhouse for the complex. The Centro Asturiano Hospital was built in 1928 and its 144 beds served the Ybor City neighborhood until it went bankrupt in 1991. The seven-acre site was acquired by the city in 1996 and over the next decade it was cleaned up and redeveloped for senior residences.

21ˢᵀ STREET

1408–10 21ˢᵀ STREET

Lozano, Nitzal Cigar Factory. This three-story cigar factory was built in 1905 for the Lozano, Niztal and Company (which used it until 1919), and over the years also housed the F. Lozano Son and Company, M. Bustillo and Company, and the Tampa Casket Company. In the

1970s, it was converted to use as art studios and apartments. It was later turned into the Lions Eye Institute.

22ND AVENUE

1203 22ND AVENUE

Old People's Home. This two-story building with a large columned porch was known as the Old People's Home from 1899 until 1924. Also known as the Home Association, the building, which houses the elderly, was added to the National Register in 2000.

22ND STREET

1310 NORTH 22ND STREET

Arturo Fuente Cigar Factory. This three-story factory was built in 1895 for Garcia and Company, and later was used for shipping and warehousing supplies and tobacco products. It was occupied by the Salvador Rodriguez Cigar Company and later, beginning in 1964, the Arturo Fuente Cigar Company. In later years, it has been the home of Tampa Sweethearts Cigar Company, having an entrance in the back of the building at 1301 21st Street.

23RD STREET

1301 23RD STREET

Home of Casimiro Yanez. In 1915 this house was built by contractor Pedro Rey for cigar maker Casimiro Yanez. The two-story home features an octagonal turret and multiple verandas. Mrs. Yanez helped design it based on her memories of a mansion in Spain.

BIBLIOGRAPHY

Ayers, R. Wayne. *Florida's Grand Hotels from the Gilded Age*. Charleston, SC: Arcadia Publishing, 2005.

Bane, Michael, and Mary Ellen Moore. *Tampa: Yesterday, Today and Tomorrow*. Tampa, FL: Mishler and King Publishing, 1981.

Barker, Eirlys Mair. "Seasons of Pestilence: Tampa and Yellow Fever, 1824–1905." Master's thesis, University of South Florida, 1984.

Baxley, John H., Julius J. Gordon and Diane Rodriguez. *Sleeping Around: A Study of Hotels of Tampa, Florida From 1830 to 1925*. Tampa, FL: John H. Baxley, et al., 1995.

Bentley, Altermese Smith. *History of the First South Florida Missionary Baptist Association (1888–1988)*. Chuluota, FL: The Mickler House, 1988.

Bobbitt, William R. *Wallace Fisher Stovall as Publisher of the Tampa Tribune, 1893–1925*. Master's thesis, University of South Florida, 1989.

Boone, Floyd E. *Florida Historical Markers and Sites*. Houston, TX: Gulf Publishing Company, 1988.

Bradbury, Alford G., and E. Story Hallock. *A Chronology of Florida Post Offices*. Vero Beach, FL: Florida Federation of Stamp Clubs, 1962.

Brady, Rowena Ferrell. *Things Remembered: An Album of African Americans in Tampa*. Tampa, FL: University of Tampa Press, 1997.

Brower, Ralph. *Historic Photos of Tampa*. Nashville, TN: Turner Publishing Company, 2006.

Brown, Canter, Jr. *Tampa Before the Civil War*. Tampa, FL: University of Tampa Press, 1999.

———. *Tampa in Civil War and Reconstruction*. Tampa, FL: University of Tampa Press, 2000.

Brown, Canter, Jr., and Barbara Gray Brown. *God Was With Us: An Early History of St. Andrew's Episcopal Church in Tampa, Florida*. Tampa, FL: St. Andrew's Episcopal Church, 2004.

Campbell, A. Stuart. *The Cigar Industry of Tampa, Florida*. Tampa, FL: University of Tampa, 1939.

Carbonneau, Elaine. *Reflections: Celebrating the Centennial of Sacred Heart Church, Tampa, Florida*. Virginia Beach, VA: Donning Co., 2004.

Carlton, Lynn, ed. *History of First Methodist Church, Tampa, Florida*. Tampa, FL: First Methodist Church, 1996.

Chamberlain, Donald L. *Fort Brooke: A History*. Tallahassee: Florida State University, 1968.

Covington, James W. *Plant's Palace: Henry B. Plant and the Tampa Bay Hotel*. Louisville, KY: Harmony House, 1990.

———. *Under the Minarets*. Tampa, FL: University of Tampa, 1981.

Covington, James W., and C. Herbert Laub. *The Story of the University of Tampa*. Tampa, FL: University of Tampa Press, 1955.

Daughters of the American Revolution. *The Pioneer Churches of Florida.* Chuluota, FL: The Mickler House, 1976.

Davis, William Watson. *The Civil War and Reconstruction in Florida.* Gainesville: University of Florida Press, 1964, reproduction of 1913 edition.

De Quesada, A.M. *Baseball in Tampa Bay.* Charleston, SC: Arcadia Publishing, 2000.

———. *The Spanish-American War in Tampa Bay.* Dover, NH: Arcadia Publishing, 1998.

———. *World War II in Tampa Bay.* Dover, NH: Arcadia Publishing, 1997.

———. *Ybor City.* Charleston, SC: Arcadia Publishing, 1999.

Dean, Susie Kelly. *The Tampa of My Childhood.* Tampa, FL: Susie Kelly Dean, 1966.

Deitche, Scott M. *Cigar City Mafia: A Complete History of the Tampa Underworld.* Fort Lee, NJ: Barricade Books, 2004.

Dixon, Suzy, and Paula Stahel. *The Insiders' Guide to Tampa Bay.* Manteo, NC: Insiders' Publishing, 1998.

Dunn, Hampton. *Tampa: A Pictorial History.* Norfolk, VA: The Donning Company, 1985.

———. *Wish You Were Here: A Grand Tour of Early Florida Via Old Post Cards.* St. Petersburg, FL: Byron Kennedy and Company, 1981.

———. *Yesterday's Tampa.* Miami, FL: E.A. Seemann Publishing, Inc., 1972.

Floyd, Mary. *A House Where God Lives: Sacred Heart Church, Tampa, Florida.* South Hackensack, NJ: Custombook, Inc., 1979.

Frisbie, Louise K. *Florida's Fabled Inns.* Bartow, FL: Imperial Publishing Company, 1980.

Gleasner, Diana and Bill. *Florida Off the Beaten Path.* Old Saybrook, CT: The Globe Pequot Press, 1993.

Gray, Edgar. *The Tampa Firefighter.* Tampa, FL: Paleveda Printing Company, 1978.

Greenbaum, Susan D. *Afro-Cubans in Ybor City: A Centennial History.* Tampa, FL: Tampa Printing, 1986.

Grismer, Carl H. *Tampa.* St. Petersburg, FL: The St. Petersburg Printing Company, 1950.

Haddock, Dudley. *Wallace F. Stovall: A Publisher's Publisher.* Sarasota, FL: Dudley Haddock, 1949.

Harner, Charles D. *A Pictorial History of Ybor City.* Tampa, FL: Trend Publications, Inc., 1975.

Harrison, Charles Edward. *Genealogical Records of the Pioneers of Tampa and of Some Who Came After Them.* Salem, MA: Higginson Book Co., 1998.

Hawes, Leland M. *One Hundred Years of Faith and Challenge: The Centennial History, First Presbyterian Church of Tampa, Florida, 1884–1984.* Tampa, FL: First Presbyterian Church, 1984.

Hillsborough County City-County Planning Commission. *Tampa Comprehensive Plan.* Tampa, FL: Hillsborough County City-County Planning Commission, 1998.

Hillsborough County Planning Commission. *Hillsborough County's History Heritage.* Tampa, FL: Hillsborough County Planning Commission, 1974.

Hewitt, Nancy A. *Southern Discomfort: Women's Activism in Tampa, Florida, 1880s–1920s.* Urbana, IL: University of Illinois Press, 2001.

Ingalls, Robert P., and Louis A. Perez Jr. *Tampa Cigar Workers: A Pictorial History.* Gainesville, FL: University Press of Florida, 2003.

Jahoda, Gloria. *River of the Golden Ibis.* New York, NY: Holt, Rinehart and Winston, 1973.

Jones, Maxine D., and Kevin M. McCarthy. *African Americans in Florida.* Sarasota, FL: Pineapple Press, Inc., 1993.

Kaiser, Robert J. *Tampa: The Early Years.* Charleston, SC: Arcadia Publishing, 1999.

Kite-Powell, Rodney. *In Search of David Paul Davis.* Master's thesis, University of South Florida, 2003.

Lake, Mary Louise. *History of Hyde Park United Methodist Church, Tampa, Florida, 1899–1974.* Tampa, FL: Hyde Park United Methodist Church, 1974.

Lambright, Edwin D. *The Life and Exploits of Gasparilla, Last of the Buccaneers, with the History of Ye Mystic Krewe of Gasparilla.* Tampa, FL: Hillsboro Printing Company, 1936.

Leonard, M.C. *Historic Overview of the Area of Hyde Park: House Section.* Tampa, FL: Hillsborough Community College, 1978.

———. *Historic Overview of the Area of Hyde Park: The Area Section.* Tampa, FL: Hillsborough Community College, 1978.

———. *Historic Overview of Greater Ybor City: Historic Structures.* Tampa, FL: Hillsborough Community College, 1978.

———. *Historic Overview of Greater Ybor City: Subdivision Sections.* Tampa, FL: Hillsborough Community College, 1978.

———. *Historic Overview of Port Tampa.* Tampa, FL: Hillsborough Community College, 1978.

———. *Historic Overview of Tampa Heights.* Tampa, FL: Hillsborough Community College, 1978.

———. *Historic Overview of West Tampa: General History.* Tampa, FL: Hillsborough Community College, 1978.

———. *Historic Overview of West Tampa: Subdivision Sections.* Tampa, FL: Hillsborough Community College, 1978.

———. *The Illustrated Guide to the Florida West Coast.* Tampa, FL: Purple Islands Productions, 1992.

Mann, Robert W. *Rails 'Neath the Palms.* Burbank, CA: Darwin Publications, 1983.

Marth, Del. *St. Petersburg: Once Upon a Time.* St. Petersburg, FL: City of St. Petersburg, Florida, 1976.

McCarthy, Kevin. *Aviation in Florida.* Sarasota, FL: Pineapple Press, Inc., 2003.

———. *Black Florida.* New York, NY: Hippocrene Books, 1995.

McGuire, Nina. *An Uncommon Guide to Florida.* Lake Buena Vista, FL: Tailored Tours Publications, Inc., 1992.

McQuigg, Jackson. *Tampa Union Station.* Dover, NH: Arcadia Publishing, 1997.

Mendez, Armando. *Cuidad de Cigars: West Tampa.* Tampa, FL: Florida Historical Society, 1994.

Mormino, Gary R., and Anthony P. Pizzo. *Tampa: The Treasure City.* Tulsa, OK: Continental Heritage Press, Inc., 1983.

Mormino, Gary R. and George E. Pozetta. *The Immigrant World of Ybor City.* Urbana, IL: University of Illinois Press, 1990.

Muniz, Jose Rivero. *The Ybor City Story (1885–1954).* Chuluota, FL: Micklers, 1976.

Newman, Stanford J., and James V. Miller. *Cigar Family: A 100 Year Journey in the Cigar Industry.* New York, NY: Forbes Custom Publishing, 1999.

Norman, Robert, and Lisa Coleman. *Tampa.* Charleston, SC: Arcadia Publishing, 2001.

Orrick, Bentley, and Harry L. Crumpacker. *The Tampa Tribune Centennial, 1895–1995.* Tampa, FL: The Tribune Co., 1994.

Perry, I. Mac. *Indian Mounds You Can Visit.* St. Petersburg, FL: Great Outdoors Publishing Company, 1993.

Pizzo, Anthony P. *Tampa Town, 1824–1886: The Cracker Village with a Latin Accent.* Miami, FL: Hurricane House Publishers, Inc., 1968.

Port Tampa City Woman's Club. *A History of the City of Port Tampa, 1888–1961.* Tampa, FL: Port Tampa City Woman's Club, 1972.

———. *Port Tampa City: A History of Change.* Tampa, FL: Port Tampa City Woman's Club, 2003.

Powell, Evanell Klintworth. *Tampa That Was… History and Chronology Through 1946.* Boynton Beach, FL: Star Publishing Company, Inc., 1973.

Rupertus, John C. "History of the Commercial Development of Franklin Street." Master's thesis, University of South Florida, 1980.

Scheinbaum, Mark I. *Jose Marti Park: The Story of Cuban Property in Tampa.* Tampa, FL: University of South Florida, 1976.

Schell, Rolfe F. *DeSoto Didn't Land at Tampa.* Fort Myers Beach, FL: Island Press, 1966.

Shedden, David. *Florida Newspaper Chronology 1783-2000.* St. Petersburg, FL: Poynter Institute, 2001.

Sherrill, William E. *A Call to Greatness: A History of the First Baptist Church, Tampa, Florida, 1859-1984.* Orlando, FL: Golden Rule Press, Inc., 1984.

Shofner, Jerrell. *Florida Portrait: A Pictorial History of Florida.* Sarasota, FL: Pineapple Press, Inc., 1990.

Snyder, Robert E. and Jack Moore. *Pioneer Commercial Photography: The Burgert Brothers, Tampa, Florida.* Gainesville: University Press of Florida, 1992.

Spencer, Donald D. *Florida's Historic Forts, Camps and Battlefields: A Pictorial Encyclopedia.* Ormond Beach, FL: Camelot Publishing Company, 2006.

Steffy, Joan Marie. *The Cuban Immigrants of Tampa, Florida, 1886–1888.* Master's thesis, University of South Florida, 1975.

Stewart, Laura, and Susanne Hupp. *Historic Homes of Florida.* Sarasota, FL: Pineapple Press, Inc., 1995.

Tagliarini, Sheila Lee. *Tampa: A Southern Cowtown, 1858–1878.* Master's thesis, University of South Florida, 1996.

Taylor, Paul. *Discovering the Civil War in Florida: A Reader and Guide.* Sarasota, FL: Pineapple Press, Inc., 2001.

Turner, Gregg M., and Seth H. Bramson. *The Plant System of Railroads, Steamships and Hotels.* Laurys Station, PA: Garrigues House, 2004.

Turner, Nancy. *Faith of Our Fathers: A History of St. Andrew's Episcopal Church.* Tampa, FL: St. Andrew's Parish, 1977.

University of Tampa Foundation. *A History of the Tampa Bay Hotel.* Tampa, FL: University of Tampa Foundation, 1971.

Vila, Bob. *Bob Vila's Guide to Historic Homes of the South.* New York, NY: Lintel Press, 1993.

Westfall, L. Glenn. *Don Vicente Martinez Ybor, the Man and His Empire: Development of the Clear Havana Industry in Cuba and Florida in the Nineteenth Century.* Gainesville, FL: University of Florida. Doctoral thesis, 1977.

———. *Tampa Bay: Cradle of Cuban Liberty.* Key West, FL: Key West Cigar City USA, 2000.

Winsberg, Morton D. *Florida's History Through Its Places: Properties in the National Register of Historic Places.* Tallahassee, FL: Florida State University, 1988.

INDEX

About the Author

Steve Rajtar grew up near Cleveland, Ohio, came to Florida to go to college, earned degrees in mathematics, anthropology, law and taxation and decided to stay. He's been involved with the Boy Scouts for over twenty-five years and is an activity leader with the Florida Trail Association. The combination of a love of the outdoors and local history has resulted in his establishment of over 150 historical tour routes through the communities of central Florida, which can be used by anyone to get up close and personal with the region's historic sites. He has written several books on various aspects of hiking and history and loves to guide tours by foot, bicycle and kayak.